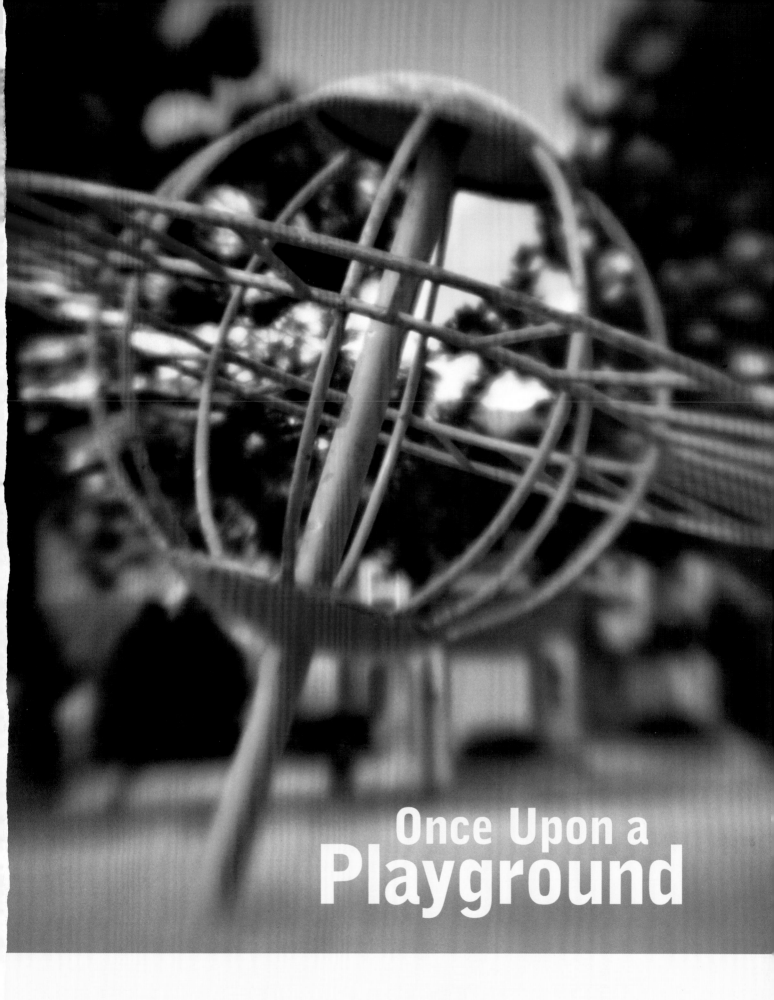

Once Upon a
Playground

ForeEdge

Once Upon a Playground

Brenda Biondo

A Celebration of Classic American Playgrounds, 1920–1975

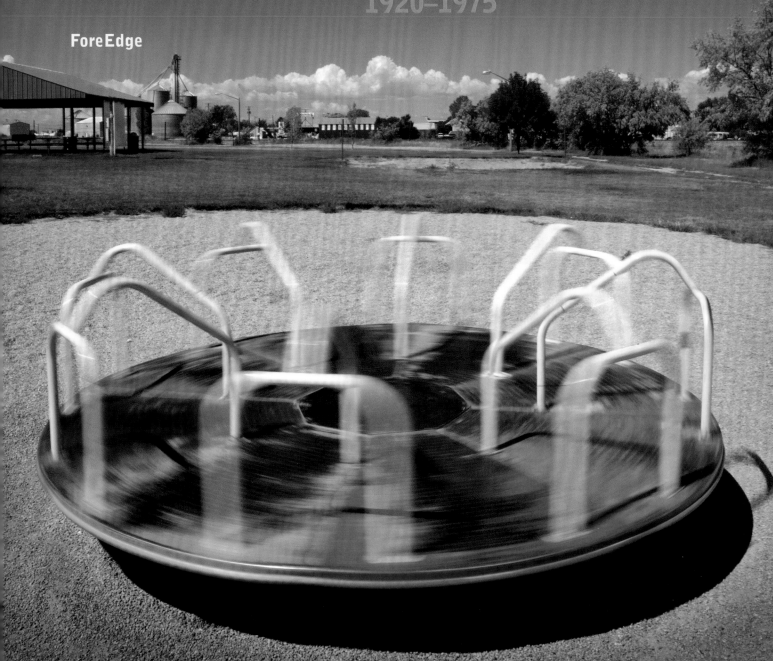

ForeEdge

An imprint of University
Press of New England
www.upne.com
© 2014 Brenda Biondo
All rights reserved
Manufactured in China
Designed and typeset in The Sans
and The Serif by Eric M. Brooks

For permission to reproduce any
of the material in this book, contact
Permissions, University Press of
New England, One Court Street,
Suite 250, Lebanon NH 03766; or
visit www.upne.com

Hardcover ISBN: 978-1-61168-512-1
Library of Congress Control
Number: 2013954866

5 4 3 2 1

For my children,
Sophia and Connor

Contents

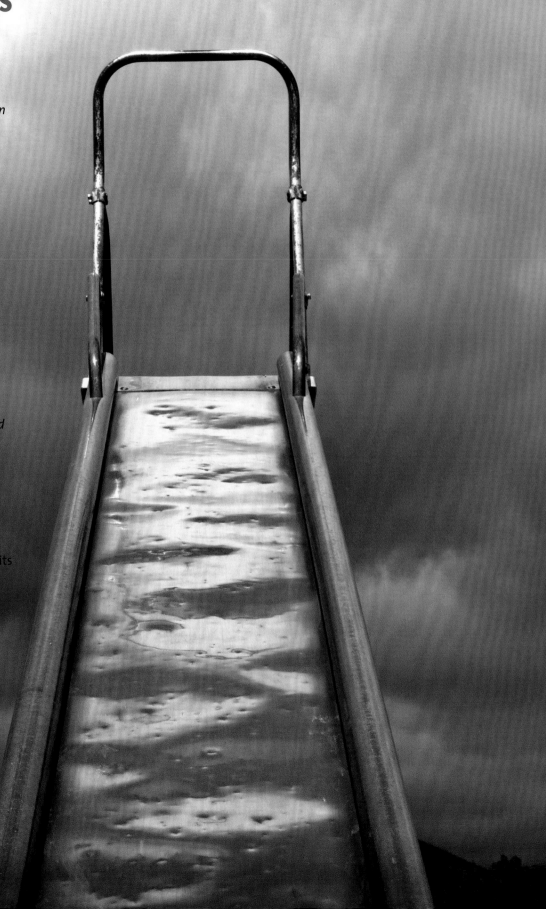

EverWear
PLAYGROUND AND
WATER APPARATUS

CATALOG No. 18

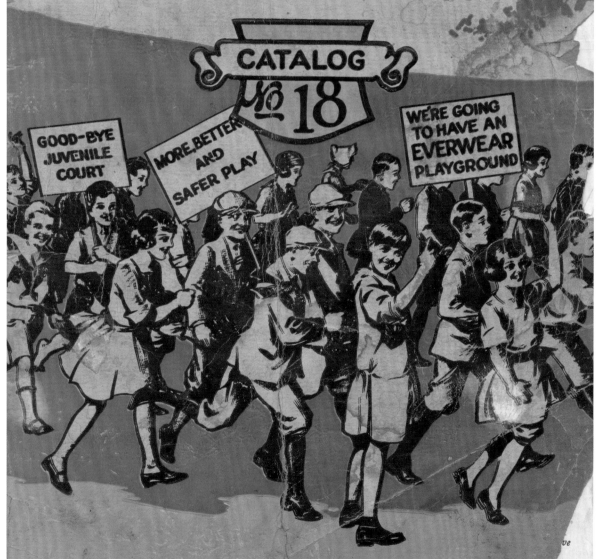

GOOD-BYE JUVENILE COURT

MORE, BETTER AND SAFER PLAY

WE'RE GOING TO HAVE AN EVERWEAR PLAYGROUND

Foreword

The haunting images of playgrounds in this book are important visual documents that ignite our collective and personal memories. Brenda Biondo's photos and use of historical images evoke nostalgia for several eras, from the 1920s through the 1970s, and give us a glimpse into the childhood play of earlier decades. Biondo searched hard for these surviving pieces of vintage playground equipment, and her book is a vital record of their existence.

Playgrounds were, and remain, microcosms of the values and interests of a country at a particular time. It is no wonder, then, that successive generations have altered or eliminated playgrounds as society has evolved. While there was never a single cause for playground removal, safety concerns and changing national aspirations were commonly at the heart of each playground transformation.

When we look to the relatively recent past—the last forty years—we see a jumble of restricting safety measures and procedures. Anything old has often been ripped out in hopes of creating a feeling of greater security. Intense scrutiny of playgrounds began in the 1970s. Early computers were able to generate data about the number of playground accidents. This information implicated playgrounds as hazards. The birth of the Consumer Product Safety Commission in 1972 and its subsequent publication in 1981 of guidelines for public playgrounds (continually updated ever since) have affected the size and height of equipment, the distance between pieces, and the surfacing material underneath.

America's first public playgrounds appeared in the early twentieth century, in the Progressive (Reform) Era.[1] These had a precise social agenda that was fueled by widespread belief that government could improve the lives of the underprivileged. Municipalities constructed playgrounds in order to socialize and educate the newly arrived immigrant population. The densest cities, such as New York and Chicago, built playgrounds to keep children from crime, to teach them how to interact with each other, and to familiarize them with American traditions. Programming was critical to this mission.

Playgrounds, hubs of daily urban life for immigrant and poor populations, were a neighborhood force that readied young people for adult life. These fenced spaces were effectively community centers that were more

Circa 1926

EverWear Manufacturing Company

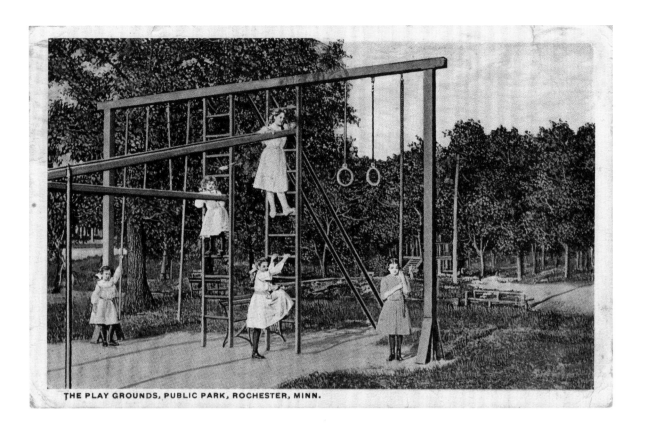

THE PLAY GROUNDS, PUBLIC PARK, ROCHESTER, MINN.

Postmarked 1918

The collection of postcards on the following pages shows playground equipment from the turn of the twentieth century.

comprehensive and extensive than anything we think of as a play area. Progressive Era playgrounds often included running tracks, sports fields, and free-standing buildings that might have a branch library or a dental clinic.

A section of the playground, usually labeled the "apparatus" or "gymnasium," was closest to what we would call a play space. Sometimes there were seesaws or a giant stride (a pole with six or eight suspended and dangling ladders), but the apparatus was the major piece of equipment and it was there to encourage exercise. It was very high and offered several activities, including swinging from "monkey bars" or rings or gliding down steep slides. There were ladders that look as if they leaned against the equipment or were suspended from it, instead of being incorporated into it. The entire apparatus seems to have tottered. We apparently are not being overly judgmental, since at least one city pulled these out in 1912 when they felt they had become unsafe.[2]

The Progressive Era apparatus was not just for children. Anyone could use it. Night lighting was a critical supplement so that everyone, including adults, could get a strenuous workout. Biondo's two striking images of later equipment at night are lovely in their own right, as well as being a reminder of why lighting first assumed importance in the early twentieth century.

A shift occurred once the immigrant population matured and felt at home. There was no longer a fervent social goal underpinning the

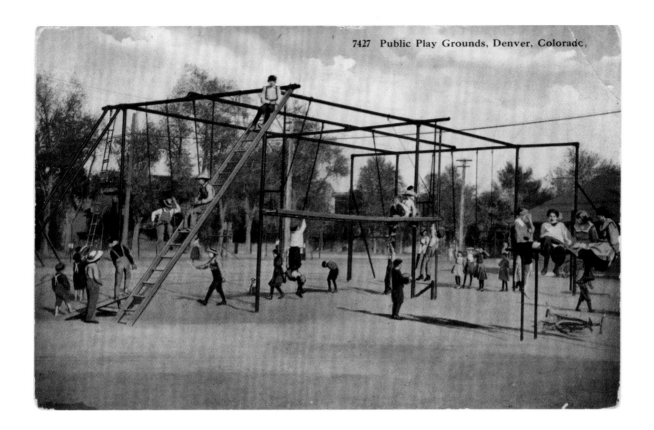

7427 Public Play Grounds, Denver, Colorado.

playground. It became a vehicle for pleasurable recreation. This happened by the early 1930s.[3] Equipment exclusively for children became the model, the forerunner of our present concept of a playground. This new-style play space, which remained an enclosed and carefully defined site, sprang up in urban, suburban, and rural public parks. It was typically an assortment of isolated parts. These were frequently undecorated swings, seesaws, high slides, sand boxes, and jungle gyms. They were meant to have a long lifetime with as little maintenance as possible. The surface material beneath them was hard and unforgiving. The play pieces were almost entirely metal (wood swing and seesaw seats were the exception). The harsh and forbidding feeling of these playgrounds eerily replicated the austerity of the Depression.

Biondo's photos illustrate that there was also equipment that was inventive, more group oriented, and sometimes terrifying. There were a variety of merry-go-rounds, horizontal ladders, slides twenty-five or thirty feet high, and versions of a "revolving jingle ring" (a pole, similar to a giant stride, with suspended rings). By pairing vintage catalog images with her own photos, Biondo shows us how children were expected to use these pieces and why they must have clamored to repeat these thrilling experiences.

A makeover came in the postwar years, after 1945. Play advocates tried to scrap the past and head in a new direction. There were several distinct streams of departure during a complex moment. It was an age when

Circa 1910

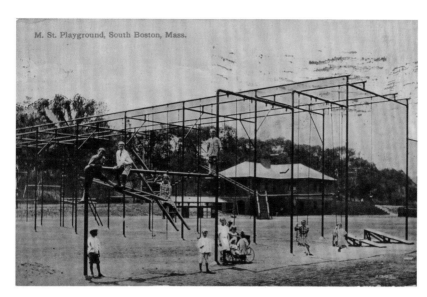

Postmarked 1912

Postmarked 1910

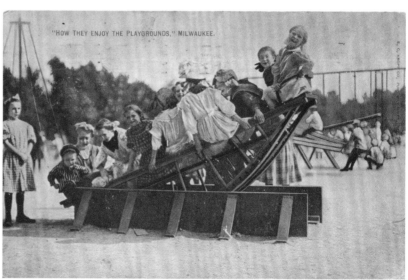

Circa 1912

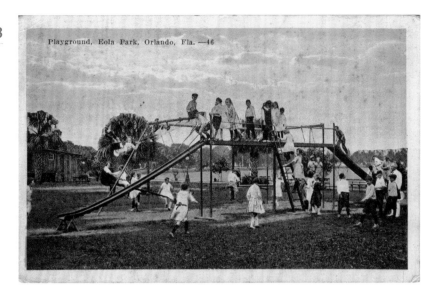

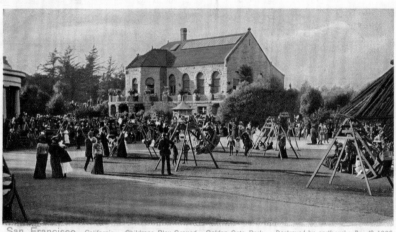

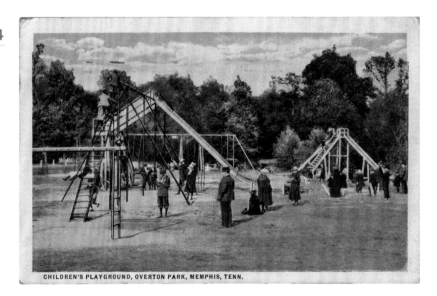

1911

Children playing on equipment in Pelham Bay Park, in the Bronx, New York (Bain News Service/Library of Congress)

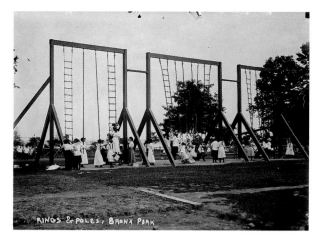

1911

New York City playground (Bain News Service/ Library of Congress)

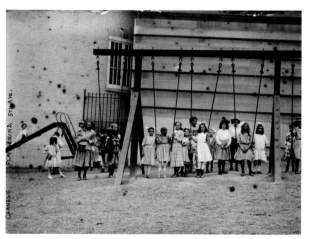

1905

A girls' playground on Harriet Island in St. Paul, Minnesota (Detroit Publishing Co./Library of Congress)

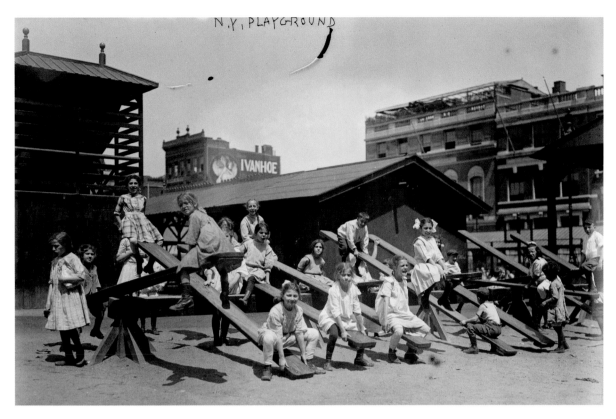

Circa 1910–1915

A New York playground (Bain News Service/Library of Congress)

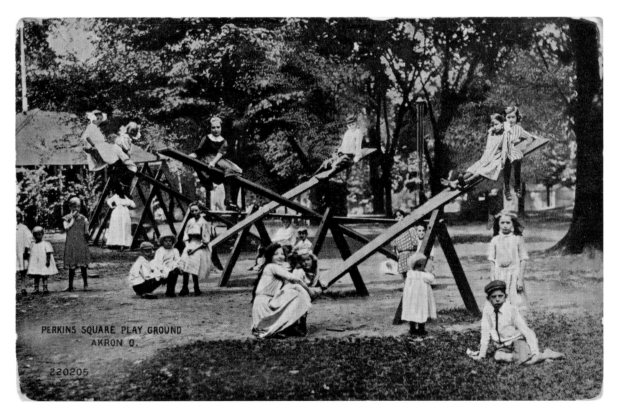

Postmarked 1914

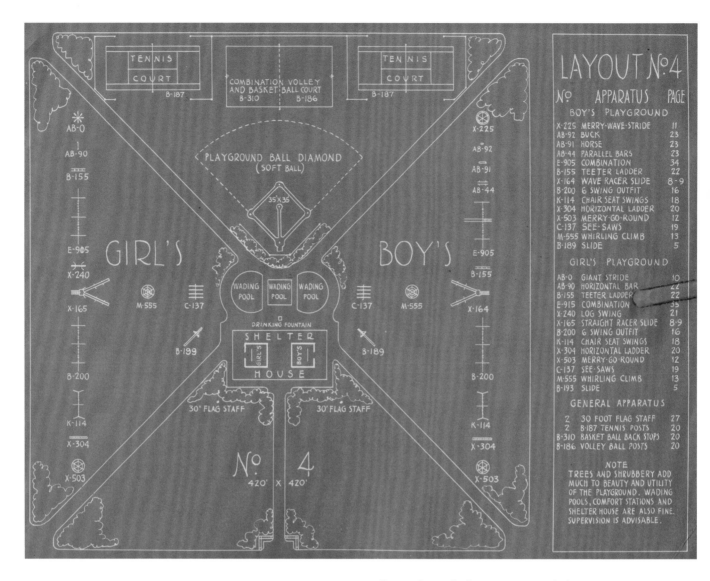

1930

The inside back cover of the
EverWear Manufacturing
Company catalog

our country optimistically embraced diverse accomplishments: economic success, increased leisure time, an expanding population, intensified suburbanization, a countrywide road network, world leadership in the arts, and the introduction of Disneyland (1955). Television became more prevalent in American households. The Cold War was an ongoing concern.

One stream saw the appearance of independent artists who designed playground equipment. They favored abstract shapes and nonfigurative concepts. The Museum of Modern Art helped to launch this phase by sponsoring a competition for playground design in 1954. Toy manufacturer Creative Playthings (a cosponsor with Parents' Magazine of the MoMA competition) created a separate division, Play Sculptures, to commission artists to design playground structures.

Fantastical creatures showed up on postwar playgrounds. Imaginary additions—such as dragons, oversized spiders, and free-form animals—mirrored the view of psychologists and parents that children

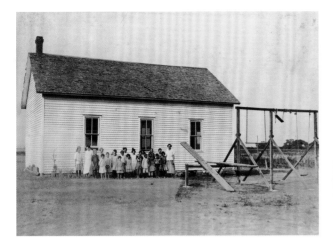

1916

A teacher and students at a school in Comanche County, Oklahoma (Lewis Wickes Hine/Library of Congress)

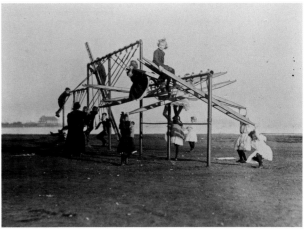

1909

Children on a playground apparatus, location unknown (Lewis Wickes Hine/Library of Congress)

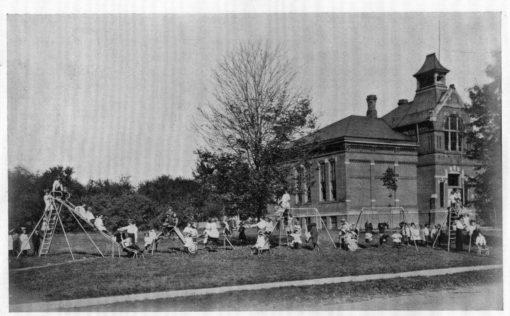

THE ASHLAND MFG CO. · EUREKA · ASHLAND, OHIO, U. S. A.

SCHOOL DAYS THAT ARE NEVER FORGOTTEN

"READING" "RITING" "RITHMATIC" "RECREATION"

OLD FASHIONED FUN IN A NEW FASHIONED WAY

The Large Illustration shows some of our All-Steel Playground Apparatus "In Action" and serves also as an Illustration of the Modern Up-to-date School where they are developing the Physical as well as the Mental and Moral Natures of the Child

"When we were a couple of kids."

Page Four

Circa 1926

Eureka catalog, Ashland Manufacturing Company

THE ASHLAND MFG CO. THE EUREKA LINE ASHLAND, OHIO. U. S. A.

Page Thirty-four

EUREKA STUDEBAKER PARK COMBINATION
Better the playground and trained leaders than reformatories and uniformed guards.

Circa 1926

Eureka catalog, Ashland
Manufacturing Company

needed more creativity in their lives. *The Wizard of Oz* movie (1939), shown on television since the mid-1950s, was the inspiration for the Tin Man, the Lion, and the Scarecrow that sat at the top of swing sets. These, too, were meant to spur kids' imaginations.

Equipment became more realistic and even specific to news headlines and to popular culture in the 1960s and 1970s. The choice of imagery was both current and deeply imprinted on the minds of parents, the "baby boomers." All Americans, young and old, could take pride in our country's moon landing in 1969. Space ships and radar screens, both popular in the 1970s, reflected younger children's fascination with the *Jetsons* and older kids' allegiance to *Star Trek*. The same space novelties resonated with the parents and may have been intended more to be touchstones for them than for their offspring. Grown-ups marveled that they could fly in a commercial jet plane. These adults recalled the children's programming on 1950s television, when space explorer *Captain Video and His Video Rangers* captured their attention.

There was a similar appeal to adults who would have looked fondly

Mitchell Climbing Swing No. 950

The Mitchell Climbing Swing, another original Mitchell device, is a body builder besides a play piece. It may be attached to a six swing frame, thereby making a new piece of equipment for your old swing outfit. The Climbing Swing is built for a frame 12 feet high. The photograph illustrates clearly its attachment to the 3-inch top pipe. It is made entirely of steel with the exception of the wood platform and will accommodate many children. Climbing and swinging gently at the same time furnishes many thrills.

No. 950 — Climbing Swing, complete with pipe. Shipping weight approximately 850 lbs.

Outfit comprises 2 A-2 End Fittings, trusses and one climbing swing, shipped knocked down.

Pipe Specifications: 1 piece 3-inch galvanized pipe 15 feet long, 6 pieces 2-inch galvanized pipe 15 feet long. 6 GA-15 Ground Anchors.

No. 951 — Climbing Swing complete less end fittings and pipe. Shipping weight approximately 550 lbs.

SPECIFICATIONS

Six Arches — Constructed of 2¼-inch x ⅝-inch x ¼-inch I-beam steel.

Height of Arch — From center to center 9 feet 6 inches.

Length of climbing swing 10 feet

Cross Bars — ¾-inch pipe fastened to arch with special coupling.

Height of platform above ground 22 inches.

12

Mitchell Manufacturing Company

Patent Pending

on Wild West playgrounds. The programs *Hopalong Cassidy* and *The Lone Ranger* had enthralled them when they were young. Appropriate to the Cold War, these fictional heroes taught about the triumph of good over evil. Children in the 1970s recognized the same material on playgrounds from movies and television, even though Westerns were in decline in TV programming.[4]

Architects and landscape architects entered the playground arena. Biondo's photos of geodesic-inspired domes and four-way climbers may be derivatives of that trend. Architects and landscape architects also sought ways to link the traditional slides and sand boxes. They wanted to forge an innovative climbing and exploratory environment that would engage children physically and mentally. They did not want to return to the connected pieces on the "apparatus" of the early twentieth century, but to invent more expansive ways to energize an entire setting. Architect Richard Dattner and landscape architect M. Paul Friedberg (following in

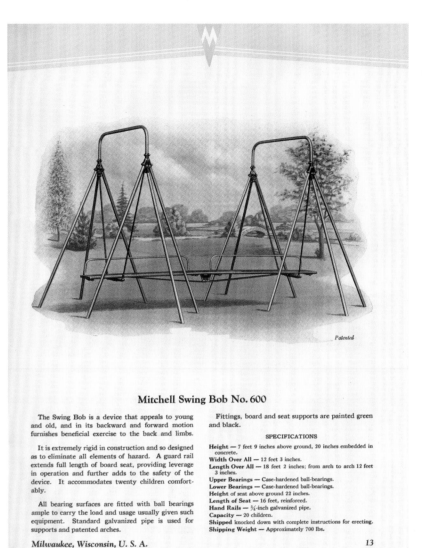

Mitchell Swing Bob No. 600

The Swing Bob is a device that appeals to young and old, and in its backward and forward motion furnishes beneficial exercise to the back and limbs.

It is extremely rigid in construction and so designed as to eliminate all elements of hazard. A guard rail extends full length of board seat, providing leverage in operation and further adds to the safety of the device. It accommodates twenty children comfortably.

All bearing surfaces are fitted with ball bearings ample to carry the load and usage usually given such equipment. Standard galvanized pipe is used for supports and patented arches.

Milwaukee, Wisconsin, U. S. A.

Fittings, board and seat supports are painted green and black.

SPECIFICATIONS

Height — 7 feet 9 inches above ground, 20 inches embedded in concrete.
Width Over All — 12 feet 3 inches.
Length Over All — 18 feet 2 inches; from arch to arch 12 feet 3 inches.
Upper Bearings — Case-hardened ball-bearings.
Lower Bearings — Case-hardened ball-bearings.
Height of seat above ground 22 inches.
Length of Seat — 16 feet, reinforced.
Hand Rails — ¾-inch galvanized pipe.
Capacity — 20 children.
Shipped knocked down with complete instructions for erecting.
Shipping Weight — Approximately 700 lbs.

13

the steps of architect Louis I. Kahn and sculptor Isamu Noguchi, who had designed a publicized but unbuilt playground in the 1960s) were leaders in joining pieces horizontally and vertically. They used a neutral palette, natural stones, and abstract shapes to create entire playgrounds. Kids could scamper along walls or work their way up stone mounds. Sand was often the surface material and made the entire ensemble into a giant sand pit.

These wonderfully original playgrounds, mostly in New York City, were the forerunners of today's commercial, less exciting, "post and deck" off-the-shelf equipment. Many examples, especially the ones Friedberg designed (including transportable wood versions), have already vanished. Some, when threatened with demolition, have elicited a strong response from local residents. These playgrounds were magnets for the community and, being abstract assemblages, were able to stimulate the imagination of children. Kids came daily, met up with their

buddies, and enacted dramatic scenarios set within these spaces; they believed they were sailing on pirate ships or building forts or soaring into the sky. These were individualized spots where kids kept reinventing their surroundings.

It is unclear which of today's playgrounds will elicit a similar response from future users, if these in turn become threatened fifty years from now. Our job is to make sure we invest in designs that not only challenge kids but also provide unique places and open-ended opportunities. Let's hope that photographers, decades from now and following Biondo's legacy, will have reason to look back at today's playgrounds and treasure them as important parts of our cultural heritage, sites that were lively spaces where children gathered regularly and found ways to engross and inspire each other.

NOTES

1. For descriptions of Progressive Era playgrounds, see Galen Cranz, *The Politics of Park Design: A History of Urban Parks in America* (Cambridge, MA: MIT Press, 1982; paperback ed., 1989), 62–87. San Francisco's Children's Playground (1887) may be an anomaly. In spite of its name, it may fall more under the category of "pleasure ground," which Cranz describes as a picturesque site for strolling that preceded the Progressive models.

2. Rachel Iannacone, "Open Space for the Under Class: New York City's Small Parks 1885–1920," Ph.D. dissertation, University of Pennsylvania, 2005.

3. Galen Cranz has written perceptively about this. See Cranz, *The Politics of Park Design*, 103–22.

4. Gary A. Yoggy, "Prime-Time Bonanza! The Western on Television," in Richard Aquila, ed., *Wanted Dead or Alive: The American West in Popular Culture* (Urbana: University of Illinois Press, 1996), 160–87.

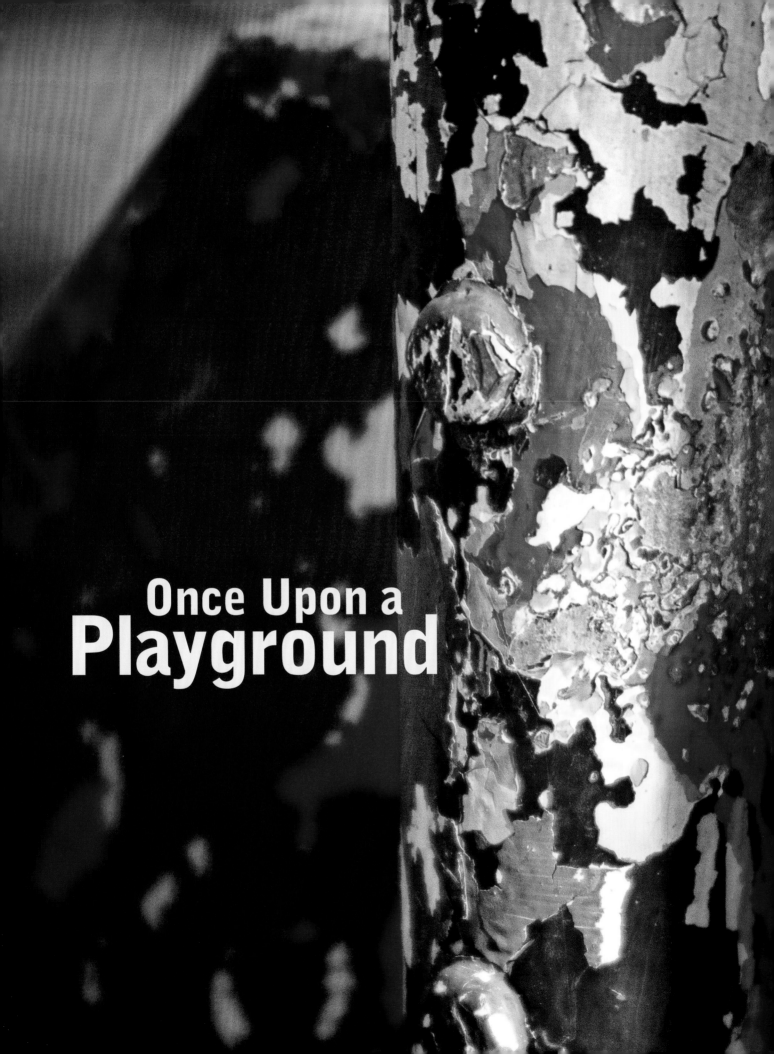

Once Upon a
Playground

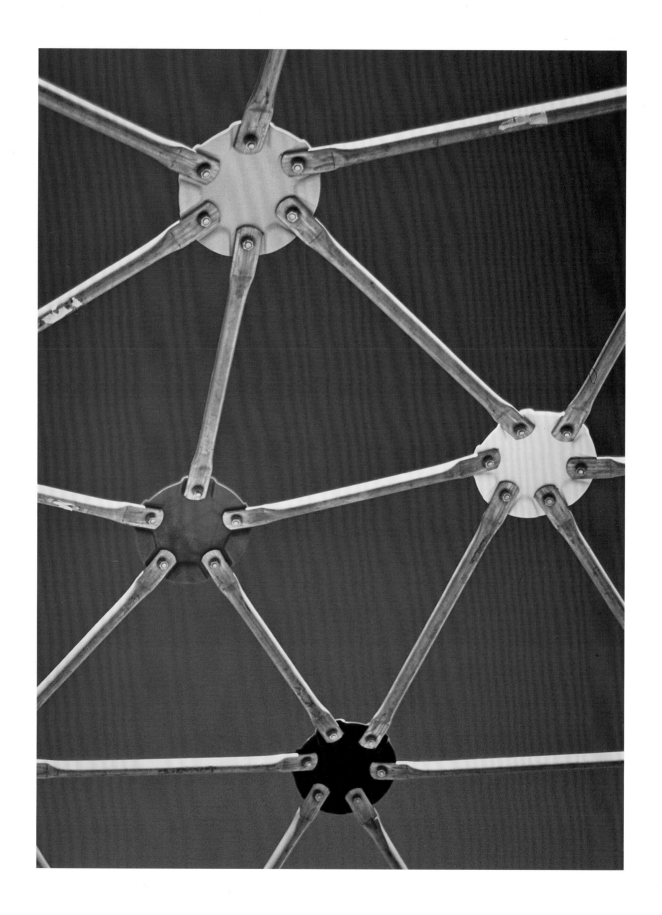

Introduction

Childhood playgrounds hold a special place in the memories of generations of Americans. For most of the twentieth century, classic metal and wooden equipment—tottering seesaws, spinning merry-go-rounds, towering slides—was a staple in nearly every schoolyard and town park. These once common elements of the American landscape are some of the most beloved icons of childhood, as well as tangible pieces of our country's cultural heritage.

Although I spent plenty of free time on playgrounds as a child in the 1960s and '70s, I didn't give them much thought until decades later, when I started visiting parks near my home in Colorado with my young daughter. It wasn't long before I noticed that the type of playground equipment I loved when I was growing up was nowhere to be found in my neighborhood parks. Instead, there were only swings and large plastic structures, multicolored and multilevel—all seemingly well loved by the local children, but very different from the earlier play equipment I remembered.

As a mother, it's easy for me to understand why parents and towns want to fill their parks and schoolyards with updated equipment and structures that engage kids in fun and safe ways. Even my husband refers (only half-jokingly) to some of the old pieces I've photographed as "Slides of Death." But I also feel strongly that these vintage pieces of equipment—because they hold such a prominent place in our own personal histories—are worth preserving in some way.

In 2005, I decided to document these childhood artifacts before they are gone forever. I began searching them out on weekends and during specific playground-hunting trips, spending the next seven years visiting as many playgrounds in as many towns around the country as I could get to. On a typical outing I would drive a circular route, usually out in rural areas, stopping at every town, no matter how small, to see what was there. Nearly every town I visited had at least one elementary school and one

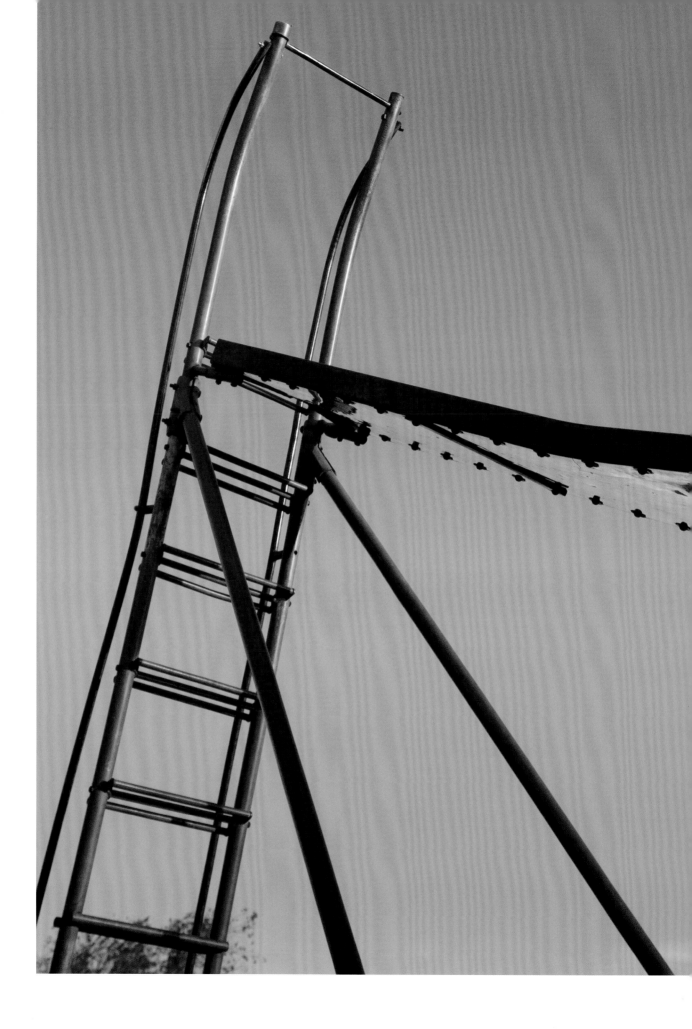

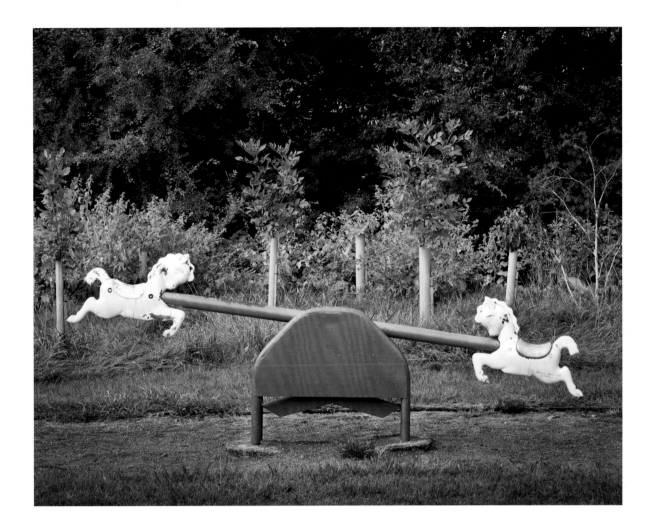

town park with some type of play equipment. Usually the smallest and least affluent towns had the oldest equipment.

Occasionally I'd pull into a town, find its primary park, and be confronted with a shiny plastic structure so new looking that it almost taunted me with the idea that only months before a huge, ancient piece of playground equipment might have stood on that same ground. Other times, friends or family members would tell me about a great piece of equipment they had recently seen while traveling, and at first chance I would head out to that town only to find a worn patch of dirt where some equipment had obviously recently stood. On several occasions, I'd go back to shoot equipment in a different season only to find it had been torn down in the interim. (After schools and towns renovate their playgrounds, most of the old equipment is hauled off to scrap yards—although smaller pieces can often be found for sale on eBay.)

Those experiences made me appreciate even more when I *did* find old equipment still standing in its original location—especially when it was an unusual style or something I hadn't seen before. The variety of equipment manufactured between 1920 and 1975 turned out to be greater

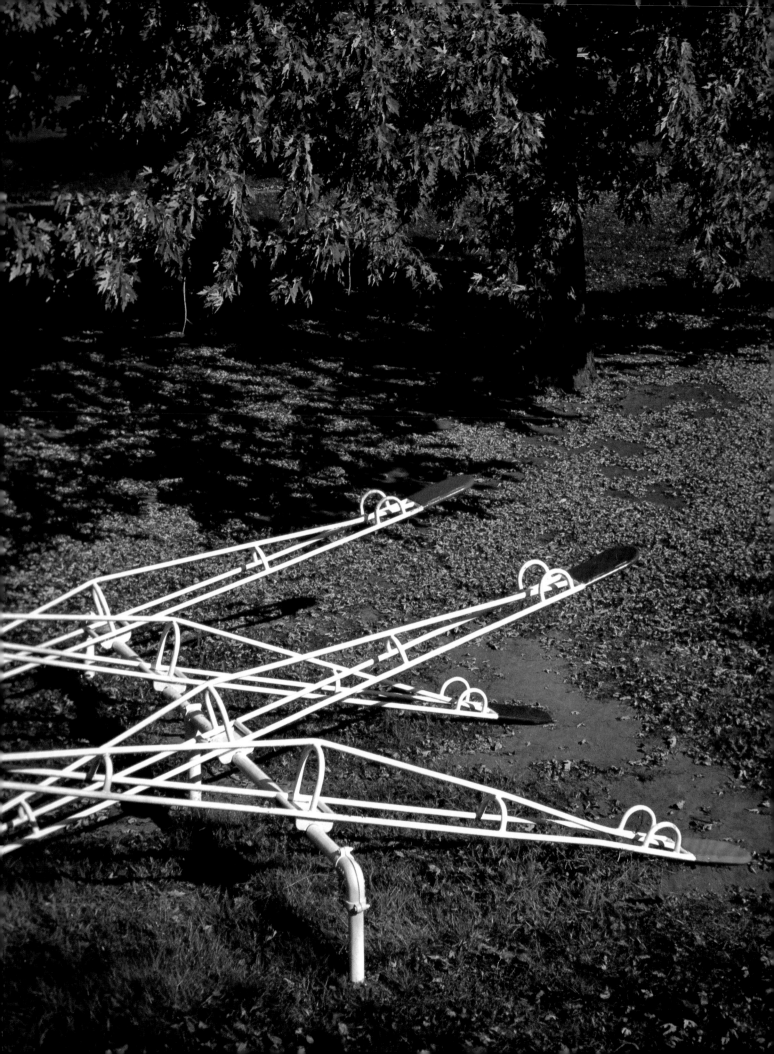

than I'd expected when I began this photographic project. And it didn't take me long to notice how the designs of some equipment reflected the popular culture of the era in which it had been manufactured and installed. For example, equipment in the shape of rocket ships, satellites, and lunar landers from the 1960s and '70s reflects society's fascination with space exploration at that time. Some designs also testify to society's changing acceptance of certain stereotypes; the era of equipment in the shape of Native American and Asian caricatures has obviously, and thankfully, passed.

There are some designs I've seen in old catalogs that, as much as I've searched, I could never find—whether because they were too rickety or unsafe to have survived into the twenty-first century, or because I just wasn't lucky enough to stumble across them in my travels. For that reason, this book should be viewed as a visual tribute to many of the popular and prevalent structures, rather than a definitive catalog of all the equipment from a particular time.

To give readers a better idea of how the equipment evolved over time, I've organized the book in chronological order instead of by type of equipment. Each chapter covers two decades and includes both equipment that first appeared during those twenty years and equipment still popular and being manufactured during those decades. (In a few cases, I've been unable to find any historical documents that could help me date an unusual piece of equipment; for the photos of those pieces of equipment, I had to guess the decade of manufacture for the sake of placement in this book.) Whenever possible, I've matched historical images with recent photographs of the same equipment; when the exact equipment couldn't be found and photographed, I've matched the historical images with photos of similar equipment. (Most of the historical images are from my personal collection of catalogs and other playground ephemera, supplemented by images from the Library of Congress.)

Although I continue to photograph old equipment wherever and whenever I come across it, vintage pieces get harder to find each year. As these pieces of equipment steadily fade from the American landscape, I hope the images in this book will help preserve them in our memories.

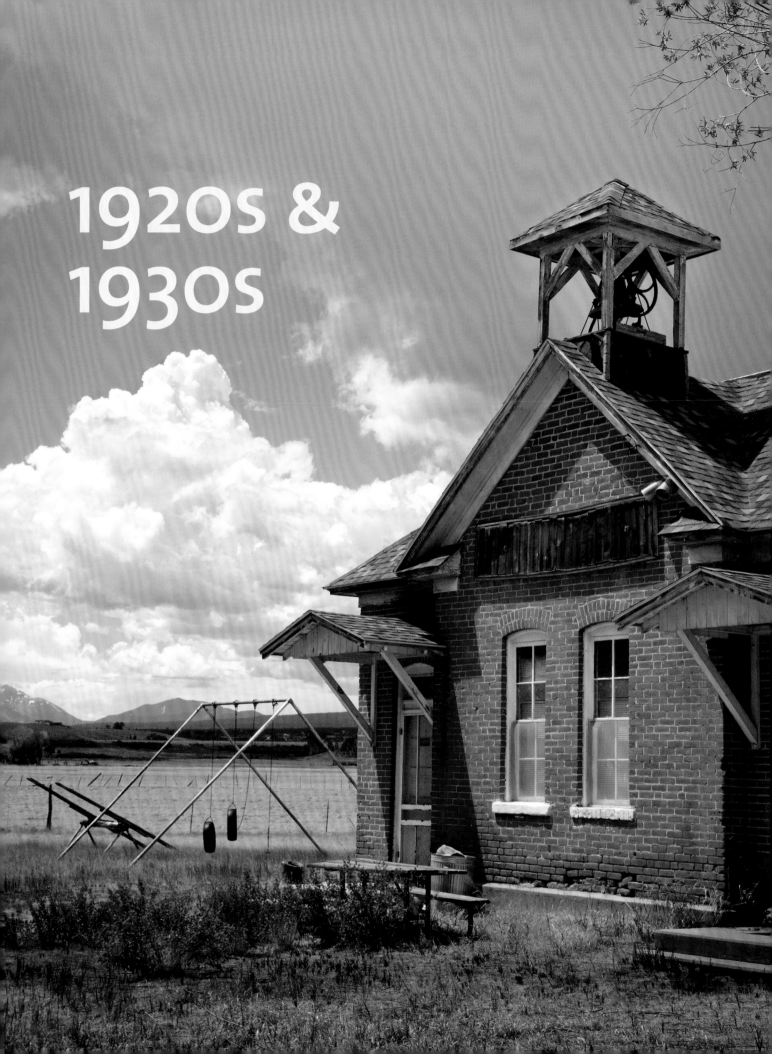

1920s &
1930s

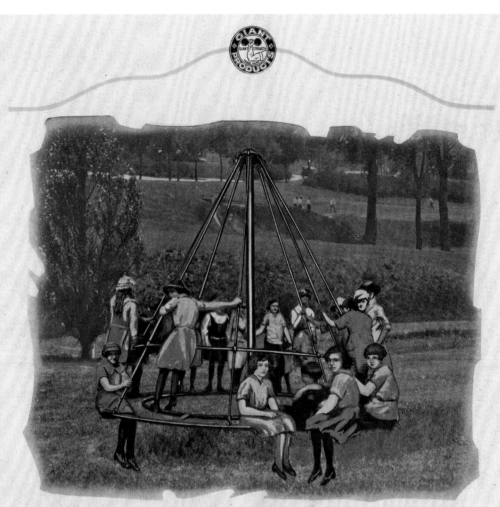

Junior Wave

JUNIOR WAVES are built for the smaller children, and are found on many playgrounds. In building apparatus for small children great care must be taken to insure the user from possible accident. In this unit you will find that safety has not been overlooked yet it provides numerous thrills for the children.

PRICED within the reach of most any organization, yet sustaining the quality of supreme workmanship, this unit has become one of the most popular in the famous Giant Line. Any playground would be justly proud of this equipment.

THE CONSTRUCTION features of this apparatus are the same as that of Giant Waves. The quality of workmanship and materials are the same.

THE JUNIOR WAVE is 7 feet 6 inches high, and the platform measures 7 feet in diameter. All joints are securely fastened to insure safety to all.

THE NEATNESS of design must not be overlooked, as the trim outline of this apparatus shows up outstandingly on the playground.

*No. U -28—Complete with Galvanized Supporting Post (Approximate shipping weight, 222 lbs.) _____ $ 68.00

No. US-28—Complete, except Center Post (Approximate shipping weight, 154 lbs.) _____ 51.00

No. UG-28—Wave Post, one-piece pipe 3½ inches in diameter and 10 feet long, Galvanized (Approximate shipping weight, 68 lbs.) _____ 17.00

No. UP-28—Wave Post, Painted (Approximate shipping weight, 68 lbs.) _____ 12.00

1931

Giant Manufacturing Company

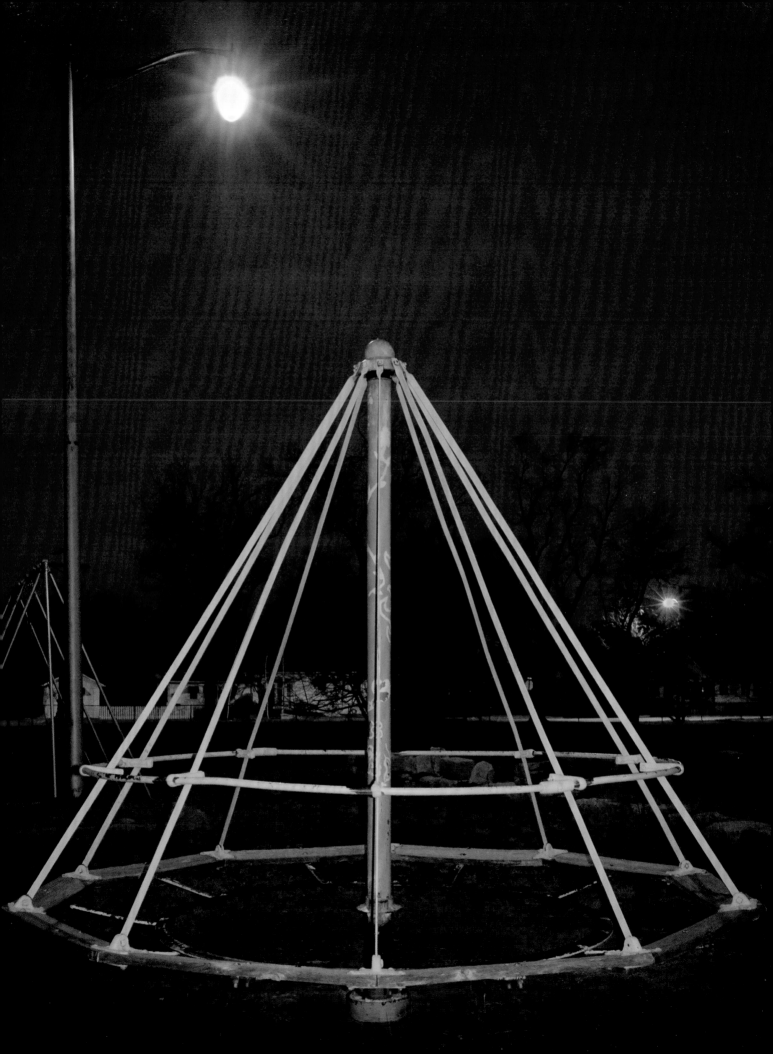

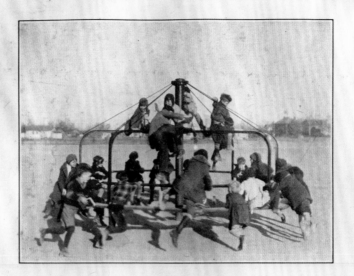

Safety

You can't keep children from climbing all over a piece of apparatus. Karymor is so constructed that there is no place about the device for a child to get caught in a pinch or jam. Several State Institutions for Blind Children have installed Karymors because of the many safety features.

A Typical Rural School

Because of the difference in the ages and sizes of the children in a Rural School, it is a difficult problem to keep them interested in the same thing for very long at a time. A Karymor on your playground will solve this better than any other way. It will easily handle all of the children at one time in the average Rural School.

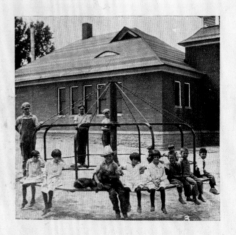

1931

Karymor Playground Apparatus
catalog, R. F. Lamar and Co.

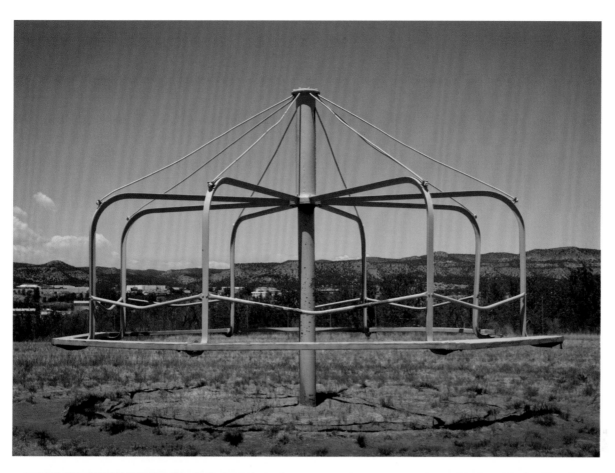

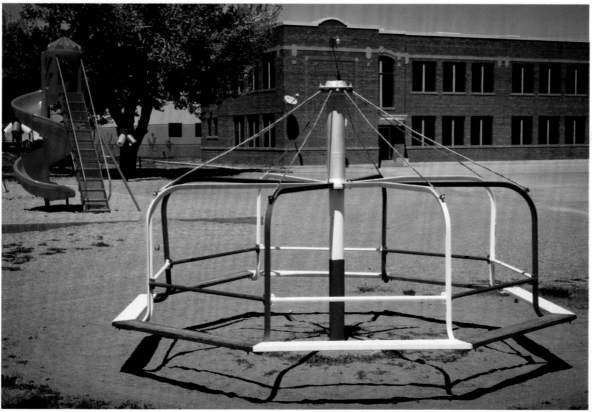

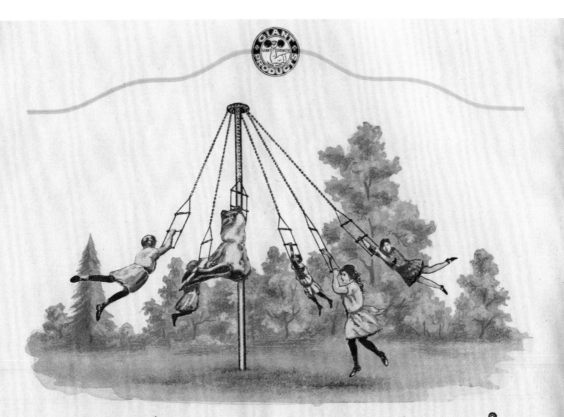

Giant Stride

ACTION! THRILLS! Boys and girls have great fun on the Giant Stride. It is safe and gives them healthful exercise. The running and whirling movement develops the arm and leg muscles. This action stimulates the lungs into full action which develops the chest. One to eight children can play at the same time. All playgrounds should be equipped with one or more Giant Strides.

THE POPULARITY of this piece of apparatus with schools and parks results from the stability of the apparatus. The long wearing and frictionless bell is a popular feature of the Giant Stride. The approved Stride Ladder is another important item. The heavy case-hardened ball-bearing operates in a chilled ball race. The bearings run in a bath of oil eight inches deep.

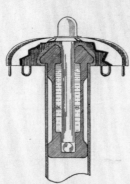

Frictionless Bell

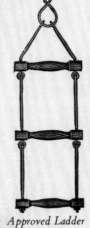

Approved Ladder

THE GIANT STRIDE occupies a very small area on the playground and is used by both boys and girls at all seasons.

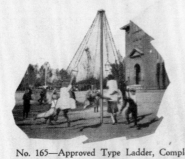

*No. 18—Giant Stride, with Eight Approved Ladders, Complete with Chain and Safety Hook, No Post (Approximate shipping weight, 55 lbs.) .. $ 47.00

*No. 16—Giant Stride, with Six Approved Ladders, Complete with Chain and Safety Hook, No Post (Approx. shipping weight, 48 lbs.) ... 36.00

No. 15-G—Giant Stride Supporting Post Only, Galvanized (Approximate shipping weight, 125 lbs.) 23.00

No. 15—Giant Stride Supporting Post Only, Painted (Approximate shipping weight, 125 lbs.) 20.00

No. 160—Bell Only, will Accommodate Six Ladders (Approximate shipping weight, 25 lbs.) 12.00

No. 180—Bell Only, will Accommodate Eight Ladders (Approx. shipping weight, 25 lbs.) 15.00

No. 165—Approved Type Ladder, Complete with Chain and Safety Hook 4.00

No. 169—All-Metal Ladder, Aluminum Rungs, complete with Chain and Safety Hook 5.00

1931

Giant Manufacturing Company

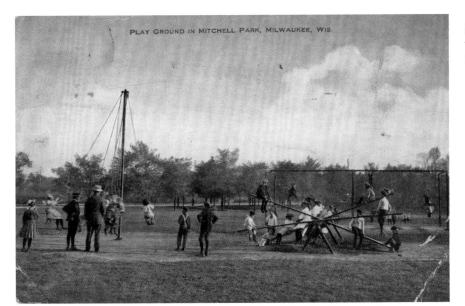

PLAY GROUND IN MITCHELL PARK, MILWAUKEE, WIS.

Postmarked 1908

Postcard

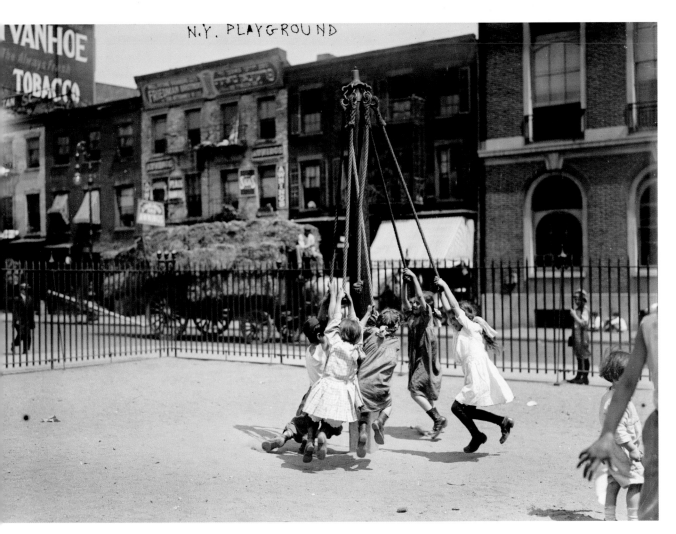

N.Y. PLAYGROUND

Circa 1913

Playground scene (Bain News Service/Library of Congress)

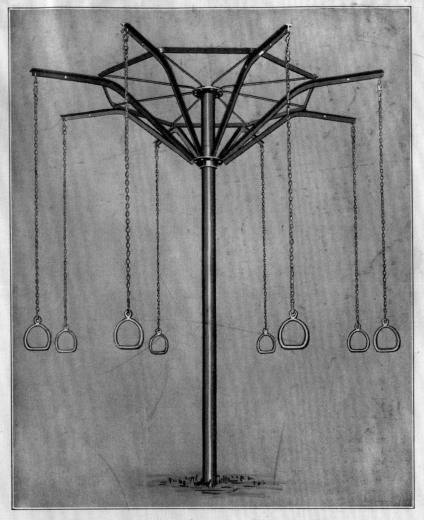

Karymor Stationary Jingle Ring

THIS is the stationary type of our Jingle Ring outfit. The frame is entirely rigid and does not revolve.

Adjustable Feature—Each arm of this device can be adjusted to three different positions, namely, horizontal, above horizontal, and below horizontal. Each arm is equipped with two holes that permit an adjustment of the chains, i. e., one chain may be suspended from the outside hole on one arm and on the next arm it can be suspended from the inside hole. With the device adjusted in this manner the course of travel is up and down with a zig zagging motion. Or, the device may be used in the conventional manner with all of the chains suspended from the outer row of holes and the arms in horizontal position.

SPECIFICATIONS

Diameter—(9′) Nine Feet.
Main Mast—4½″ O. D. Heavy Steel Pipe.
T-Bar Supporting Arms—(8) 1¾″x1¾″x¼″ Copper Bearing Steel.
Hanger Rods—(8) ½″ O. D. Solid Round Steel Rod.
Tie Braces—(8) 1⁵⁄₁₆″x³⁄₁₆″ Flat Steel.
Rings—(8) Aluminum improved stirrup type. Length of ring and chain (6′) Six Feet.
Chain—Heavy Tenso type galvanized. Each chain is equipped with a heavy log chain swivel.
Height of Rings Above Ground—(6′) Six Feet.
Height over all—(12′) Twelve Feet.
Finish—Entire device attractively enameled in beautiful color combination of Vermillion Red and Royal Blue.
Installation—Material—3 sacks cement, 1 yard gravel; Labor—2 men, 7 hours.

No. 106—Karymor Stationary Jingle Ring Outfit, weight about ..365 lbs.

1931

Karymor Playground Apparatus catalog, R. F. Lamar and Co.

14

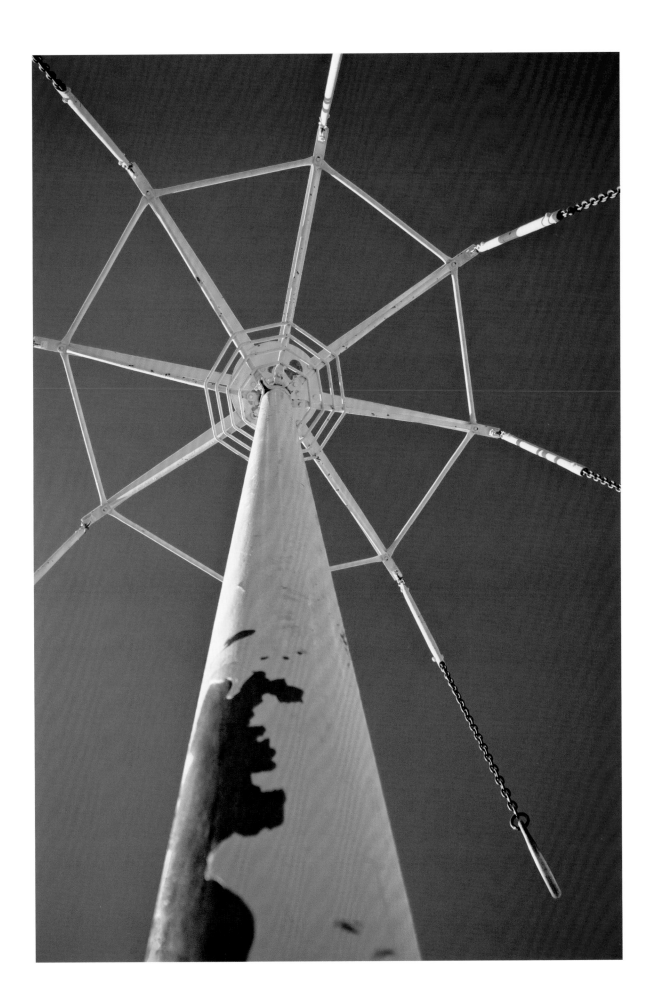

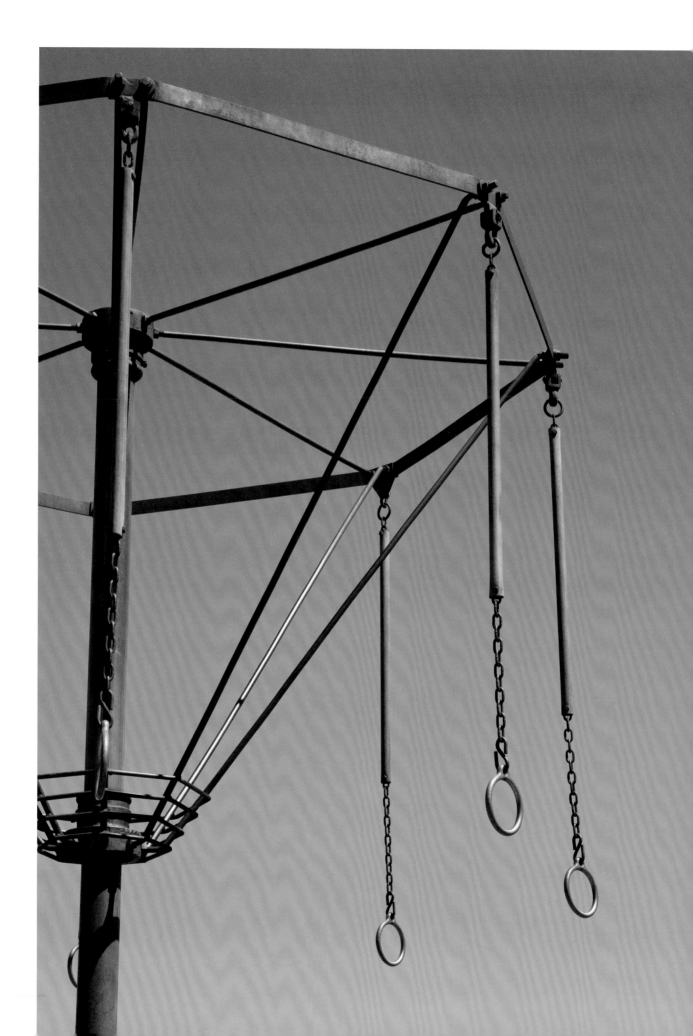

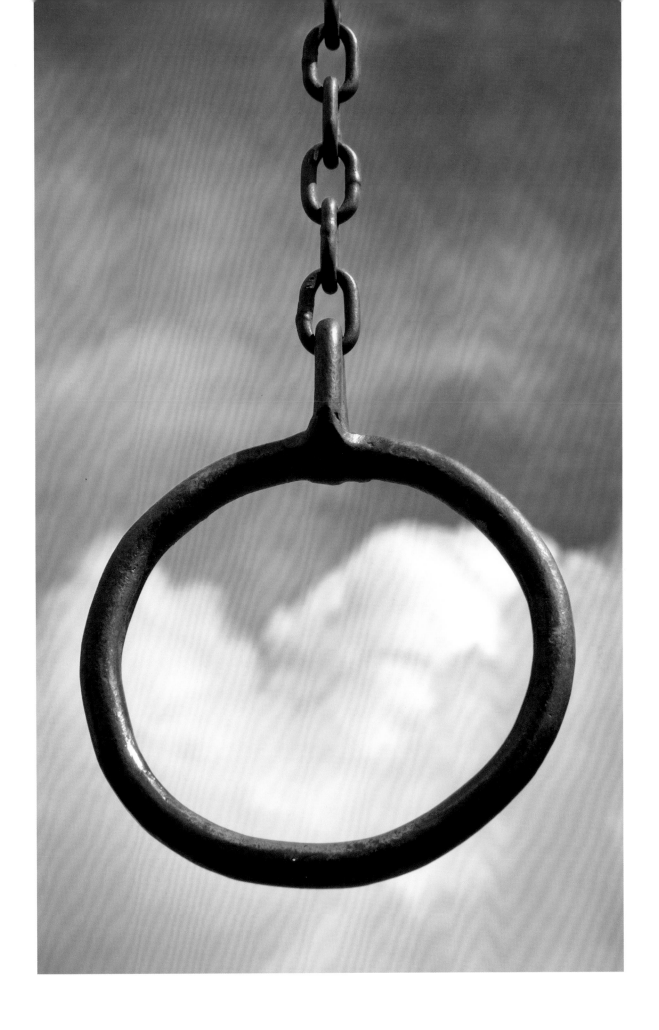

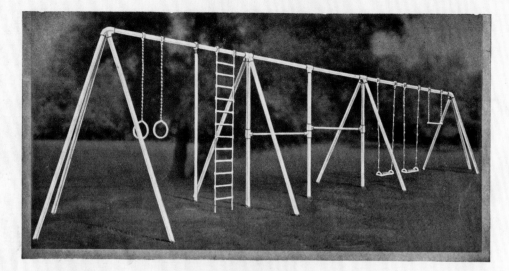

Split Clamp Fittings
FOR EASY ERECTION

Outdoor Gymnasium

No. 376 gymnasium has been a favorite for many years. It is time-tried and proved, and has capacity of eight children.

Overhead frame member is 3-inch galvanized steel pipe with all supports of 2-inch galvanized pipe. All frame fittings hot galvanized.

The swings, rings and trapeze are all fitted with oilless bearing hangers. Horizontal bars are adjustable, and anchors are furnished for steel climbing pole, and flexible ladder. All support pipes are galvanized and imbedded in concrete.

No. 376—12 feet high, all apparatus, fittings and pipe complete, weight about 1100 lbs. ⸺ $225.00

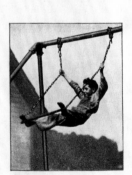

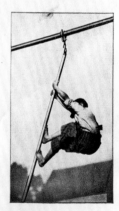

| FLEXIBLE LADDER | FLYING RINGS | TRAPEZE BAR | CLIMBING POLE |

Page 8

Circa 1920

FunFul catalog, General Equipment Company

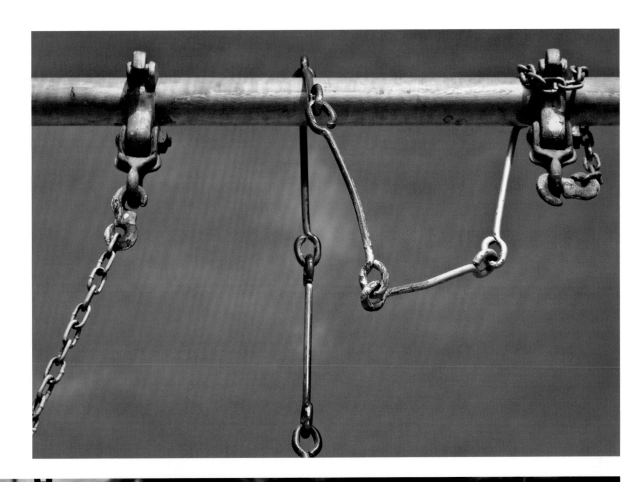

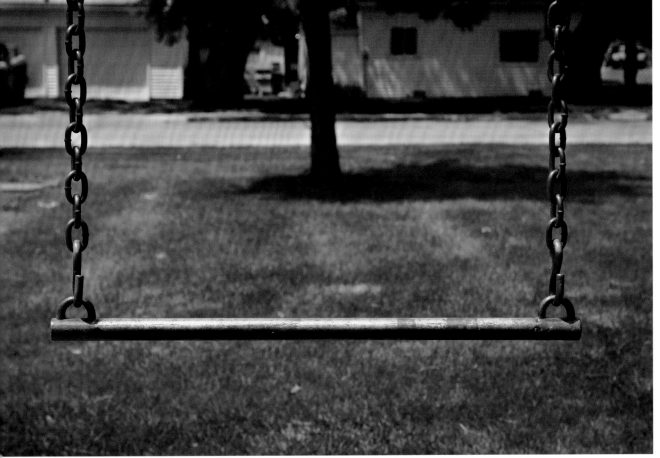

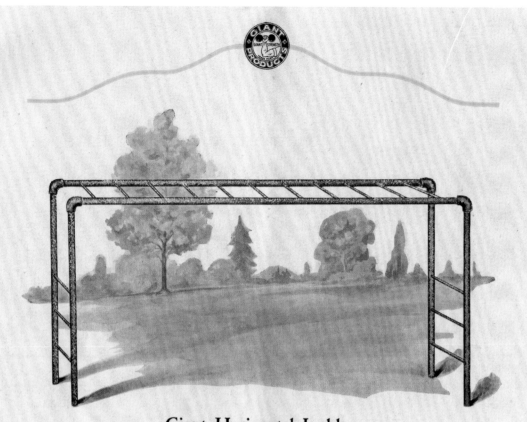

Giant Horizontal Ladder

ALL CHILDREN have a propensity for climbing. It is as natural as breathing. This tendency is recognized and encouraged with the Horizontal Ladder.

IT IS ONE of the neatest pieces of playground equipment that can be purchased and it requires a minimum of space for erection.

MADE OF all pipe construction the upright legs and horizontals are first quality, full weight pipe 2½ inches in diameter. The rungs are securely connected to sturdy 2-½ inch side pieces.

LENGTH over all, 16 feet. Height, 7½ feet above ground, embedded 2½ feet. All parts on Giant Horizontal Ladder weather-proofed.

*No. 96—Giant Horizontal Ladder (Approximate shipping weight, 275 lbs.)_____$69.00

Junior Horizontal Ladder

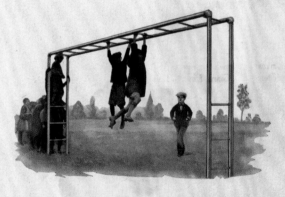

THIS PIECE of apparatus is very popular with children, and can be erected in any small area. The Junior Horizontal Ladder develops the arm and stomach muscles of the youngsters.

THE HORIZONTAL Ladder is built from high grade steel pipe. It is 6 feet high and 12 feet long. The steps on the Ladder are 17½ inches apart.

*No. JH-90—Junior Horizontal Ladder_____$49.00

[Page 24]

1931

Giant Manufacturing Company

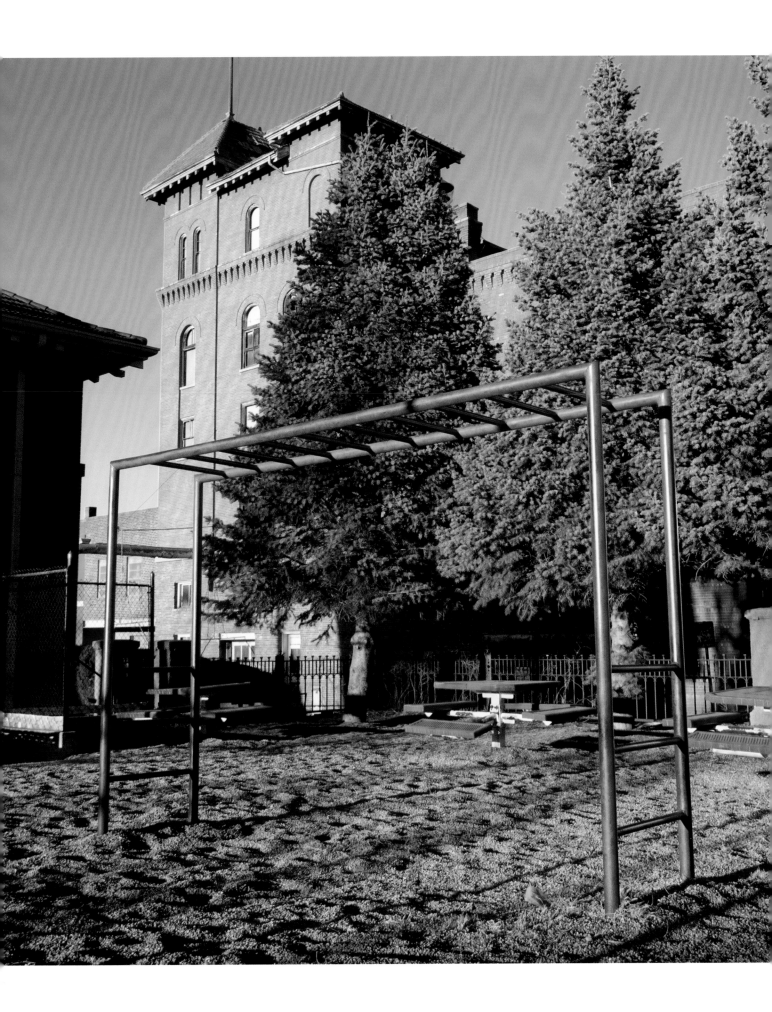

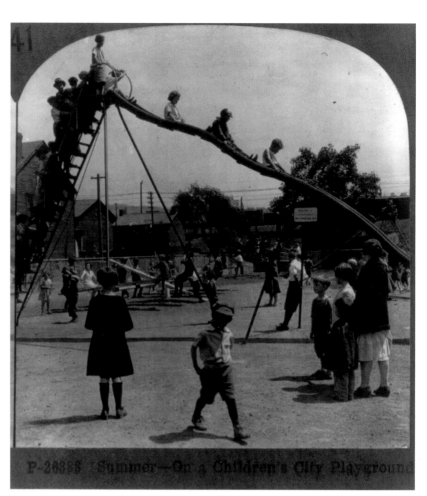

P-26898 Summer—On a Children's City Playground

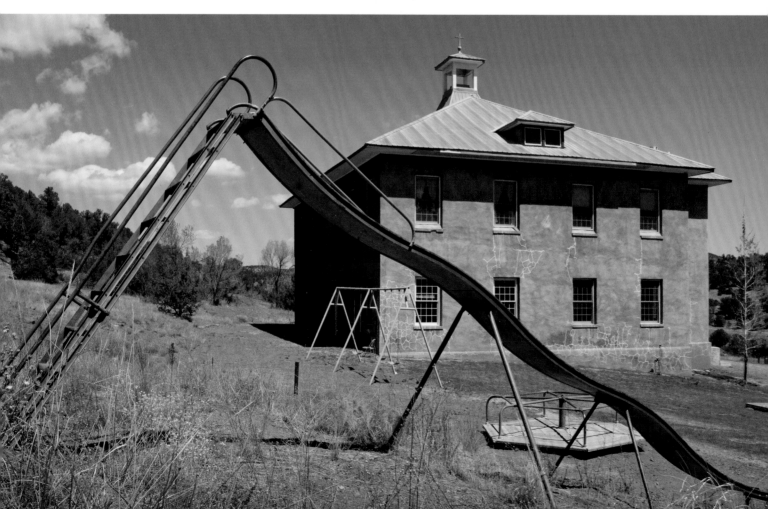

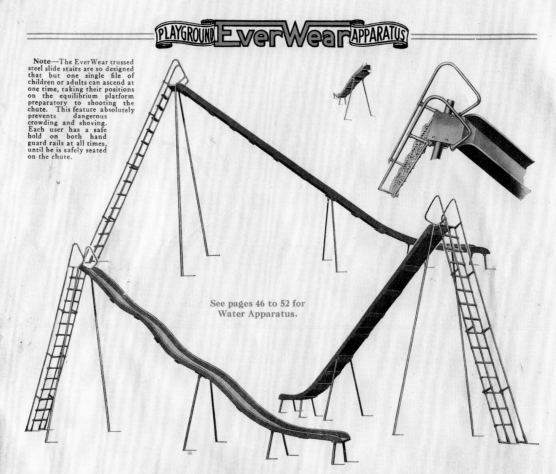

Note—The EverWear trussed steel slide stairs are so designed that but one single file of children or adults can ascend at one time, taking their positions on the equilibrium platform preparatory to shooting the chute. This feature absolutely prevents dangerous crowding and shoving. Each user has a safe hold on both hand guard rails at all times, until he is safely seated on the chute.

See pages 46 to 52 for Water Apparatus.

26 Foot Straight Slide No. B-307
30 Foot Wave Slide No. B-308

THESE long chutes are an enlargement of the Slides shown on pages 6 to 9 and are designed for older children. They are so constructed as to be attached to gymnasium frame carrying other apparatus if desired. We usually furnish them with stairs and braces as a separate outfit as shown above.

The side rails of all chutes are made of absolutely clear seasoned maple. The bedways of all "wave" chutes are No. 18 gauge ARMCO galvanized sheet metal, but the bedways of all straight type chutes will be furnished with either maple or ARMCO metal bedways—as you elect—the price being the same. The curve and retarding table at lower end of chute are so planned as to retard the speed and allow the user to alight in a standing position.

The all-steel stairs are made of a double run of galvanized pipe firmly locked together by malleable fittings and equipped with perforated malleable tread steps. By means of special fittings an ample metal platform is provided at the top of stairs, thus permitting the user to acquire full equilibrium before starting down the chute. Stairs are set at an angle of 62 degrees. The chute is attached to this platform by means of a hinged apron. The illustration at the right shows the type of platform used to attach these chutes to gymnasium frame having 3-inch top beam. All metal parts galvanized.

No. B-307. Long Slide, ARMCO metal or maple bedway, straight type, chute 26 ft. long, width 18 in., stairs 14 ft. 2½ in. high to platform, either as a separate outfit as shown or for attachment to gymnasium frame, complete.
Shipping Weight, 750 lbs.

No. B-308. Long Slide, ARMCO metal bedway only, wave type, chute 30 ft. long, width 18 in., stairs 14 ft. 2½ in. high to platform, either as separate outfit as shown or for attachment to gymnasium frame, complete.

Shipping Weight, 750 lbs.

THE EVERWEAR MANUFACTURING COMPANY, SPRINGFIELD, OHIO, U. S. A.

Circa 1926

EverWear Manufacturing Company

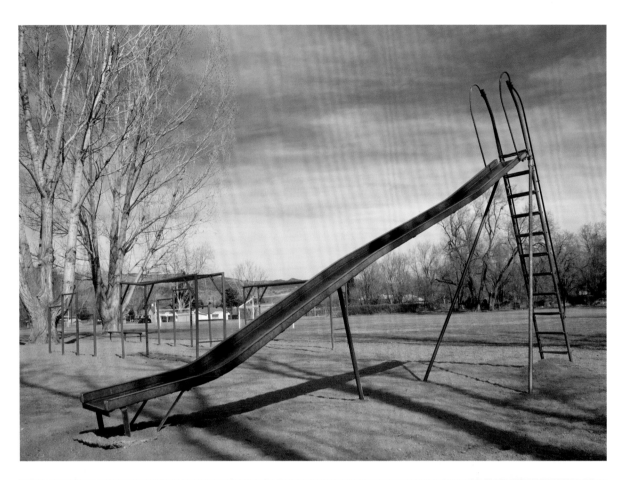

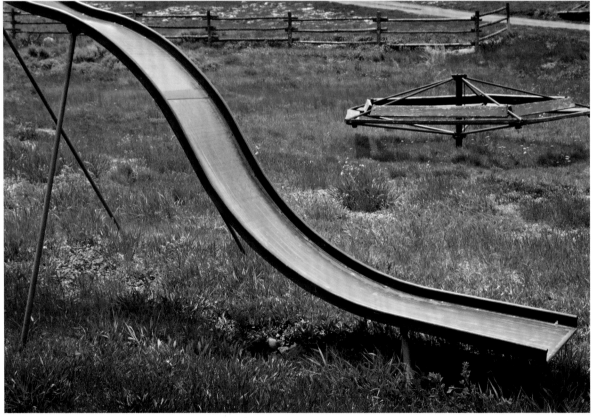

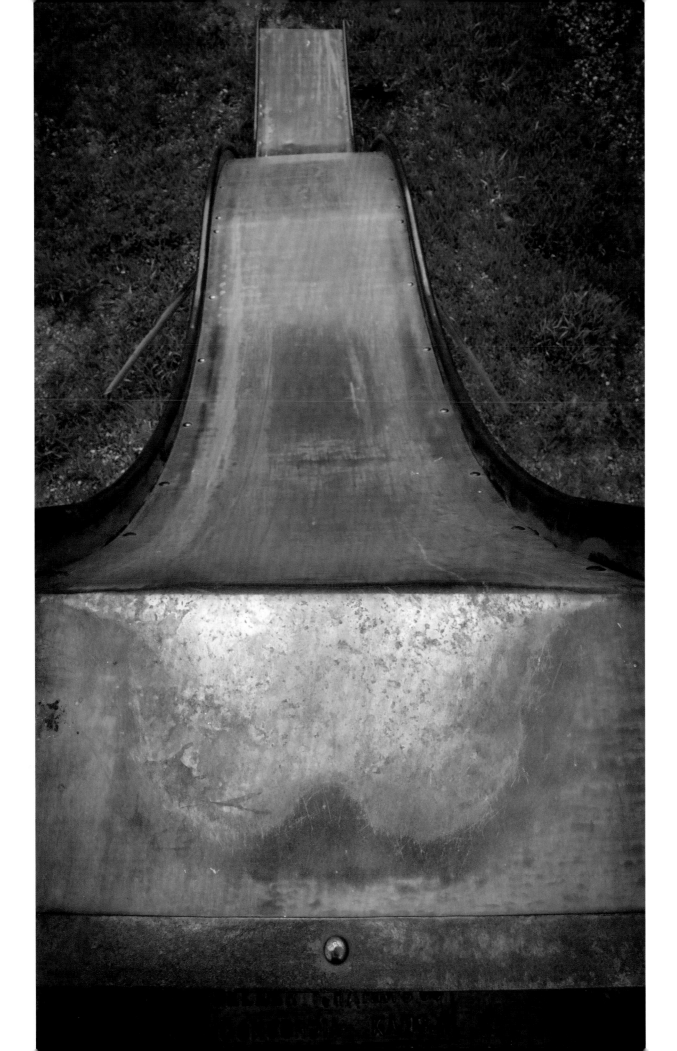

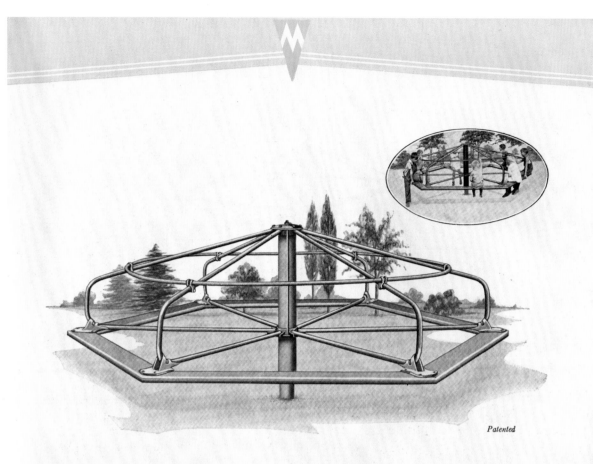

Patented

Mitchell Merry-go-Round No. 850

The Merry-go-Round has been almost universally adopted as an elementary piece of playground equipment. It is almost impossible to locate a fully equipped playground that does not have some type or other of merry-go-round. Because of its exceptional popularity, we have designed the above illustrated Merry-go-Round. Note its sturdy construction. It is easy to see that the device is very appealing to children and for an inexpensive piece of playground equipment, we could not recommend anything better. In its construction, you will observe that here too, the elements of safety and durability prevail. The device revolves freely without the use of dangerous mechanical levers, gears or pedals, thereby eliminating the hazard of injury.

SPECIFICATION No. 850

Standard — 5½-inch O. D. heavy steel post, 7 feet 6 inches long, embedded 3½ feet in concrete.
Frame Work — 1⅜-inch O. D. high carbon steel tube.

Milwaukee, Wisconsin, U. S. A.

Hand Rail — 1¹⁄₁₆-inch O. D. high carbon steel tube.
Upper Bearing — Case-hardened ball-bearing, which runs completely in oil. Patented. (See detail on page 11.)
Lower Bearing — Patented roller type enclosed in special case, filled with oil. Patented. (See detail on page 11.)
Height — When erected, 4 feet.
Diameter — Fourteen (14) feet.
Height of Seats — When erected 20 inches above ground.
Capacity — Fifty (50) children.
Finish — Frame work and standard, high grade red enamel; Seats, high grade green enamel.
Weight — Approximately 700 lbs.

SPECIFICATION No. 851

Standard — 4½-inch O. D. heavy steel post, 7 feet long, embedded 3 feet in the concrete.
Frame Work — 1⅜-inch O. D. high carbon steel tube.
Hand Rail — 1¹⁄₁₆-inch O. D. high carbon steel tube.
Upper Bearing — Case-hardened ball-bearing.
Lower Bearing — Sleeve type bearing.
Height — When erected, four (4) feet.
Diameter — Twelve (12) feet.
Height of Seat above ground — When erected, 20 inches.
Capacity — Thirty-five (35) children.
Finish — Frame work and standard, high grade red enamel; Seats, high grade green enamel.
Weight — Approximately 550 lbs.

9

Circa 1926

Mitchell Manufacturing Company

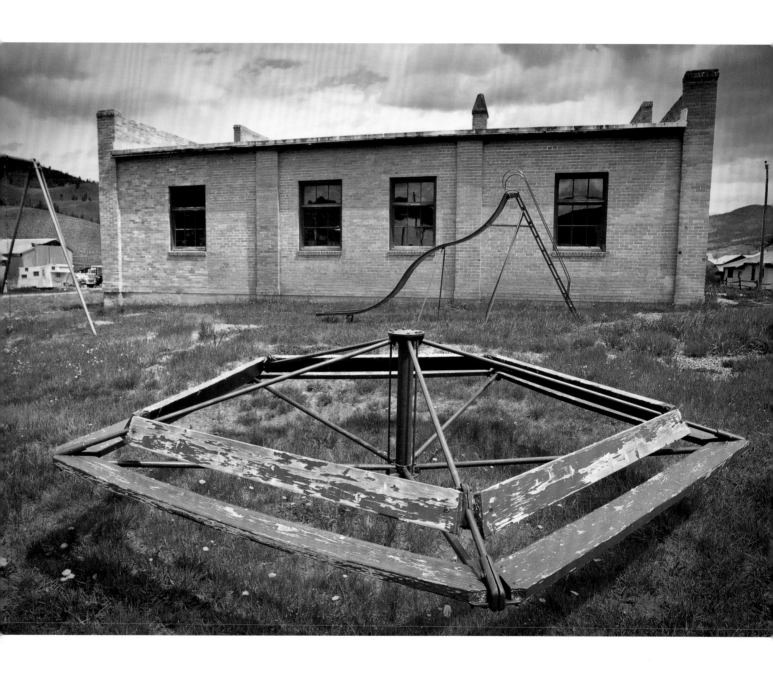

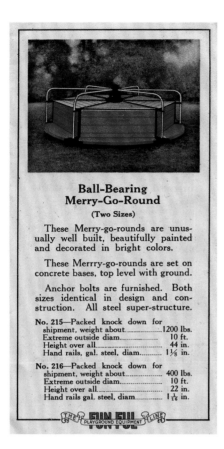

Ball-Bearing
Merry-Go-Round
(Two Sizes)

These Merry-go-rounds are unusually well built, beautifully painted and decorated in bright colors.

These Merrry-go-rounds are set on concrete bases, top level with ground.

Anchor bolts are furnished. Both sizes identical in design and construction. All steel super-structure.

No. 215—Packed knock down for
shipment, weight about.............................1200 lbs.
Extreme outside diam......................... 10 ft.
Height over all..................................... 44 in.
Hand rails, gal. steel, diam........... 1⅛ in.

No. 216—Packed knock down for
shipment, weight about................. 400 lbs.
Extreme outside diam......................... 10 ft.
Height over all..................................... 22 in.
Hand rails gal. steel, diam.............. 1$\frac{1}{16}$ in.

1925

FunFul catalog, General
Playground Equipment
Company

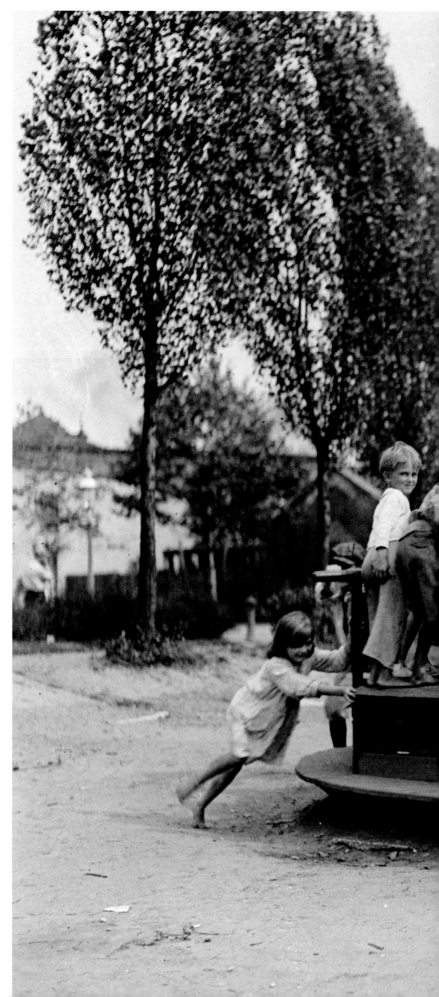

Circa 1919

Photograph captioned
Playground; location unknown
(Library of Congress)

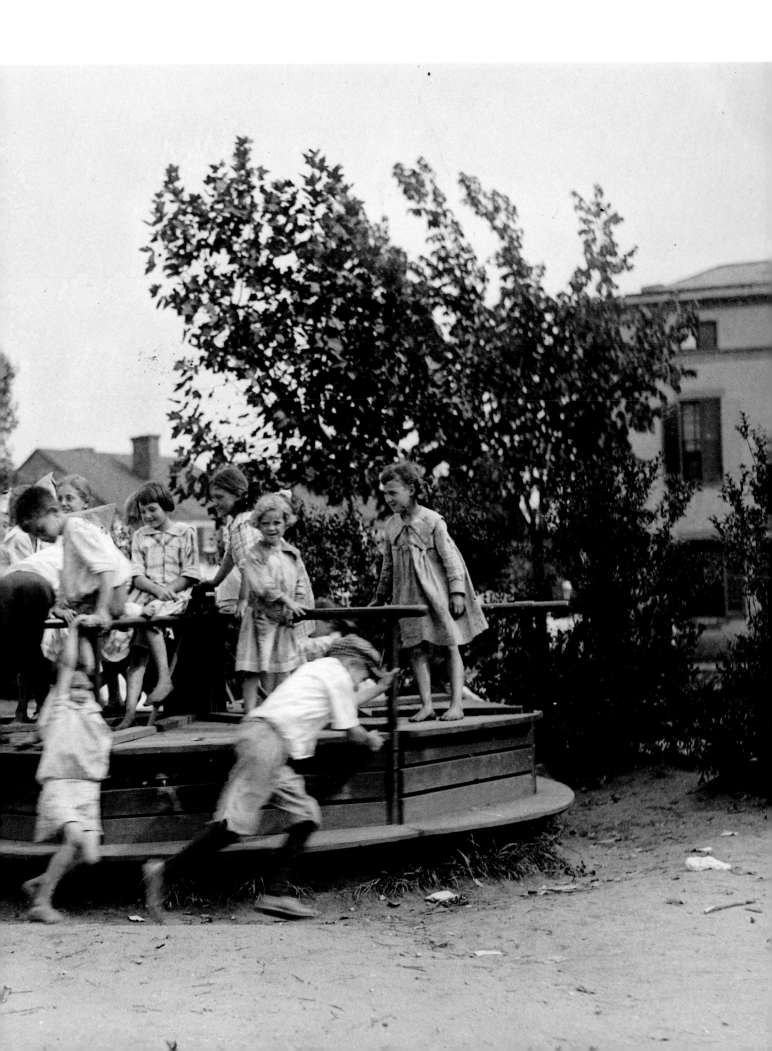

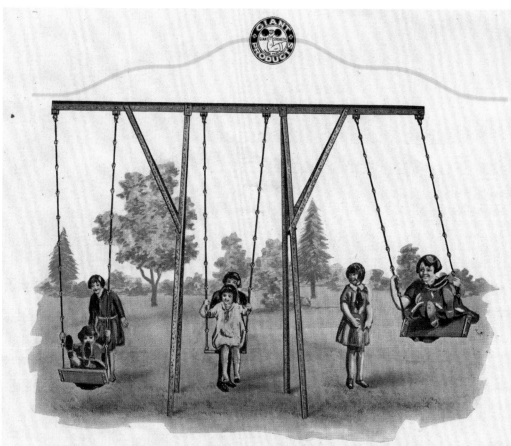

Interchangeable

WHEN THE PURCHASER must be precarious in the selection of apparatus for the playground, either because of limited funds or space, this apparatus meets the requirements, and serves the purpose of other equipment. Easily changed, and this adds to its novelty.

ON THE SMALL playground, where one cannot purchase apparatus of various types, this is ideal, and

proves its efficiency in taking care of a large group of children. It has come undefeated to the front as one of the most popular items at its cost in our line.

CONSTRUCTED only of the very best materials and workmanship, the unit will stand up against years of hard service. Each piece in this structure is standard, making the unit a strictly first grade article.

THE SLIDE furnished with this Combination is the same high quality Slide as any of the standard Slides in the Giant Line.

THE APPARATUS used on this Combination are interchangeable, and are listed separately. The Frame and Slide are also listed separately.

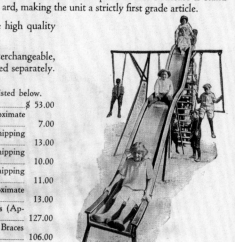

The Frame must be ordered as supporting unit for any items listed below.

*No. 20—Frame Only (Approximate shipping weight, 210 lbs.)................$ 53.00
*No. 21—Trapeze, Complete with Roller Bearings for Same (Approximate shipping weight, 11 lbs.)................ 7.00
*No. 22—Swing, Complete with Roller Bearings (Approximate shipping weight, 20 lbs.)................ 13.00
*No. 23—One Pair Flying Rings with Bearings (Approximate shipping weight, 10 lbs.)................ 10.00
*No. 24—Adjustable Horizontal Bar, Complete (Approximate shipping weight, 15 lbs.)................ 11.00
*No. 25—See-Saw, Complete with Handles and Fulcrum (Approximate shipping weight, 55 lbs.)................ 13.00
*No. 26—24-foot Wave Slide, with Stairway, Hand Rails and Braces (Approximate shipping weight, 450 lbs.)................ 127.00
No. 27—20-foot Straight Slide, with Stairway, Hand Rails and Braces (Approximate shipping weight, 425 lbs.)................ 106.00

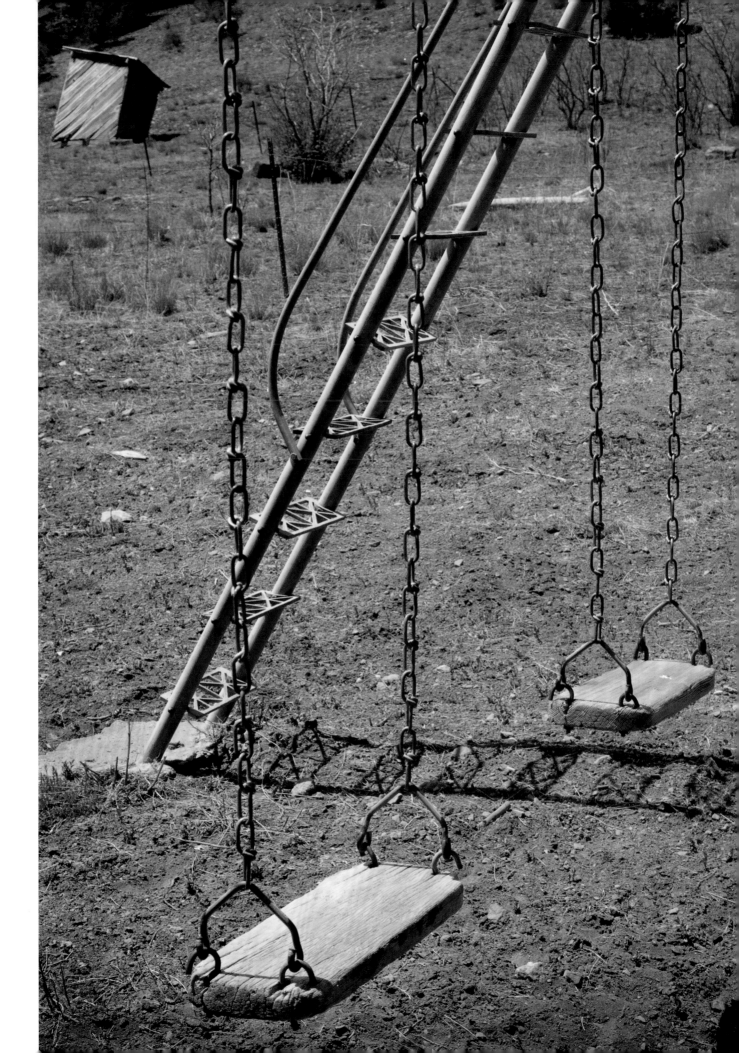

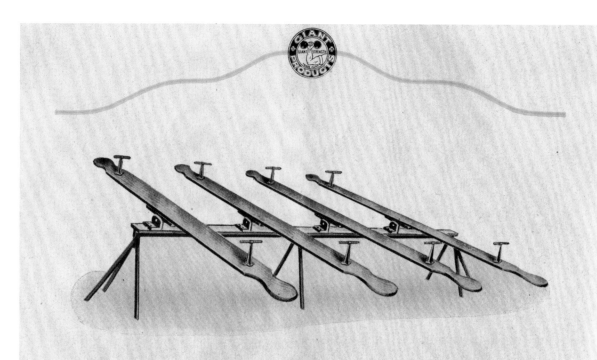

Giant See-Saws

CHILDREN enjoy this type of equipment. The See-Saw is really as old as the impulse of play itself. To prevent possible accident both for the older and younger child, a steel handle has been placed within easy reach, where at any emergency, operators may prevent their falling or being thrown from the See-Saw.

OPERATING with ease, this apparatus is very popular with children. The boards are saddle-shaped for the ease of the operators. The frictionless roller bearing fulcrum brings this apparatus into the foreground as one of the greatest units of playground equipment, because it eliminates the squeak so common in apparatus of this character.

CONSTRUCTED to last, this See-Saw is used on most playgrounds.

No. 60-T—Six See-Saws, Complete, with All Frame and Fittings (Approximate shipping weight, 700 lbs.) $122.00

No. 50-T—Five See-Saws, Complete, (Approximate shipping weight, 550 lbs.) Price $109.00

*No. 40-T—Four See-Saws, Complete, (Approximate shipping weight, 475 lbs.) Price $98.00

No. 30-T—Three See-Saws, Complete, (Approximate shipping weight, 350 lbs.) Price $72.00

No. 20-T—Two See-Saws, Complete, (Approximate shipping weight, 250 lbs.) Price $46.00

No. 10-T—One See-Saw, Complete, (Approximate shipping weight, 150 lbs.) Price $26.00

1931

Giant Manufacturing Company

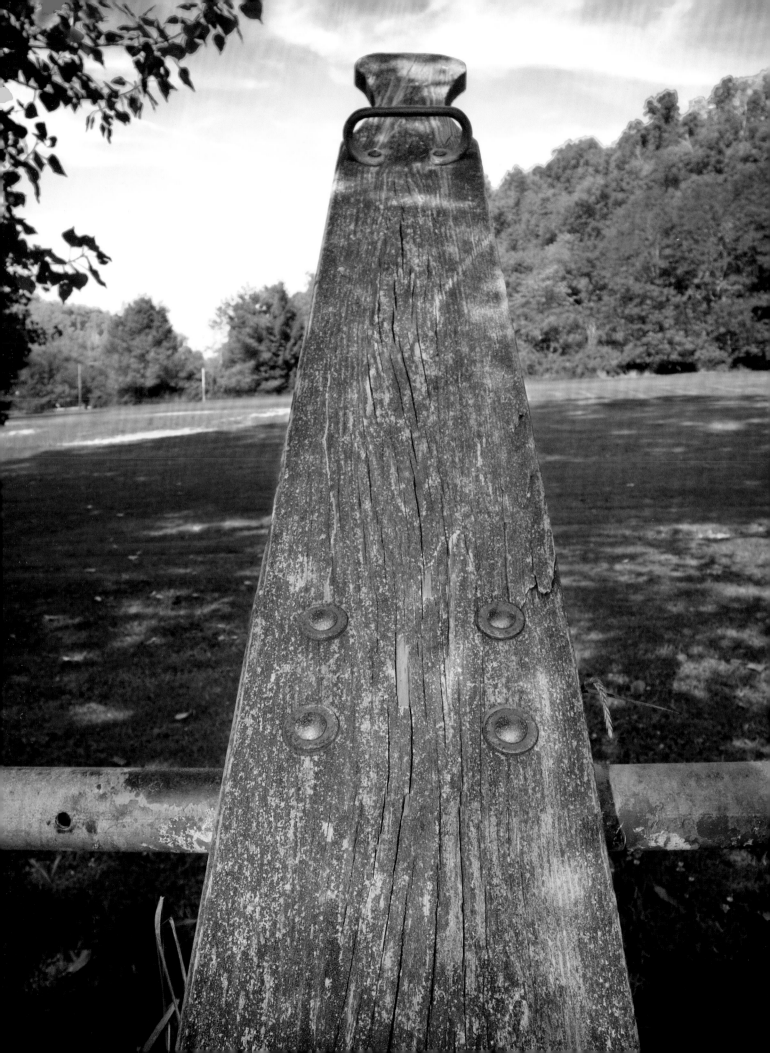

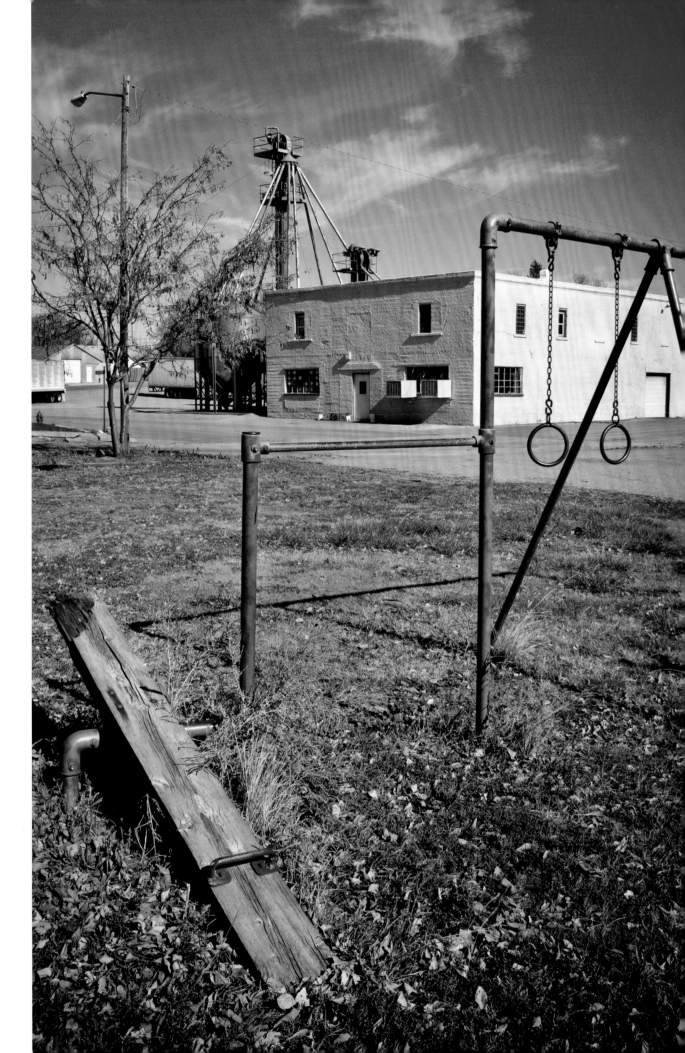

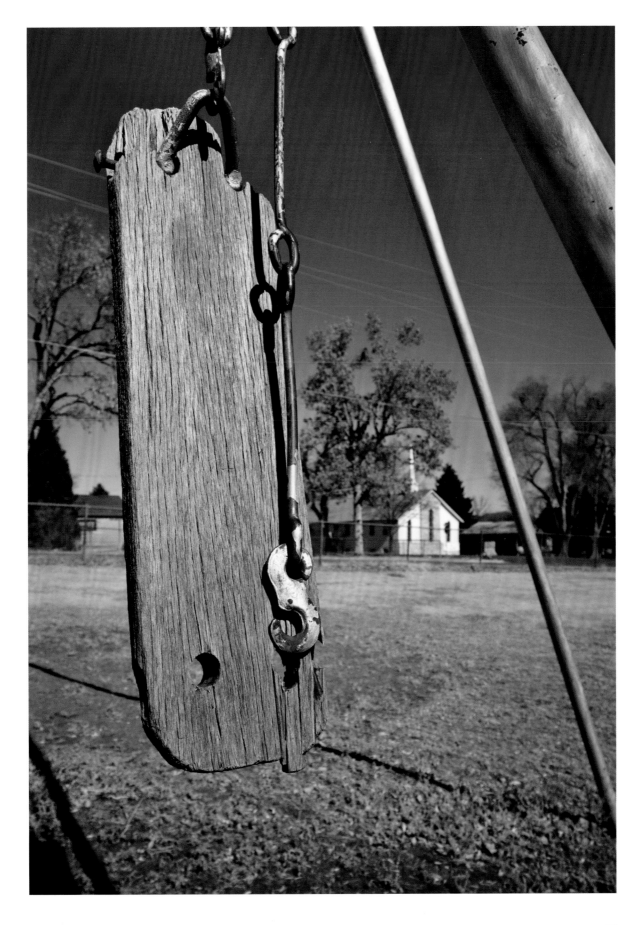

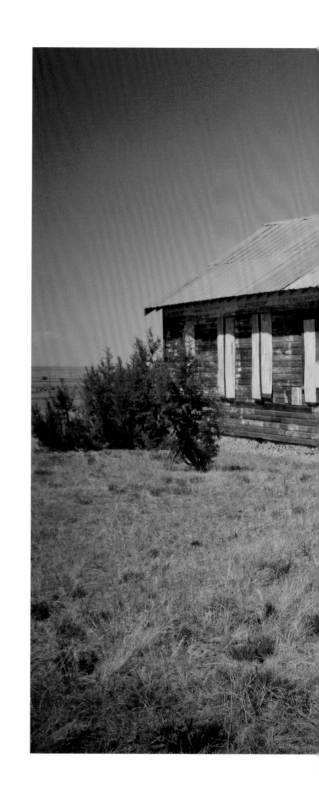

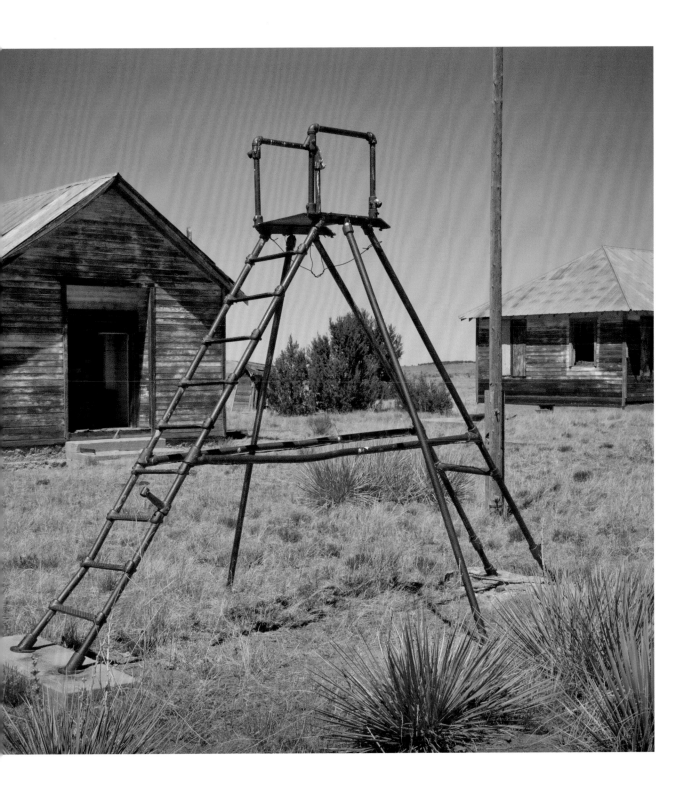

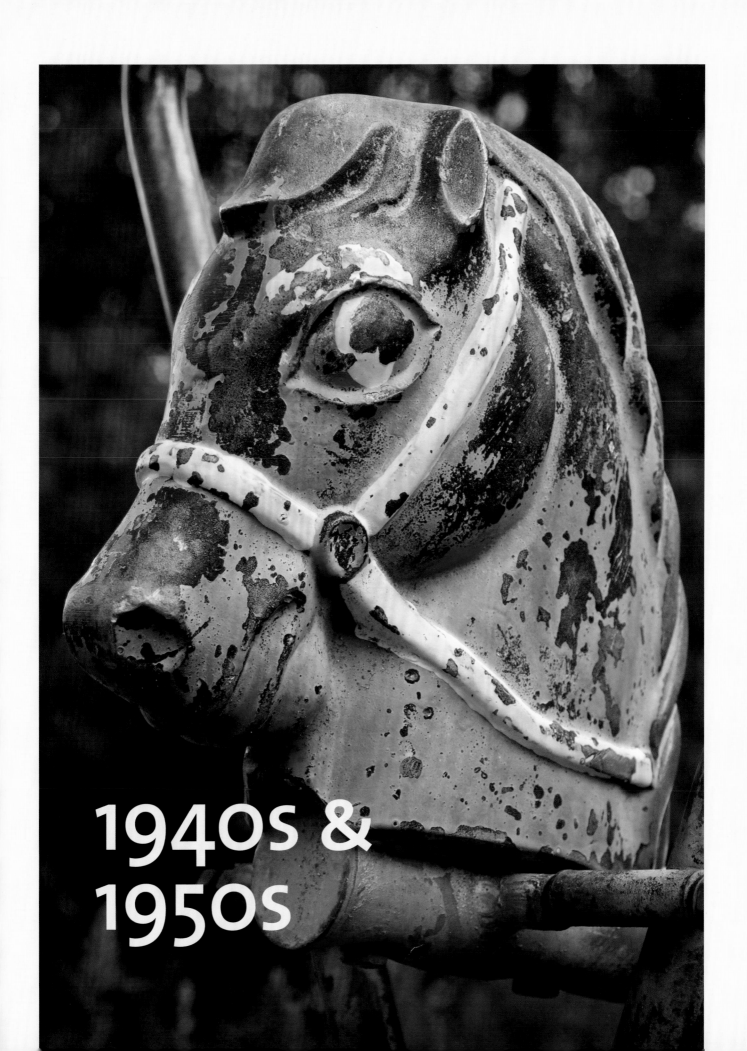

1940s & 1950s

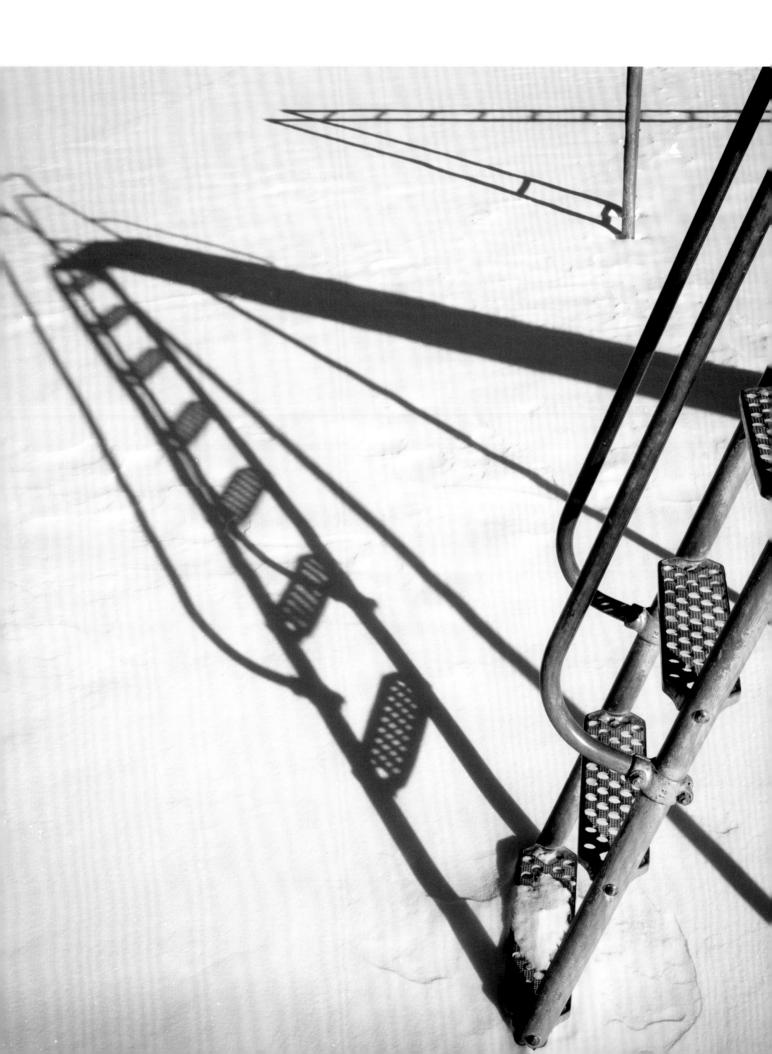

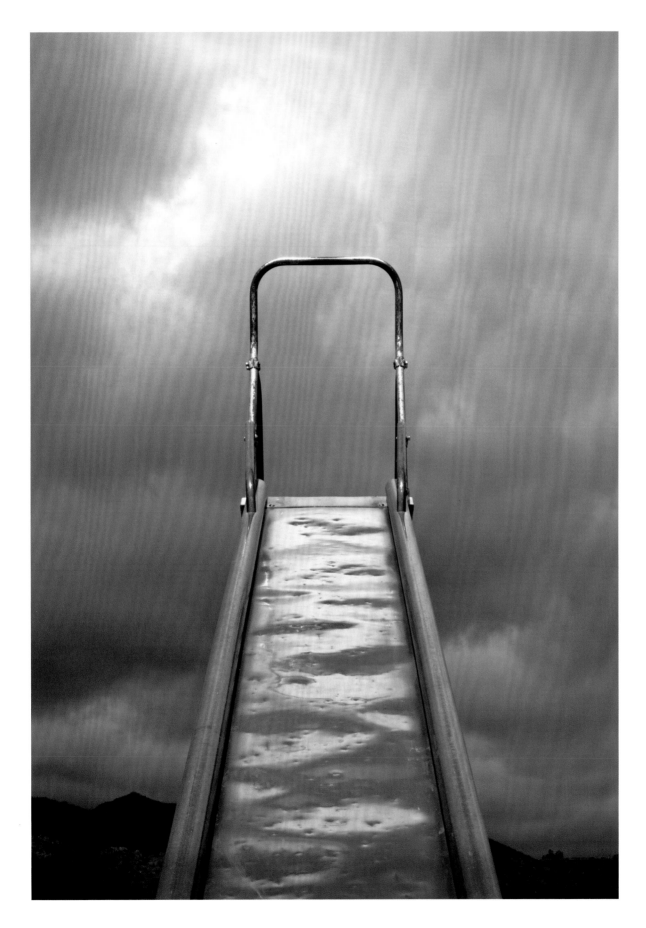

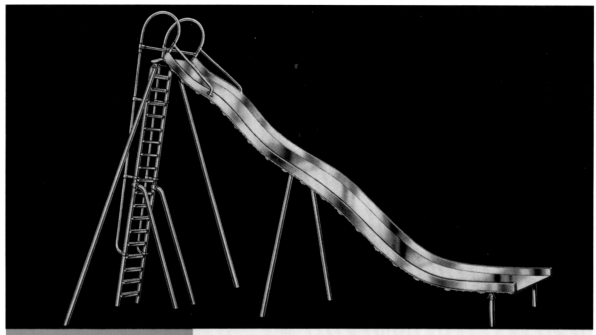

AMERICAN APPROVED *All-Steel* SLIDES EXCEL IN STRENGTH LEAD THE FIELD FOR LIFETIME DURABILITY

The large, roomy Certified Malleable Platform, illustrated above and at right, is standard equipment with American Approved All-Steel Slides. All Supports and Stair Stringers are fabricated from 1⅞-inch New, *Hot-Dip* Galvanized Tested Steel Pipe with the entire structure locked rigidly together by Certified Malleable Fittings of *exclusively* American design, tested to more than 50,000 pounds Tensile Strength. Stair Treads are fabricated from *extra-heavy-duty* Certified Malleables, also, guaranteed against breakage and heavily *ribbed* to prevent slipping. Improved Safety-Type Handrails of Tested Steel Pipe, unequalled Slide Chute construction and scores of other plus-features combine to make the AMERICAN All-Steel Slide the FINEST Slide manufactured today regardless of price.

30 ·

AMERICAN APPROVED ALL-STEEL SLIDES

Engineered to deliver perfect, repair-free performance for a lifetime, the Chute Siderails of these entirely new American All-Steel Slides are fabricated from *extra-heavy wall,* 14-gauge Elliptically shaped, flat base Steel Tubing, full 4-inches deep by 1⅜ inches wide, Galvanized to rustproof permanently. Chute Bedways of extra heavy 18 gauge Armco Ingot Iron or Allegheny Stainless Steel are rigidly secured to the Siderails by Expansion Screws spaced 3-inches apart, strongly reinforced by 3″ wide, deeply Trussed Steel Battens every 14″ down the bedway.

Superior performance, lifetime durability and far greater safety for the youngsters are further assured by special American *Certified* Malleable Fittings tested to over 50,000 pounds Tensile Strength, which lock the Chute, massive 16½-inch by 23-inch Malleable Safety Platform, large, roomy Non-Slip Safety Stair Treads, Chute Guard Rails, Safety Handrails, Stairway and Supports into a tremendously strong, integral unit. Stairway Risers and all Supports are 1⅞-inch Tested Steel Pipe with Stair Handrails and Chute Guard Rails of 1 7/16-inch steel Pipe. No unsightly, rough or imperfect welds but American Certified Malleables. No zinc spraying or metallizing, which merely films the surface, but *Hot-Dip* Galvanizing which rustproofs for life. Here are the finest, safest and most durable Slides built today!

AMERICAN'S LARGE ROOMY MALLEABLE PLATFORM ASSURES *Maximum Safety*

Standard equipment with American All-Steel Slides, the large, roomy Platform is *exclusively* AMERICAN in design and is fabricated from massive Certified Malleable Iron with a guaranteed Tensile Strength of more than 50,000 pounds per square inch. This *Safety* Platform is full 16½-inches x 23-inches in size, is heavily *ribbed* to prevent slipping, weighs thirty-five pounds stripped. Malleable Safety Platform through-bolts through formed Stairway Stringers and Supports to weld entire structure into an immensely strong, integral unit. *Hot-Dip Galvanized* for enduring rust protection.

1956

American Playground Device Company

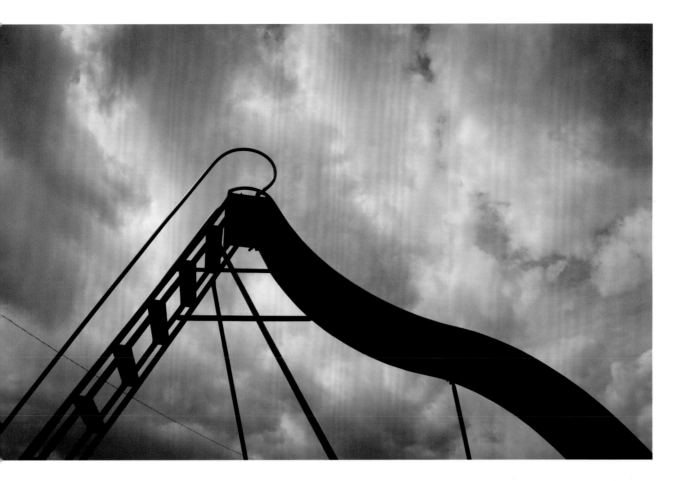

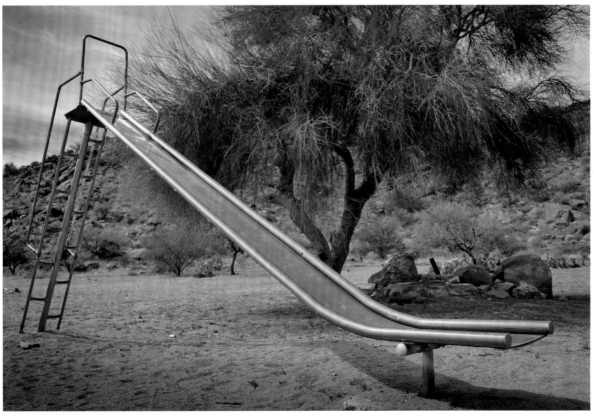

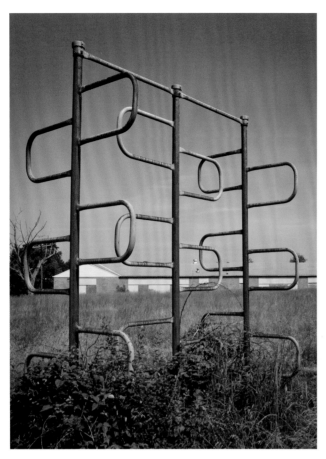
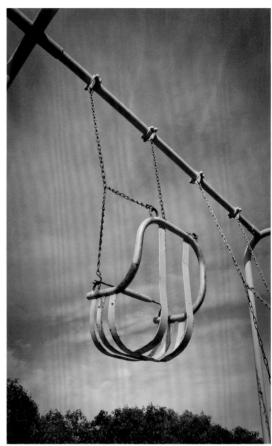
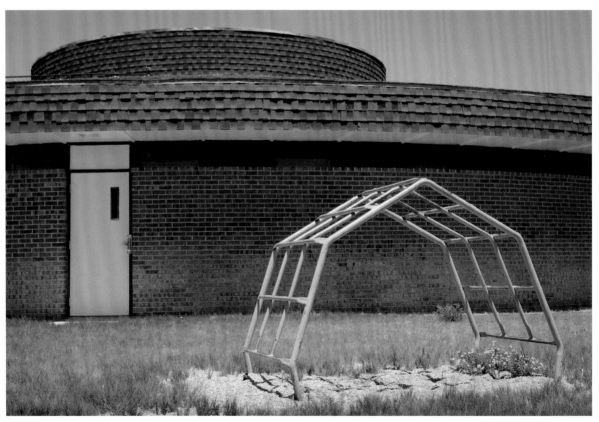

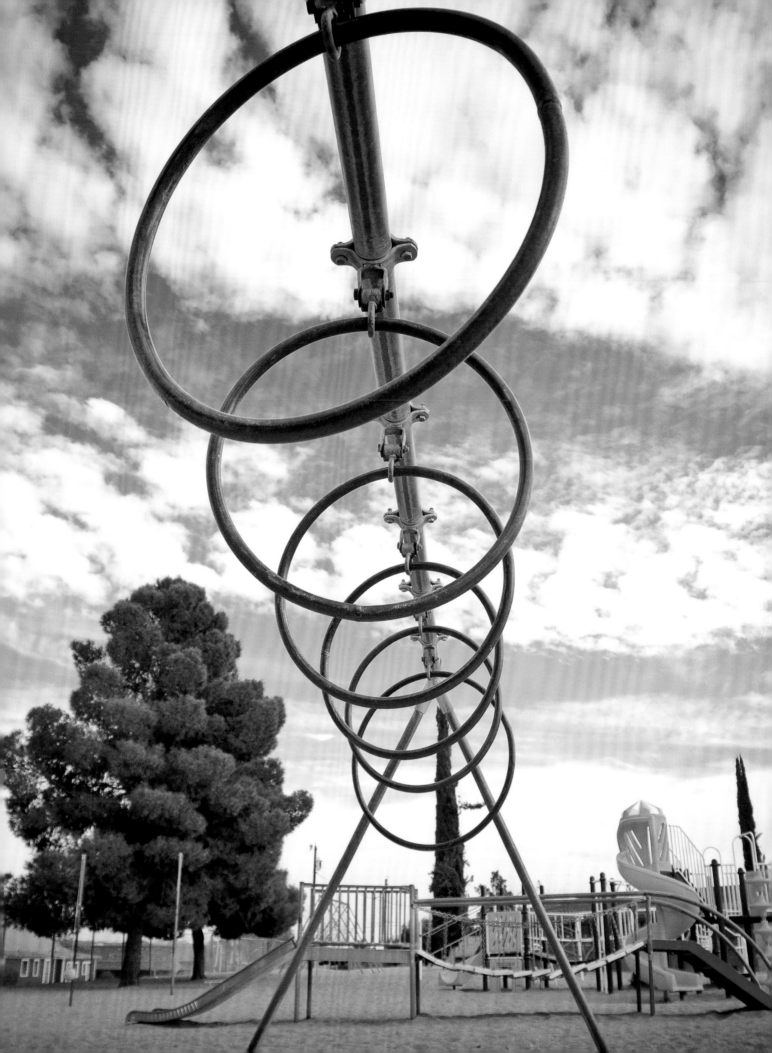

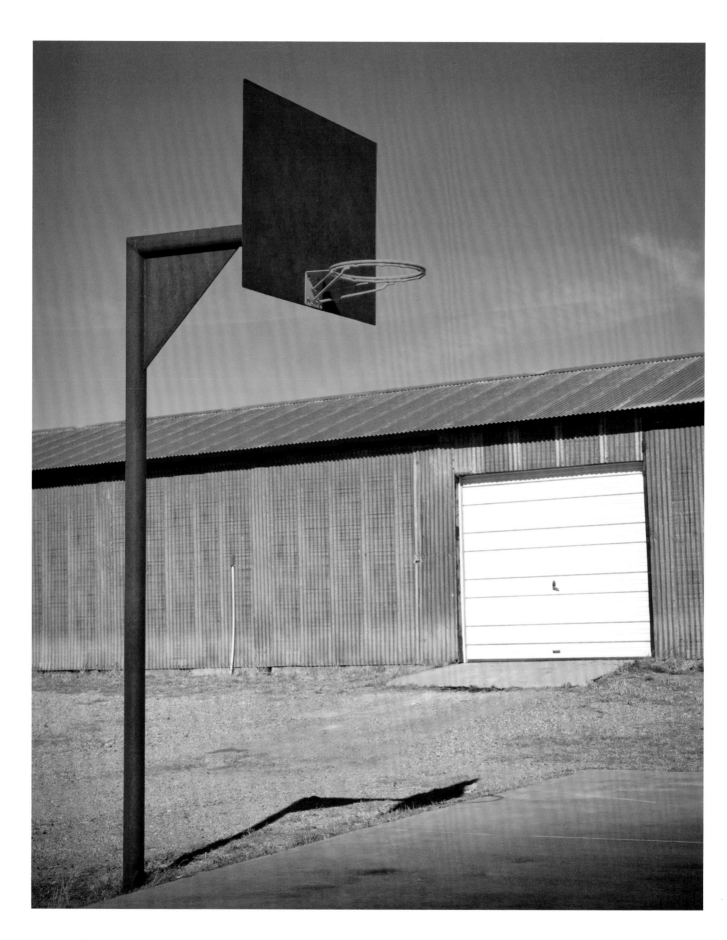

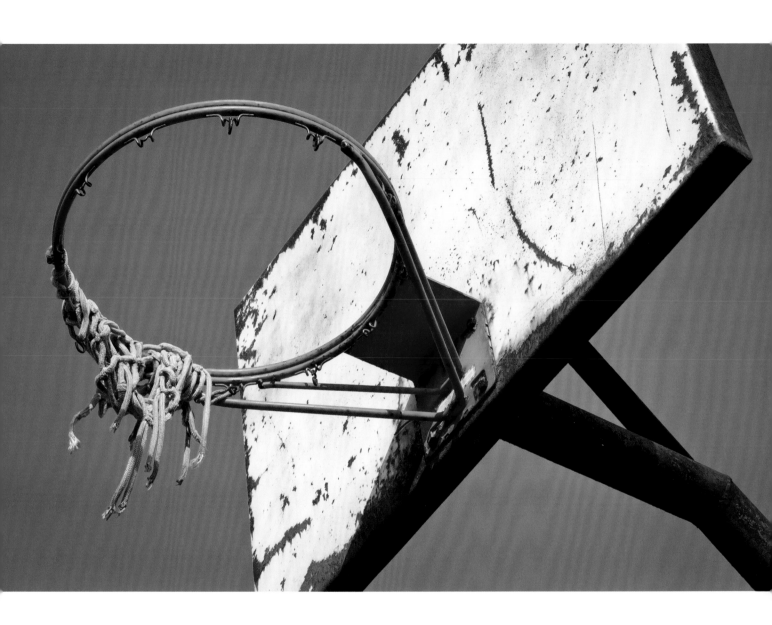

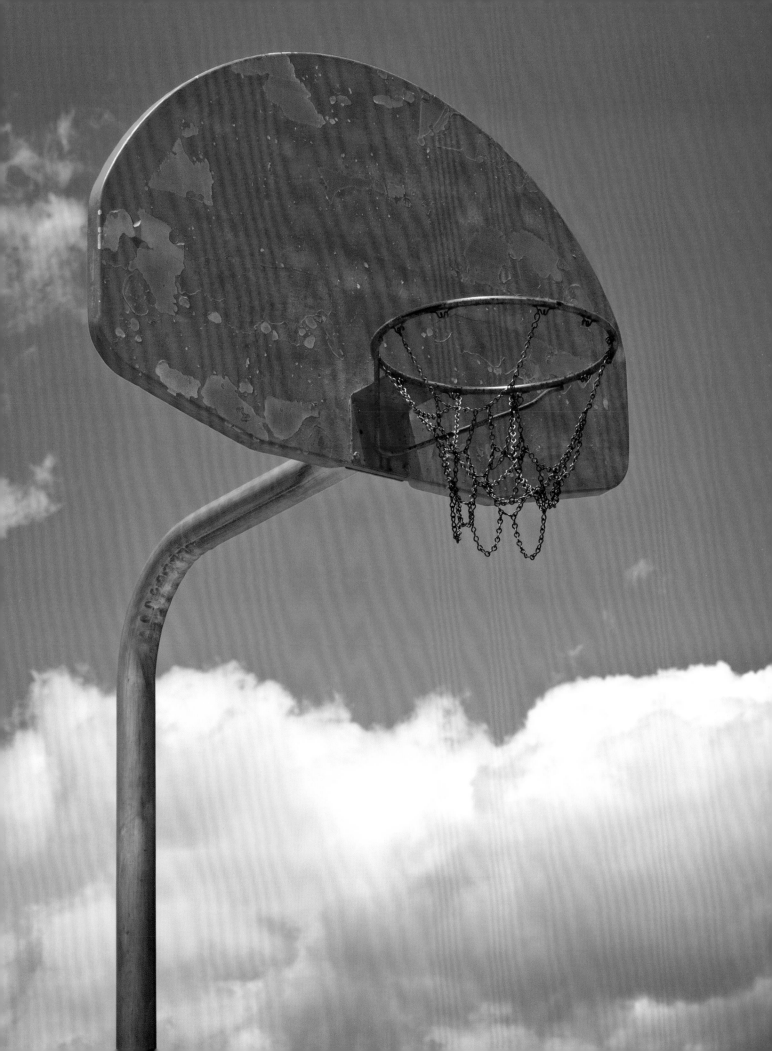

THE NEW ALL-STEEL
FAN-SHAPED BANK

No. 58-F—The new Porter All-Steel Fan-Shaped Basketball Bank has been adapted to an outdoor installation. The Bank is formed from a single sheet of 11-gauge steel with a 1½" flange. Solid steel braces are arc-welded to the rear face of the bank, to the continuous flange, to each other and to the attachment plates, unifying the assembly. The bank is further reinforced by the large goal attachment plate of 1-1/4" thick solid steel. The bank is protected by a durable outdoor metallic paint.

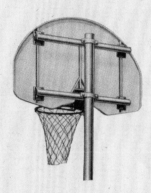

REAR VIEW

The Bank is mounted on the 3½" external diameter upright by especially constructed cross arms as illustrated in the cut at the right. The friction clamps assure a rigid installation. Complete with banks, goals, cross arms and upright pipe. Shipping weight, 400 lbs.

GOAL No. 210-B - FOR FAN-SHAPED BANK

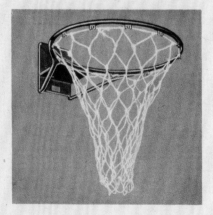

NO. 210-B. Meets all official requirements. It is all steel, electric welded, strong and durable, made to maintain a perfect circle in perfect alignment with the bank. It attaches behind the bank, in compliance with the new rules, to the lower middle attachment plate shown in the rear view illustration above. The 5/8" cold-rolled steel supporting arms are die formed to curve inward slightly so there can be absolutely no obstruction to the ball. The rim is formed of 5/8" cold-rolled steel and equipped with the original patented "No-Tie" net holder and twine net. Finished in black enamel.

NO. 210-BG. Same as above except galvanized and equipped with galvanized chain net.

24

Circa 1948

J. E. Porter Corporation

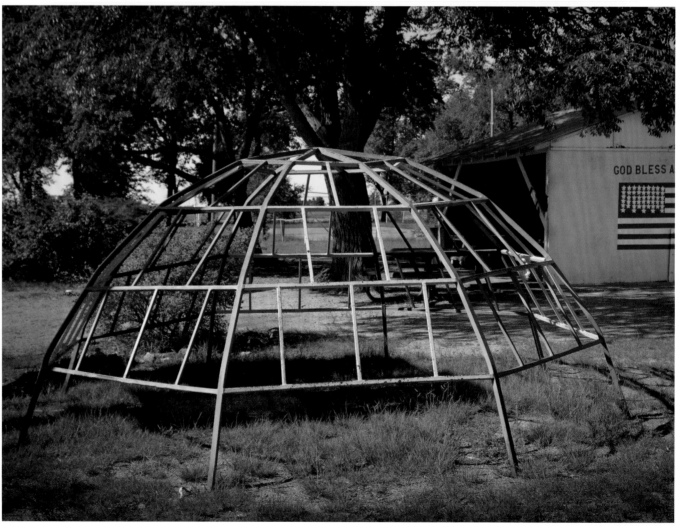

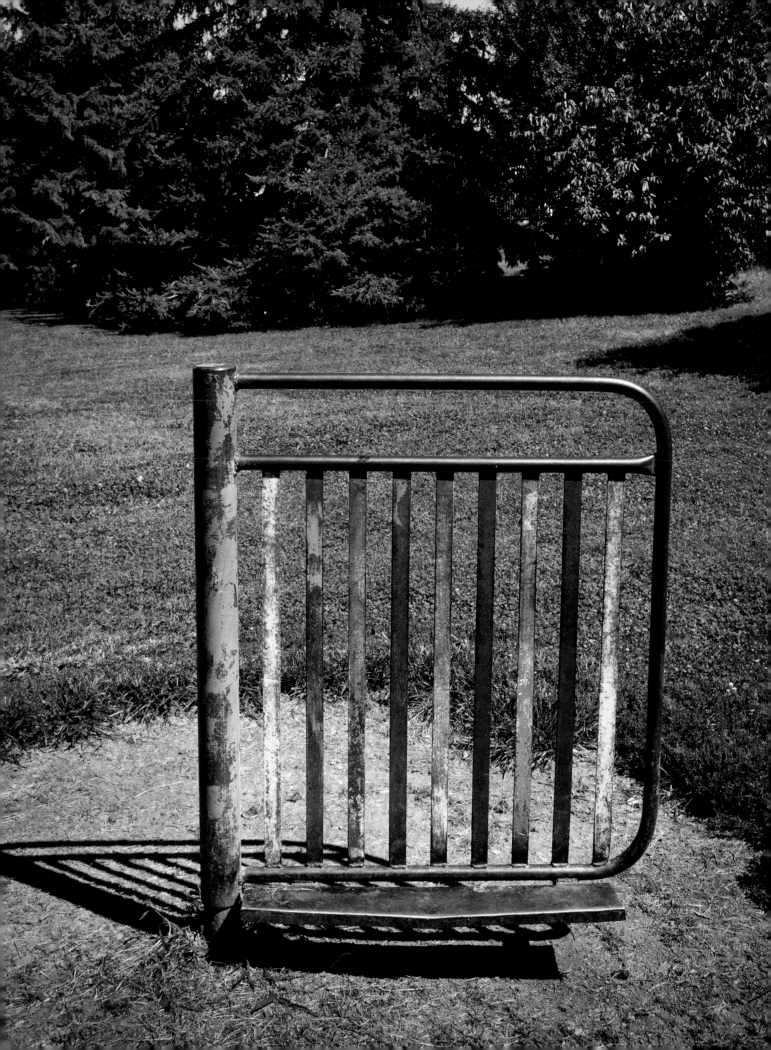

FUN-FUL Heavy Duty Merry-Go-Round

THERE IS NO OTHER MERRY-GO-ROUND ON THE MARKET LIKE IT—

We Absolutely Guarantee This Unit to Outwear and Outlast Any Other Playground Merry-Go-Round Regardless of Price, Size or Operating Conditions.

It will stand the roughest treatment and continue to run true indefinitely with very little care and attention. Many of these are in service after 20-25 years continuous use.

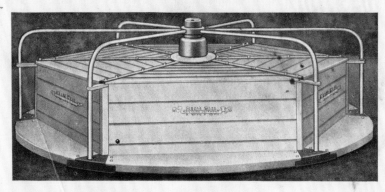

No. 214—The **LARGEST** Playground Merry-Go-Round on the market, 16 feet in diameter. Weight 2,500 lbs. **$450.00**

Standard Merry-Go-Round
(Ball-Bearing)

To meet a demand for a low priced, light weight, easily operated merry-go-round, we offer this model. The rotating frame is hot galvanized. Seat boards are of selected fir heavily painted bright orange. Hub fitted with large self-contained ball-bearings, enclosed and protected against dust, dirt, or damage.

Set on concrete base and held in position by anchor bolts. Entire unit can be removed for winter storage.

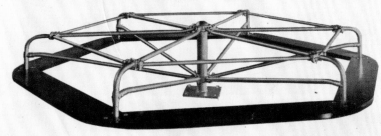

No. 210—Ten ft. diameter, weight 400 lbs. **$120.00**

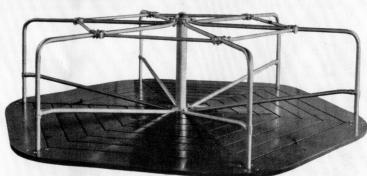

This new improved floor type Merry-Go-Round is of rugged construction, has double ball bearing races. Platform rotates close to the ground for safety. Floor offers large space for children to ride.

No. 211—Floor Type, Ten Foot Diameter, Weight 850 lbs. **$180.00**

Circa 1946

FunFul catalog, General Playground Equipment Company

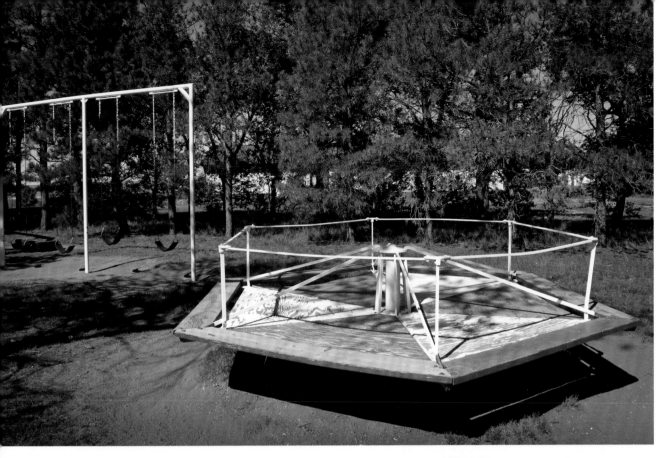

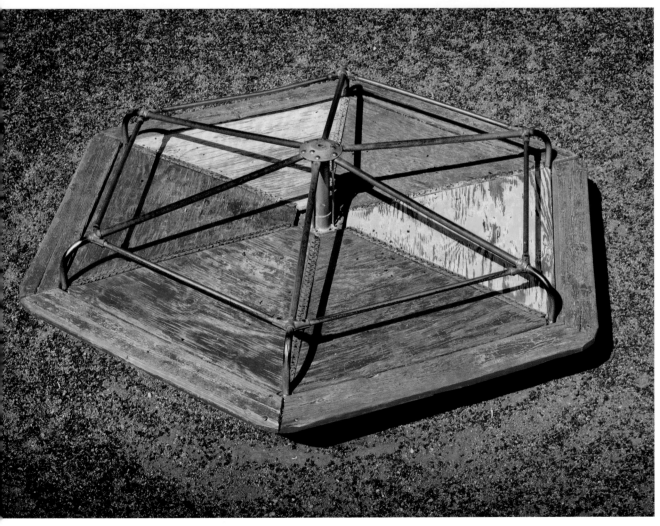

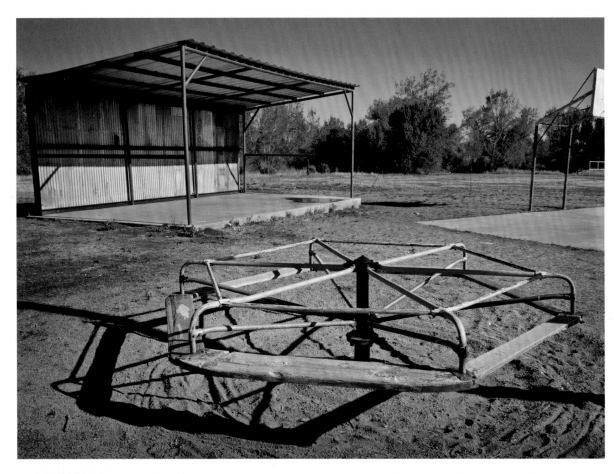

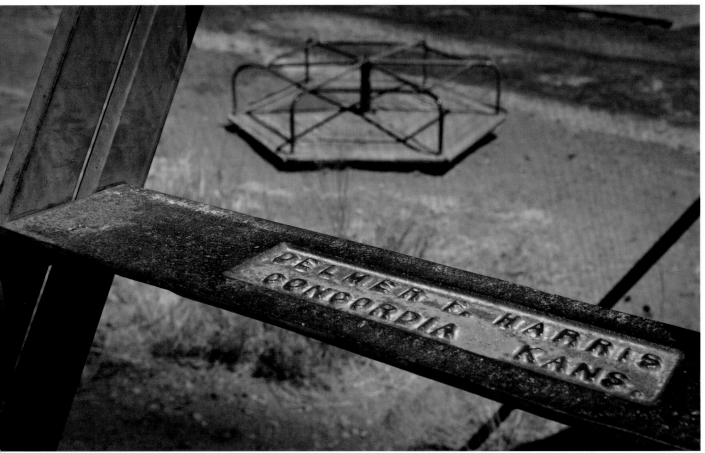

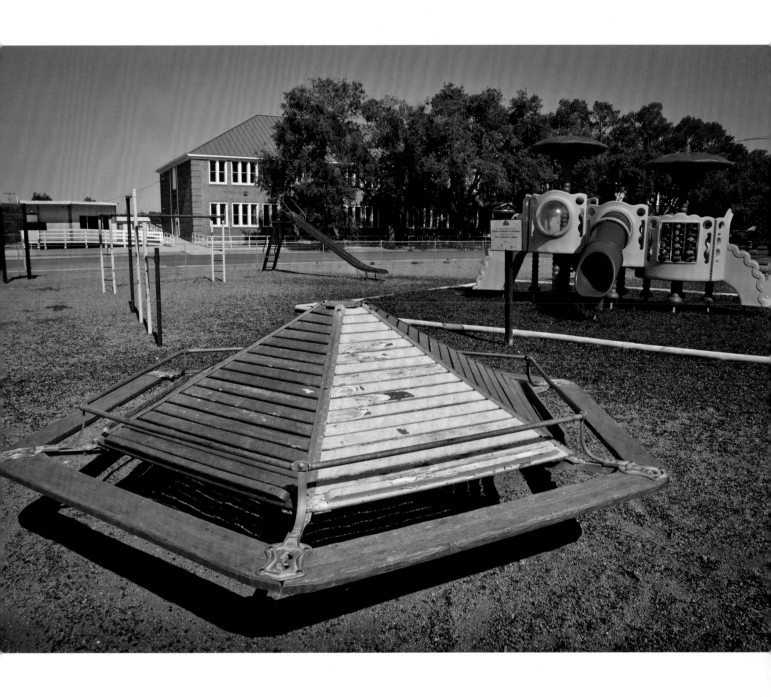

"JUNGLEGYM"

REG. U.S. PAT. OFF.

CLIMBING STRUCTURES

Leading authorities in education, recreation, health and social work everywhere for years have heaped unrestrained praise on the "Junglegym" Climbing Structure.

No device could have the legions of enthusiastic endorsers which this device has—and not be an apparatus of most unusual merit.

The "Junglegym" Climbing Structure, with more than ONE HUNDRED MILLION child-play-hours without one single serious accident, brings into use every important muscle of the body and it may be used the year around, winter included. No other piece of playground equipment can approach its economy record in capacity, in ground area required and in cost of maintenance. There are no moving parts—nothing to wear out, nothing to replace, nothing to oil, nothing to adjust.

The "Junglegym" Climbing Structure develops courage, initiative, will-power, self-reliance, sociability and imagination.

Because of these characteristics of the "Junglegym" Climbing Structure, it is called the "Magnet of the Playground."

The great success of the apparatus has, as is usually the case, attracted the attention of imitators, whose products bear a superficial resemblance to the original. In the imitation, the original values, play capacity and safety, have disappeared. The cubicle shape of the "Junglegym" Climbing Structure with its straight regularly-spaced climbing rungs has been changed into cylindrical or spherical structures, featuring curved rungs with the necessary irregularity in spacing. No fireman would trust his life on a ladder with curved steps. As is always the case —when you are offered something "just as good"—it is inferior to the original. For these reasons, the "Junglegym" Climbing Structure offers the ultimate in safety and capacity.

The present model of the "Junglegym" Climbing Structure was designed to meet the requirements of the safety engineers of the Federal Public Housing Authority.

OUTDOOR MODELS

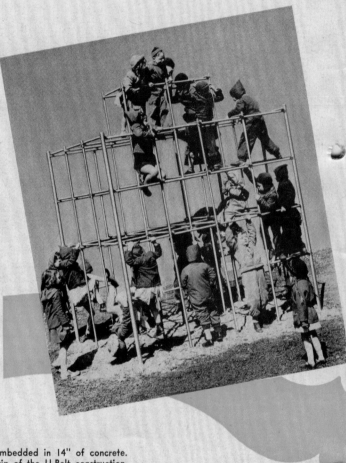

SPECIFICATIONS

All vertical pipes extend to the ground and are embedded in 14" of concrete. This feature, combined with the positive friction grip of the U-Bolt construction, insures a completely rigid structure. The unit is 8'4" long and 6'3" wide. The outside wall is 8'6" high, while the central tower is 10'6" high. All spaces are 2' square. The corner uprights are 2" in external diameter; the inside uprights and climbing bars are 1-1/16" in external diameter. All members are hot-dipped galvanized pipe.

THE PERFECT

4

Circa 1948

J. E. Porter Corporation

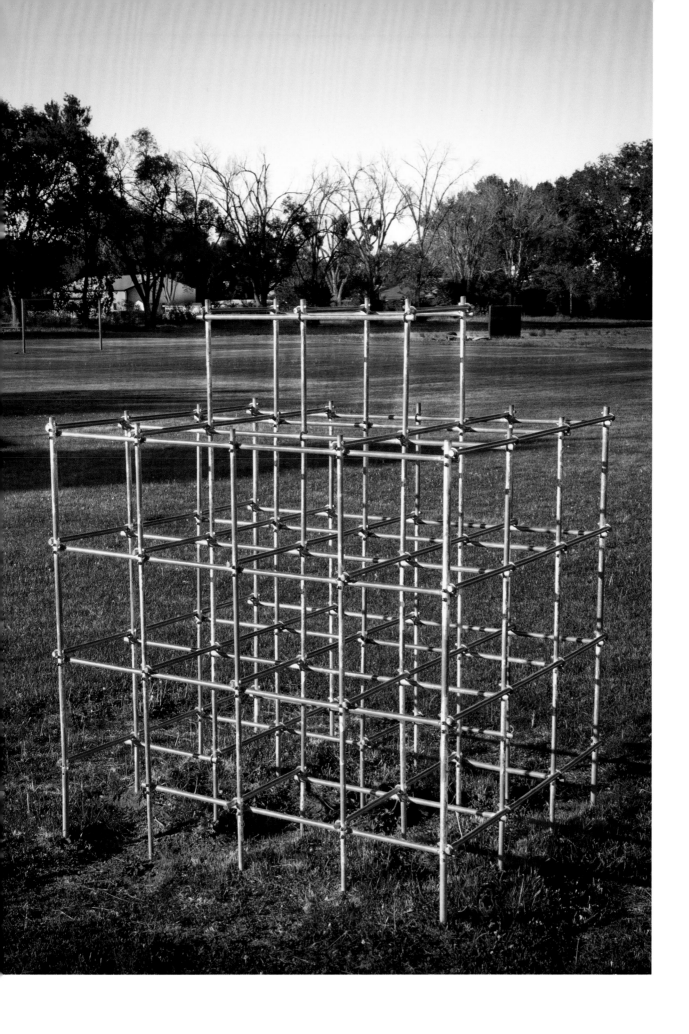

★ AMERICAN *Approved* CASTLE TOWERS

Scientifically Designed. Available in Six Ideal Sizes to Provide Safe, Healthful Play for Children of All Ages

AMERICAN *Commando* CASTLE TOWER
A SENSATIONAL, NEW CLIMBING STRUCTURE

Developed by American Engineers to fill the need for a larger climbing structure that would intrigue the interest of and provide greater climbing-play-exercise opportunities for the older, larger children, the American *Commando* Castle Tower rapidly is achieving *nation-wide popularity* among leading Educators and Recreation Directors. Practically indestructible, all members of the Commando Castle Tower are fabricated from 1 1/16-inch new Hot-Dip Galvanized Structural Steel Pipe permanently locked together into a rigid, *tremendously strong* integral unit by smoothly rounded Certified Malleable Fittings, through-bolted *through* the pipe members for lifetime durability. Entire structure is Hot-Dip Galvanized for enduring rust protection.

Incorporating all the many plus-features of improved design, superior materials and skilled craftsmanship "built-in" all American Castle Tower Units, the American Commando Castle Tower is nearly 13-feet long, 8-feet-9-inches wide and is 10-feet high above ground to provide unlimited, beneficial climbing-play-exercising for as many as *eighty-five* active youngsters simultaneously. Engineered for massive strength, the Commando Castle Tower requires *no corner braces or supports* as do some out-moded makes still on the market . . . an additional American feature which conserves ground space, assures maximum Safety for your play area. Thousands upon thousands of happy, carefree child-play-hours without maintenance or upkeep cost . . . estimated total cost divided over a period of only ten years, actually is less than *one-tenth of one mill* per child-play-hour! The nation's greatest climbing structure value.

No. CCT Commando Castle Tower complete, arranged for permanent setting in concrete, ready for installation. Weight, 1,200 lbs. **$368.70**

AMERICAN *Approved* PRIMARY CASTLE TOWERS

Ideal for Kindergarten or Nursery, American Primary Castle Towers provide an intriguing range of climbing-play-exercise for twenty children at one time. Designed to develop morale and physique, not as easy ladder climbs, Primary Towers have Rounds *ideally spaced 21"* apart on centers.

No. PCT Primary Castle Tower complete, 7' High, 5' in Diameter. Wt. 185 lbs. **$ 63.85**

No. DPT Double Primary Tower, 7' High, 11' in overall Diameter. Wt. 390 lbs. **$131.65**

AMERICAN *Portable* PRIMARY CASTLE TOWER

Here is the ultimate in climbing structure design for Nursery School and Kindergarten use, indoors or out, an *ideal* unit which provides an intriguing range of healthful climbing-play-exercise opportunities for as many as twenty children at one time. Built to the same *superior* specifications embodied in all American Castle Towers, all members are fabricated from 1 1/16-inch New, Galvanized Steel Pipe—a size which even the smallest child can grip firmly for a safe handhold—locked permanently together by *smoothly rounded* Certified Malleable Fittings of exclusive American design. The improved *Portable Base,* as illustrated at right, permits ready portability to desired locations. Entire structure is Hot-Dip Galvanized for enduring rust protection. Extreme height, 7-feet; Diameter, 5-feet.

No. PCT-P Portable Primary Castle Tower complete with Portable Base as shown, with Rounds *ideally spaced 21"* apart on centers. Weight, 200 lbs. **$74.45**

• 29

1956

American Playground Device Company

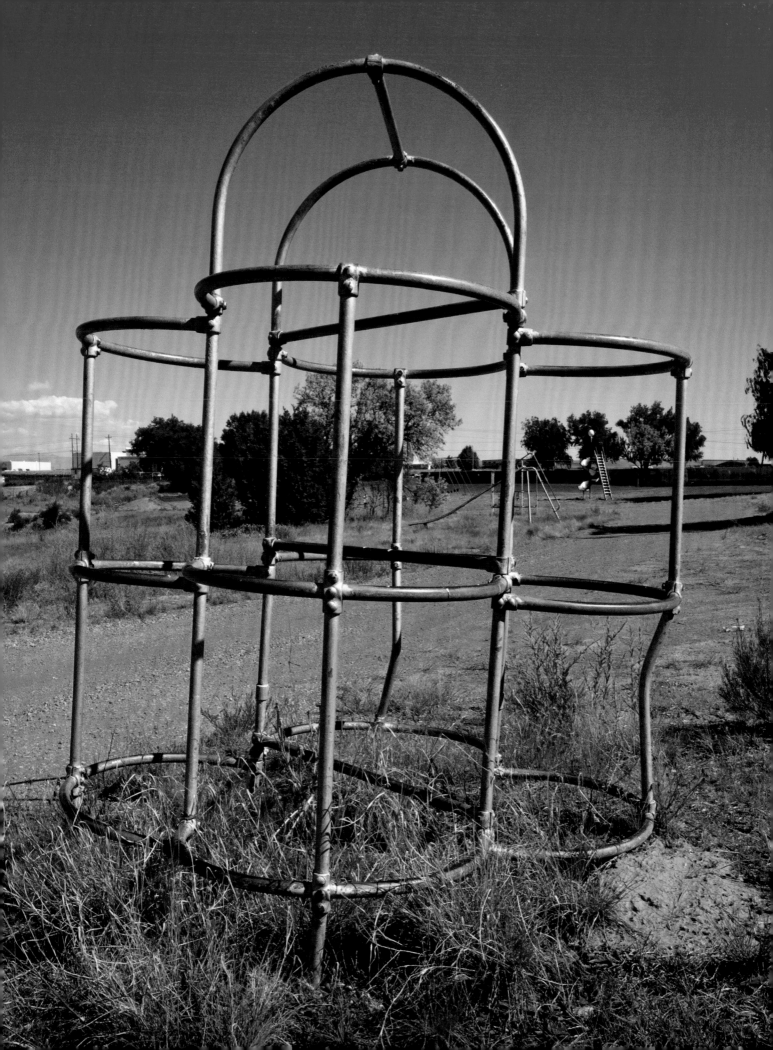

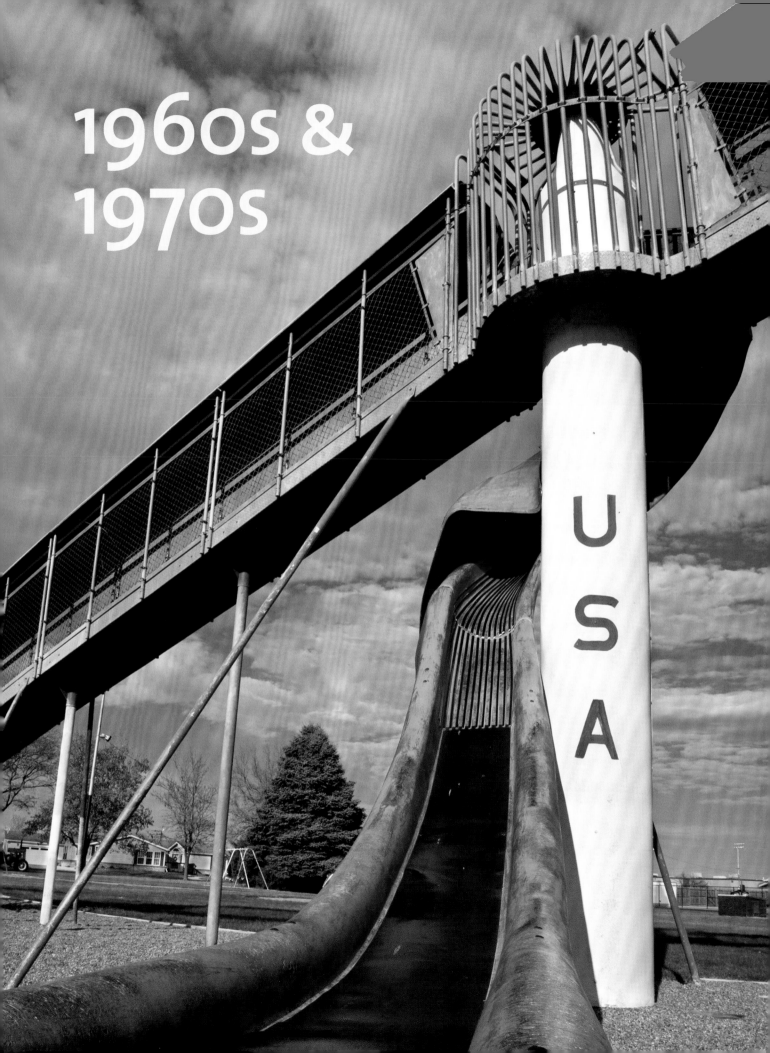

1960s &
1970s

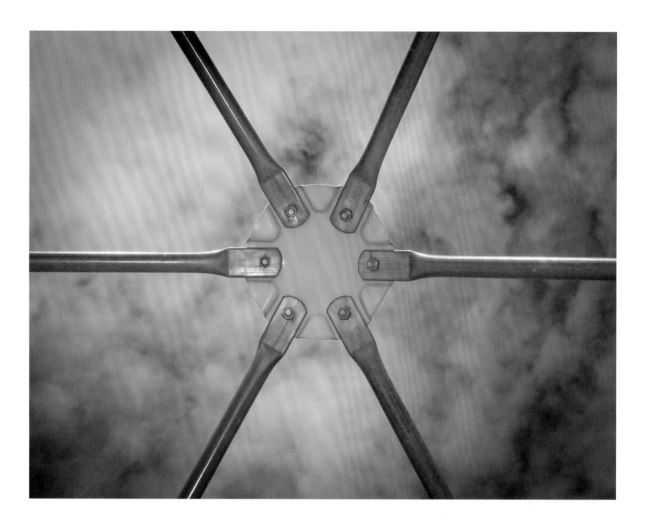

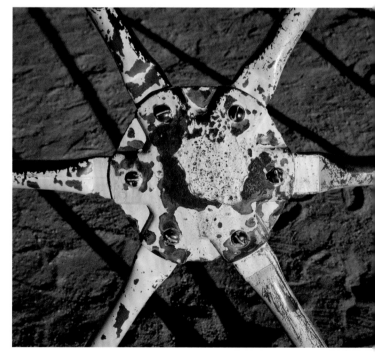

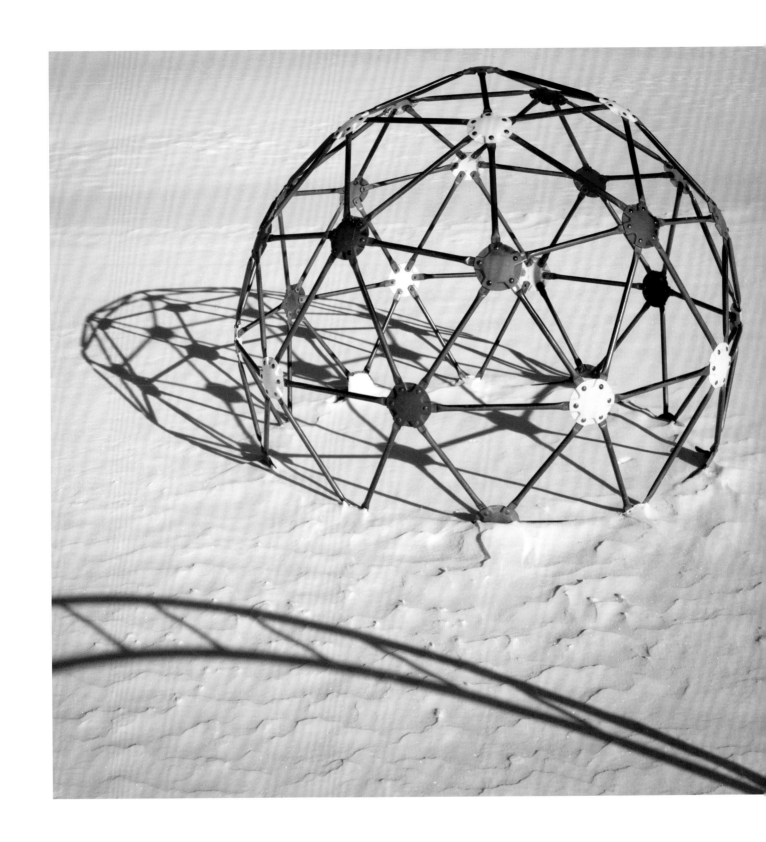

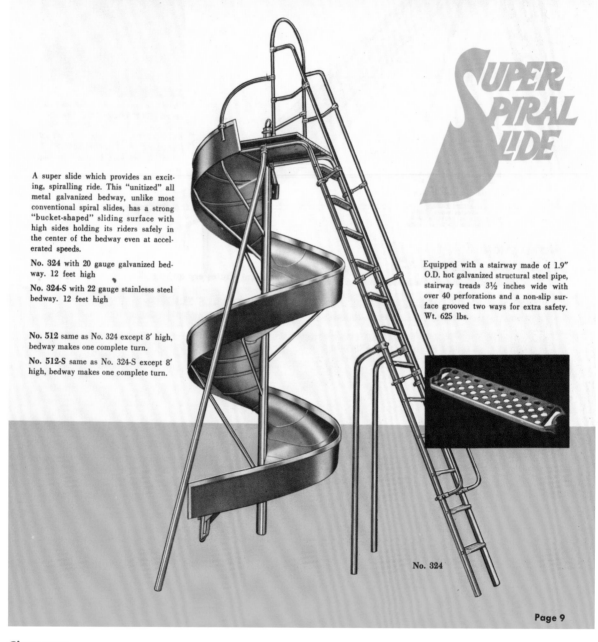

A super slide which provides an exciting, spiralling ride. This "unitized" all metal galvanized bedway, unlike most conventional spiral slides, has a strong "bucket-shaped" sliding surface with high sides holding its riders safely in the center of the bedway even at accelerated speeds.

No. 324 with 20 gauge galvanized bedway. 12 feet high

No. 324-S with 22 gauge stainless steel bedway. 12 feet high

No. 512 same as No. 324 except 8' high, bedway makes one complete turn.

No. 512-S same as No. 324-S except 8' high, bedway makes one complete turn.

Equipped with a stairway made of 1.9" O.D. hot galvanized structural steel pipe, stairway treads 3½ inches wide with over 40 perforations and a non-slip surface grooved two ways for extra safety. Wt. 625 lbs.

No. 324

Page 9

Circa 1973

Recreation Equipment Company

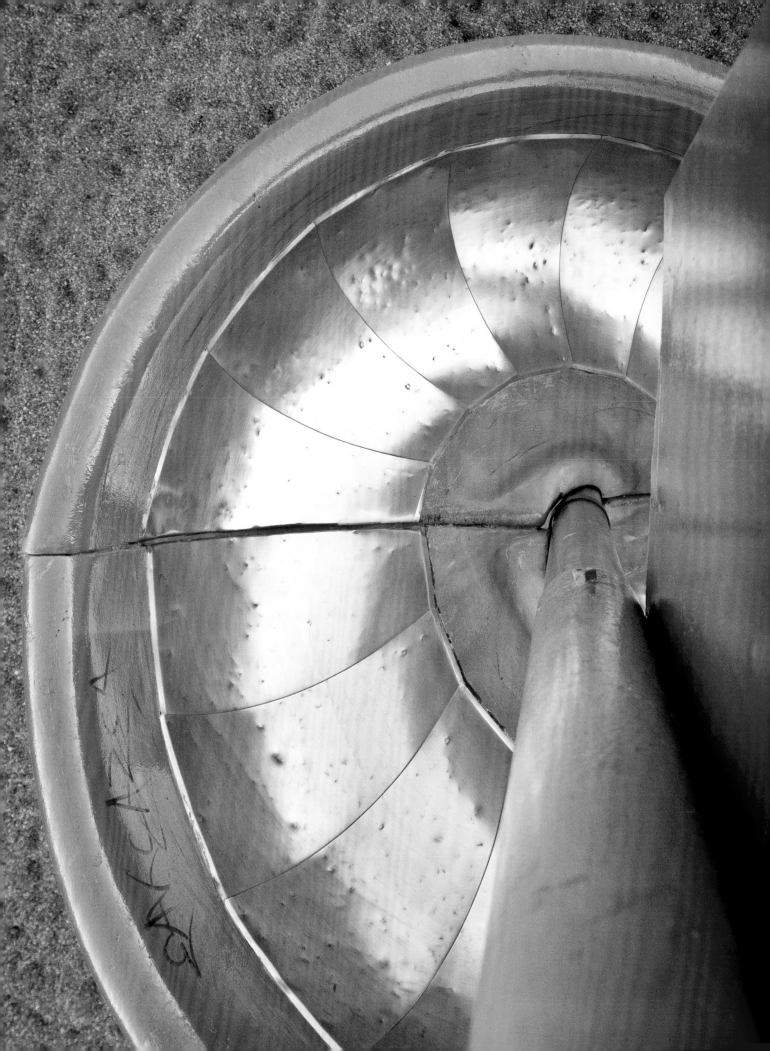

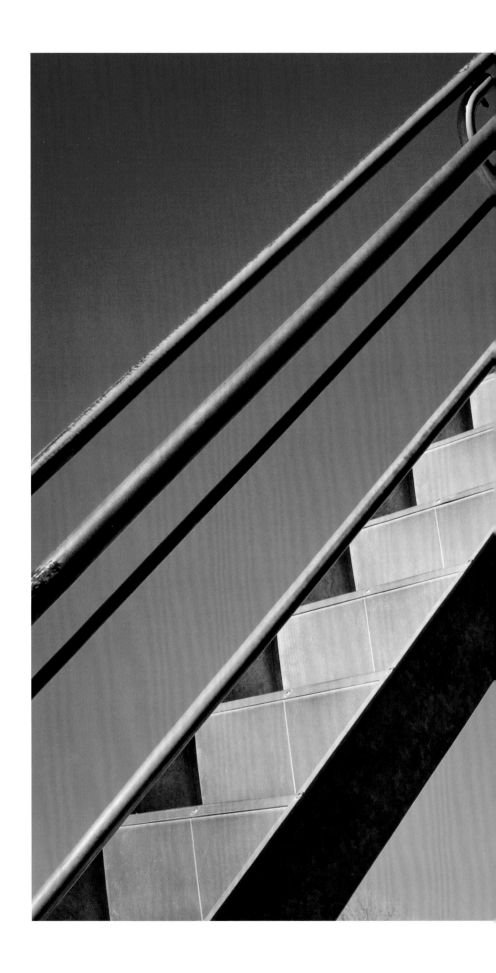

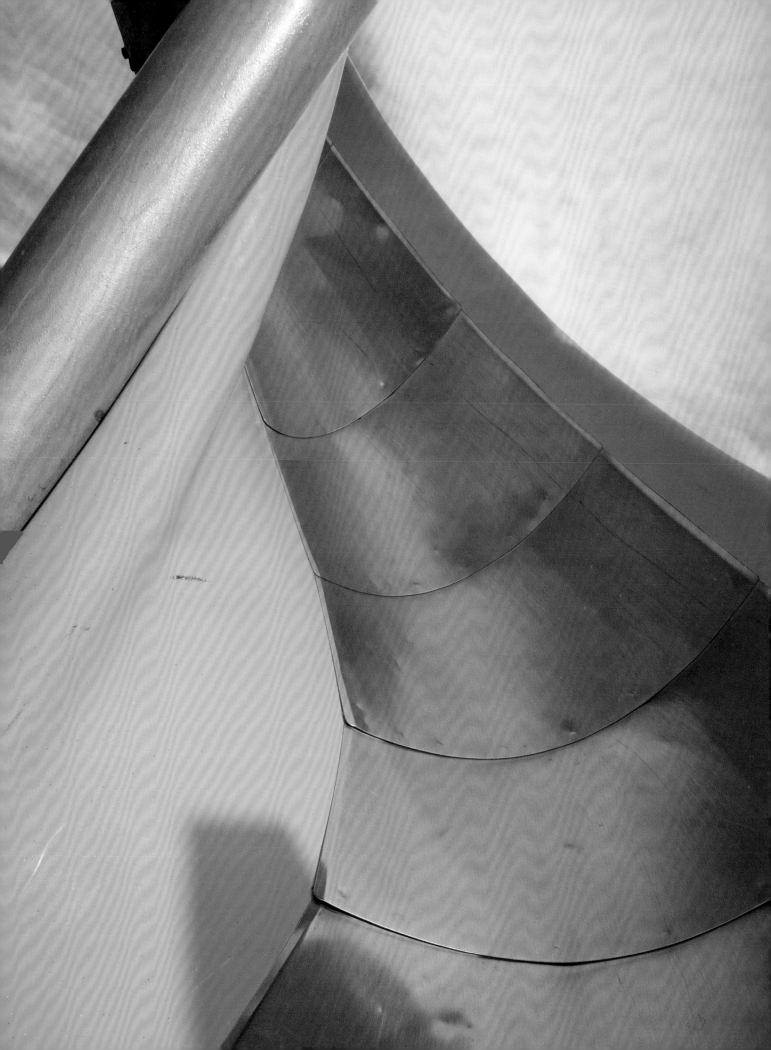

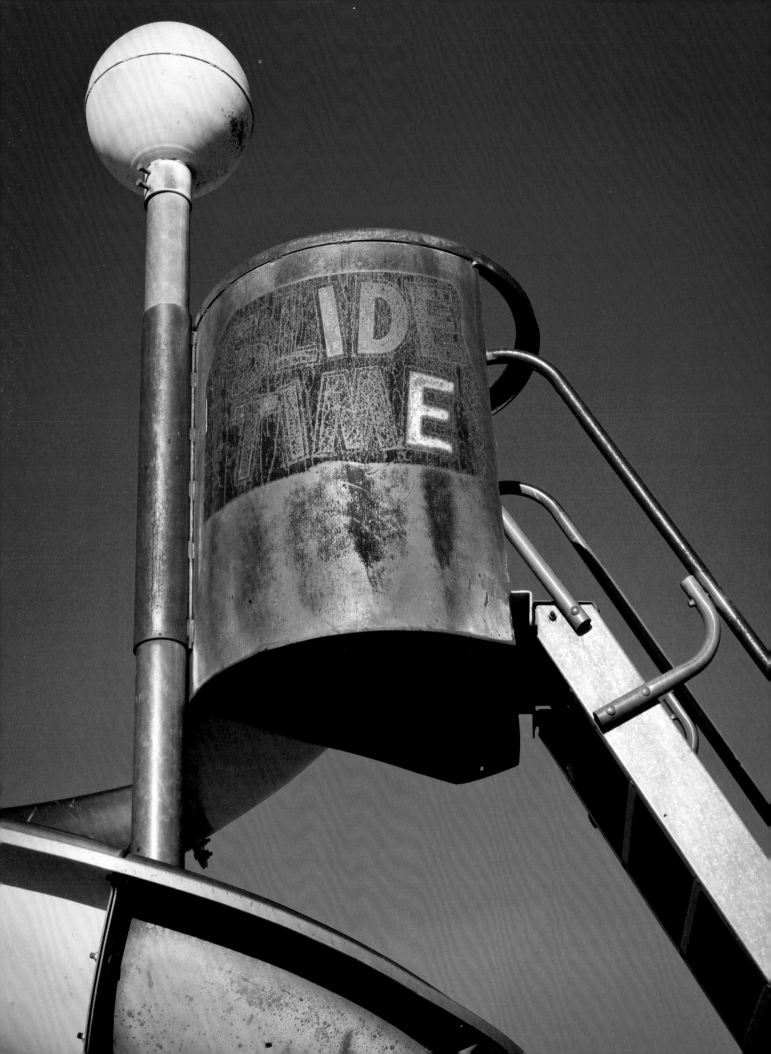

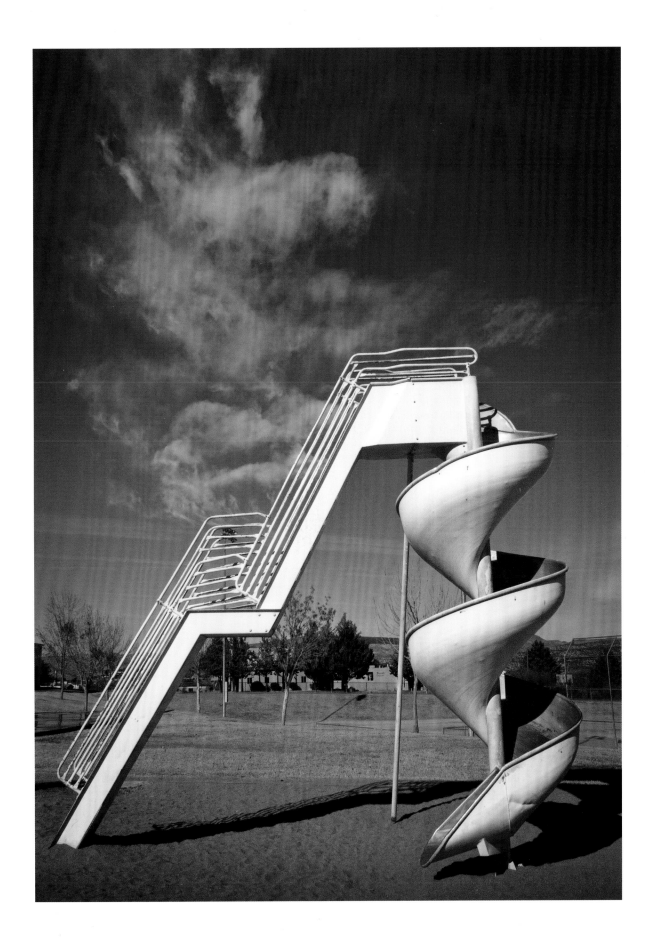

JUNIOR WAVE SLIDE

Model 105-3 Price Group 25

Small fry really get a lot of run-for-fun out of the Junior Wave Slide. Double thrills are in store with the undulating design. Triple safety is built in with the extra-deep chute, the optional safety canopy to prevent stand-up sliding at top and the safety tread steps. Bedway is molded fiber glass with 18-gauge stainless steel sliding surface. Support posts are 2 ⅜" O.D. galvanized steel pipe. Junior size allows smaller children to ride but gives older ones plenty of excitement, too. Fiber glass canopy Model 850-123 optional. Weight is 30 pounds.

GROUND SPACE: 38'' by 14'
SHIPPING WEIGHT: 430 pounds

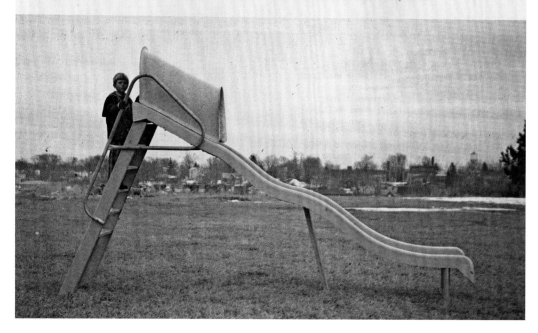

1975

Miracle
Recreation
Equipment
Company

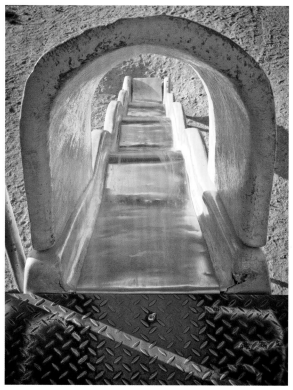

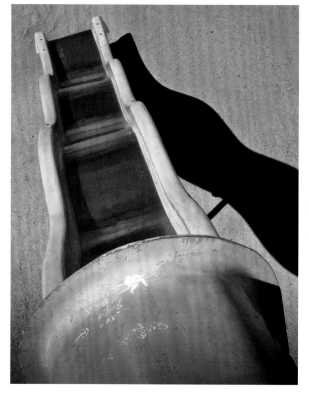

72

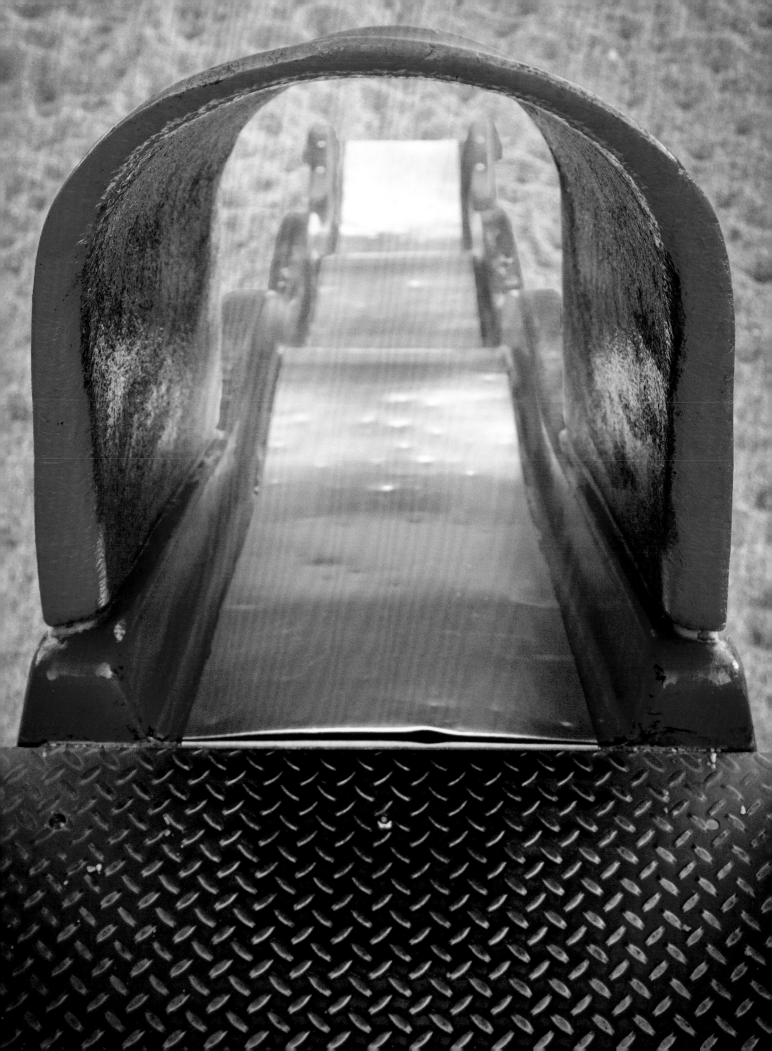

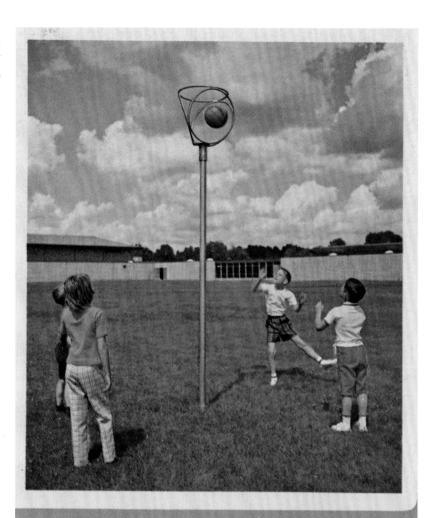

LOOP-O-BALL

The automatic return feature makes a basketball court of any area. The game teaches extreme accuracy since there is no backboard to bank shots. Loop-O-Ball can be played with official rules and can be set-up indoors or out. Units are available with or without portable base. Shaft 2⅜″ O.D. galvanized pipe.

No. 22 Portable Loop-O-Ball, wt. 66 lbs................**$64.00**
No. 23 Stationary Loop-O-Ball, wt. 46 lbs...............**$47.50**

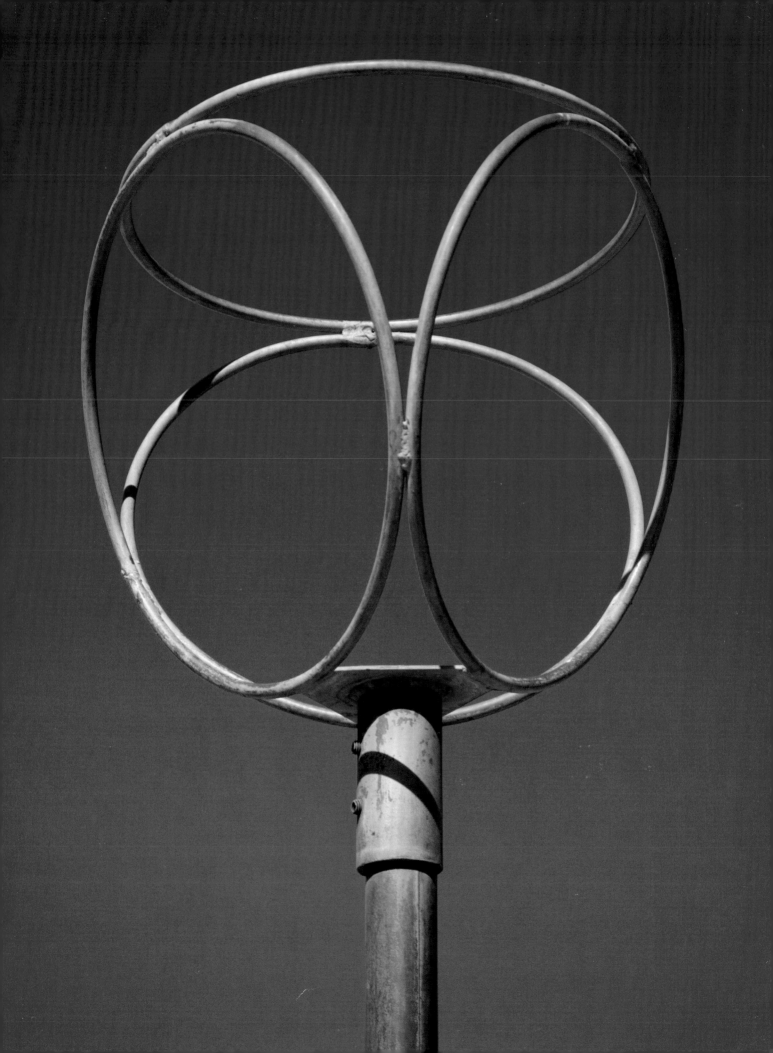

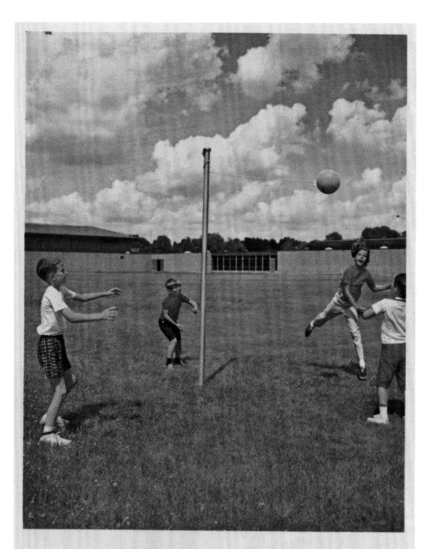

TETHERBALL

This makes a fast, exciting game with the ball being hand batted between players and the tether causing the ball to create baffling trajectories. 2⅜″ O.D. galvanized vertical shaft is 10 ft. high and is available either permanent or portable. Prices include ball and cord, the ball being built for hard use and featuring a stringless rubber cover.

No. 342 Portable Tetherball, including ball and cord, wt. 56 lbs...**$48.00**

No. 343 Stationary Tetherball, including ball and cord. wt. 47 lbs...**$33.00**

No. 344 Ball and Cord, separately, wt. 2½ lbs........**$13.00**

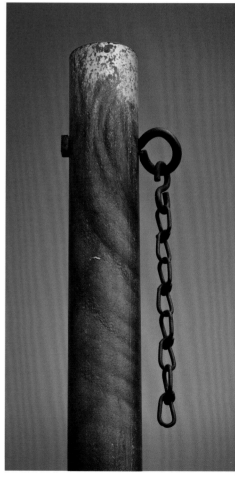

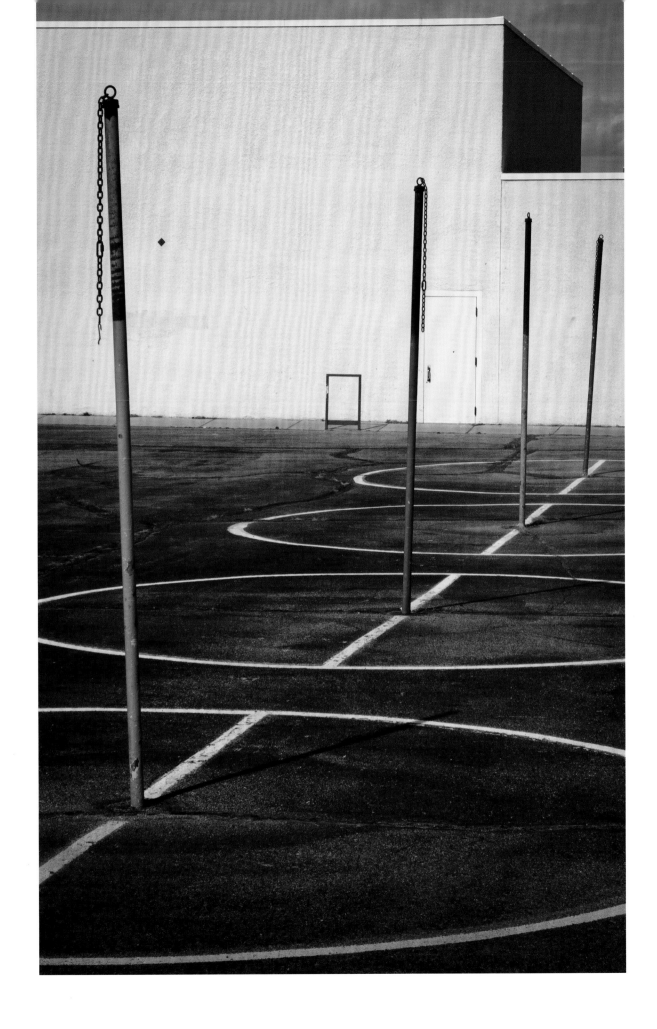

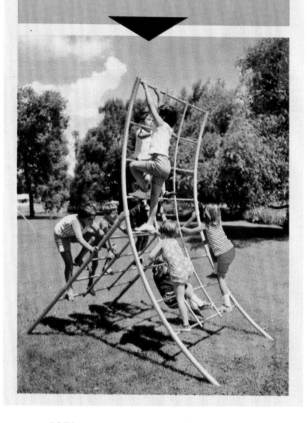

GAME TIME'S

RADAR SCREEN...

Complements the space theme and provides a wealth of body building climbing activities for youngsters on any playground. Constructed from 1⅞″ O.D. galvanized pipe with 1″ O.D. zinc-grip steel rungs. 4′ 10″ wide, 10′ 8″ high.

No. 770 Radar Screen, wt. 151 lbs............**$168.00**
Patent applied for

1971

Game Time, Inc.

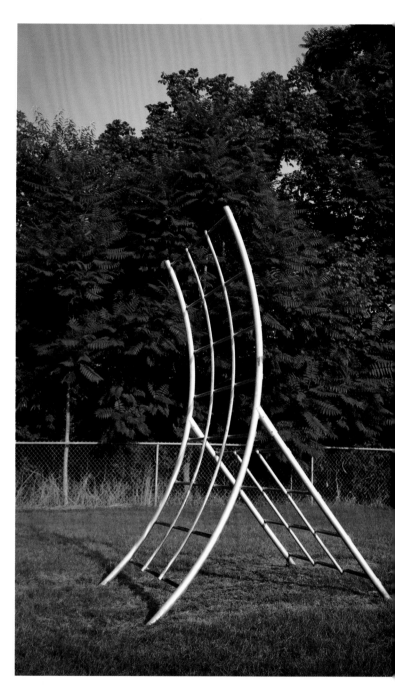

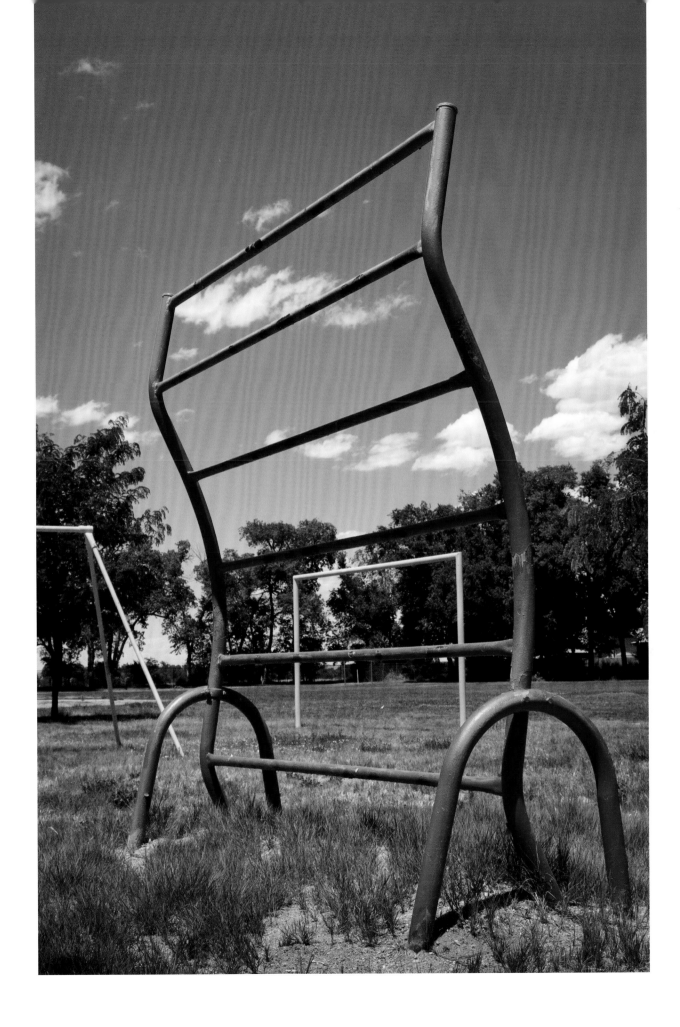

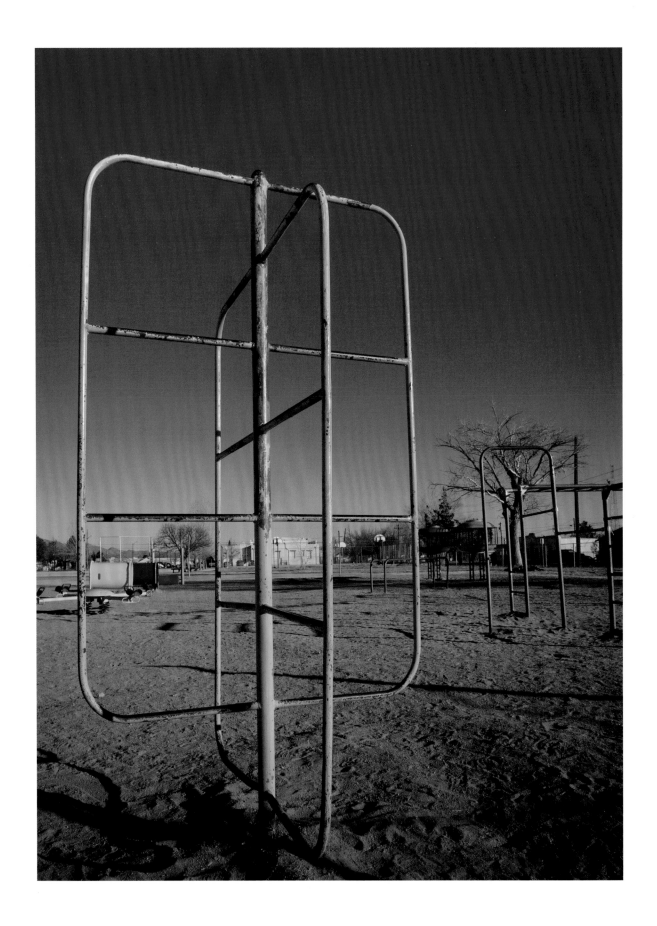

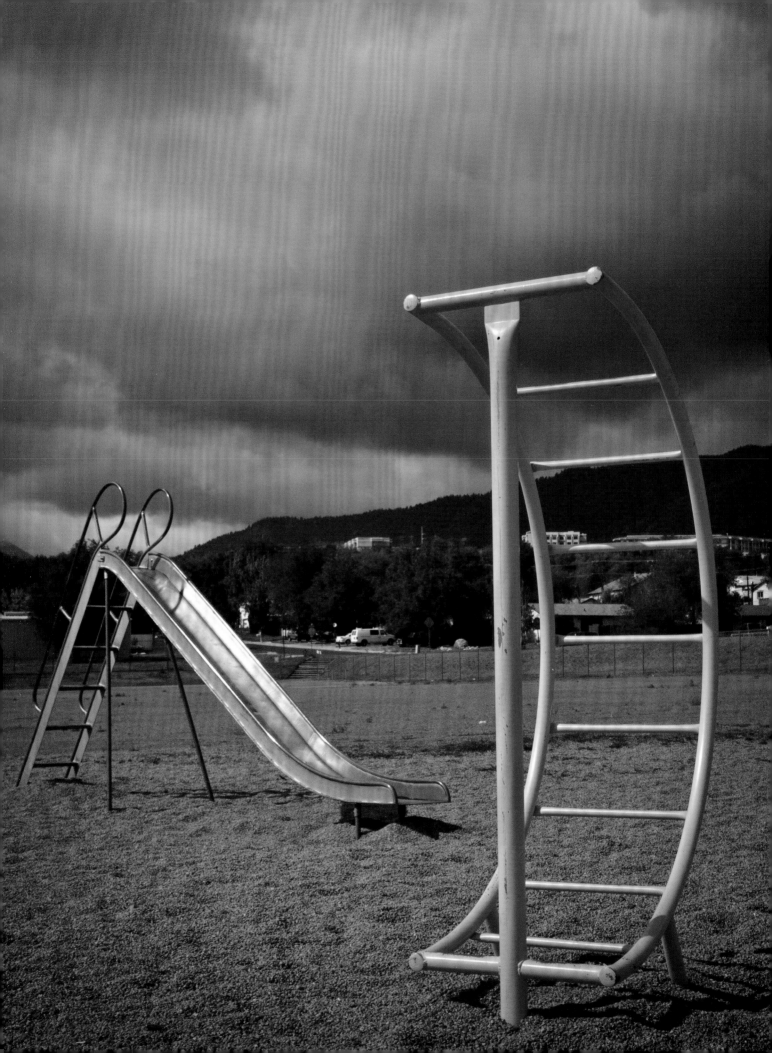

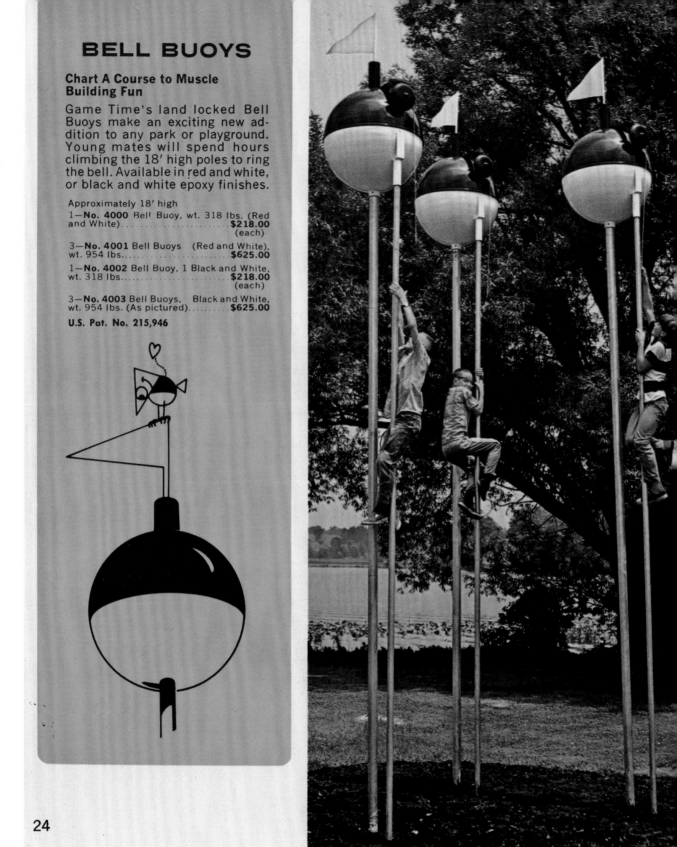

BELL BUOYS

Chart A Course to Muscle Building Fun

Game Time's land locked Bell Buoys make an exciting new addition to any park or playground. Young mates will spend hours climbing the 18' high poles to ring the bell. Available in red and white, or black and white epoxy finishes.

Approximately 18' high

1—**No. 4000** Bell Buoy, wt. 318 lbs. (Red and White).................... **$218.00**
(each)

3—**No. 4001** Bell Buoys (Red and White), wt. 954 lbs..................... **$625.00**

1—**No. 4002** Bell Buoy, 1 Black and White, wt. 318 lbs..................... **$218.00**
(each)

3—**No. 4003** Bell Buoys, Black and White, wt. 954 lbs. (As pictured)......... **$625.00**

U.S. Pat. No. 215,946

24

1971

Game Time, Inc.

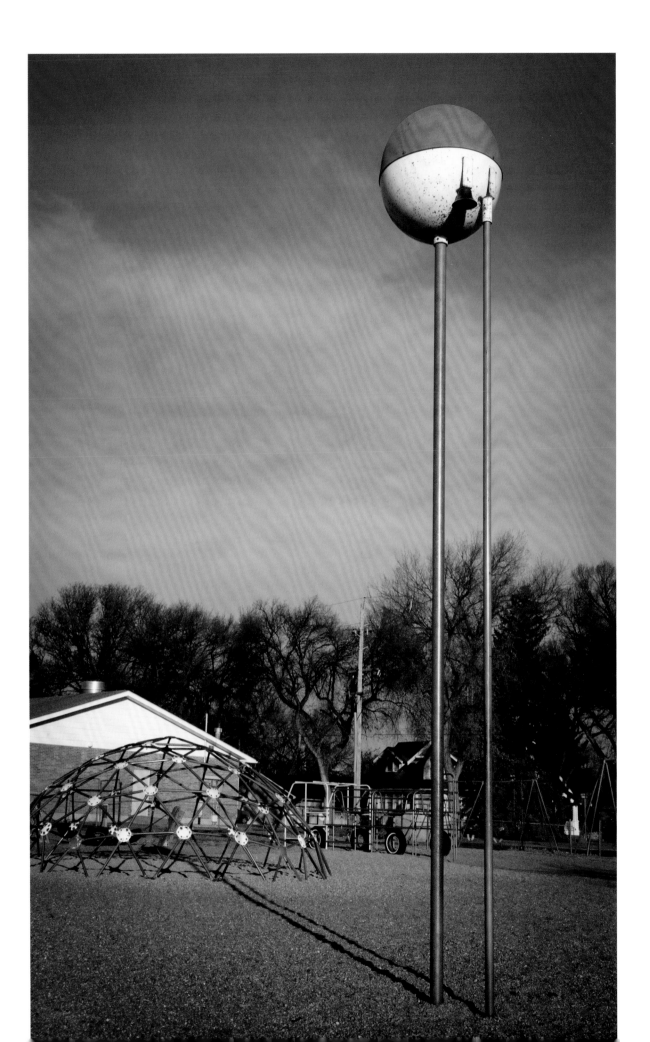

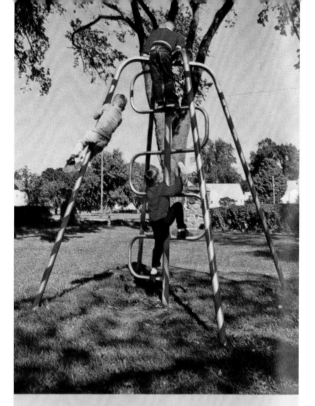

Spider Climber
MODEL SP-1

Miracle borrows an idea from the spider and weaves an intriguing web of steel to create the Miracle Spider Climber. This unit is ideal for teaching small children how to shinny although it's designed to attract aspiring young firemen of all ages.

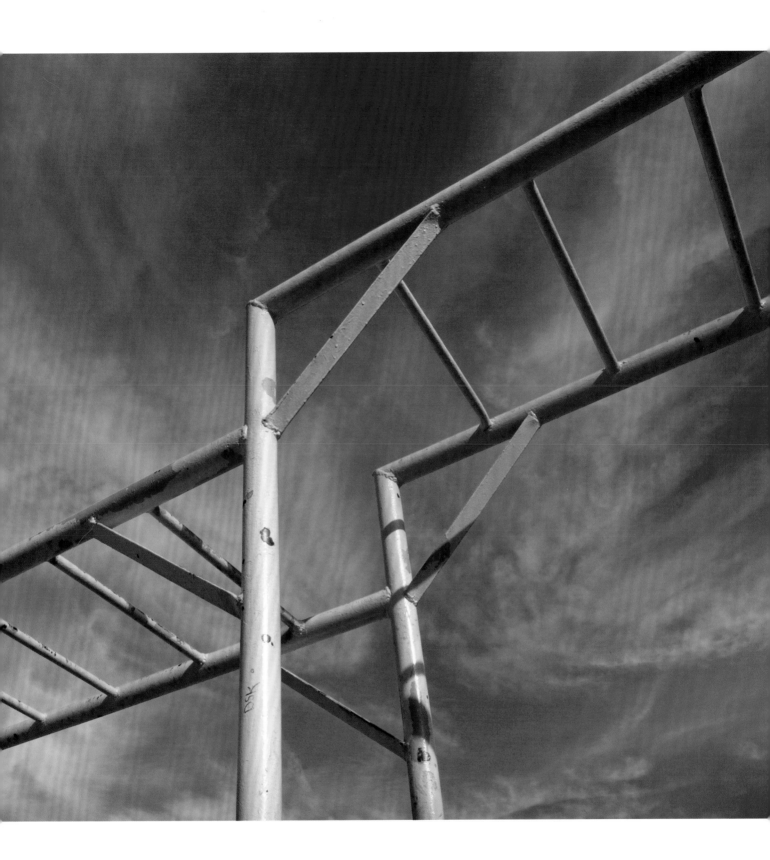

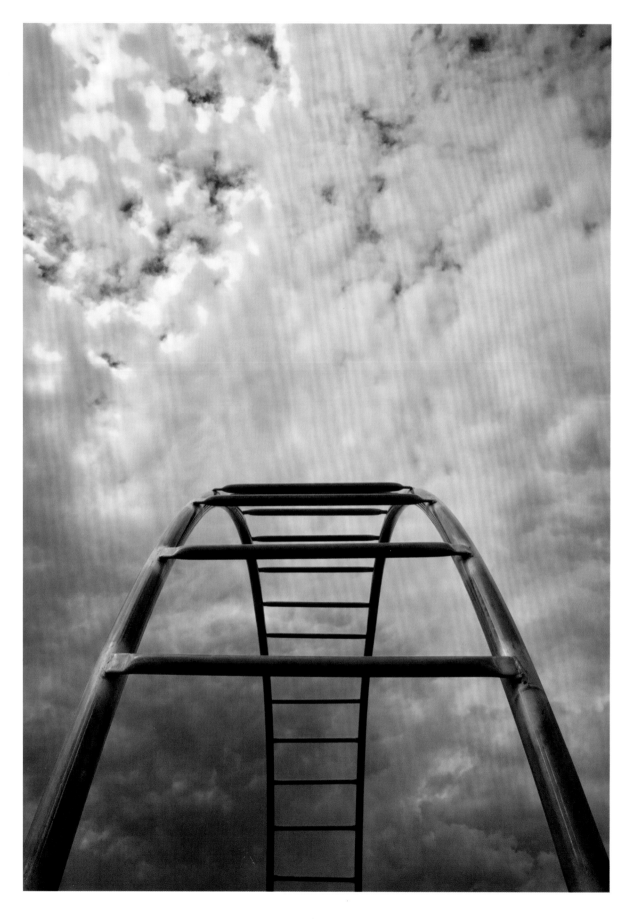

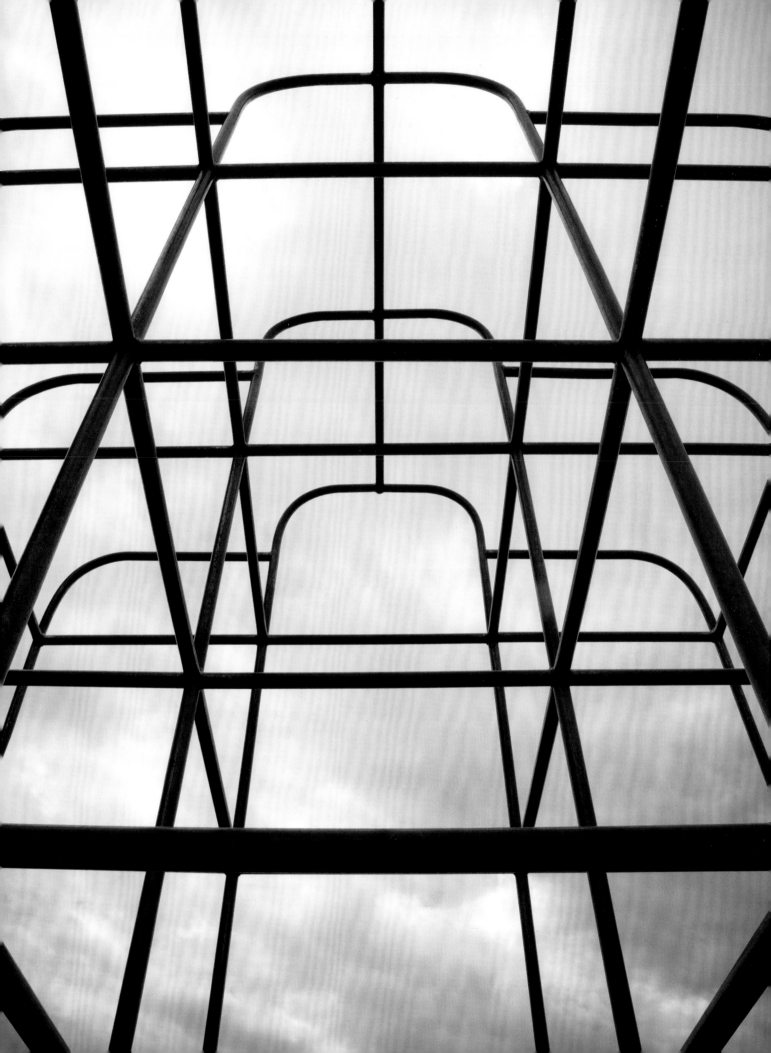

Miracle Recreation
Equipment Company
(The company's
name got longer in
the early 1970s)

FOUR-WAY CLIMBER
Model 410 Price Group 26

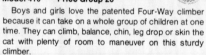

Boys and girls love the patented Four-Way climber because it can take on a whole group of children at one time. They can climb, balance, chin, leg drop or skin the cat with plenty of room to maneuver on this sturdy climber.

GROUND SPACE: 12'6'' by 18'9''
SHIPPING WEIGHT: 370 pounds.

Specifications
FRAME: 1-7/8'' O.D. galvanized structural steel pipe with 1'' O.D. galvanized steel tube pipe rungs.

TWO-WAY CLIMBER
Model 407 Price Group 26

Arch, "free fall" design of all Miracle/Jamison climbers eliminates dangerous support pipes and takes away all metal-to-metal falls. Arch design adds strength for no-sag performance even when it is loaded with youngsters. They can climb the outside or the inside safely and really develop leg and arm muscles.

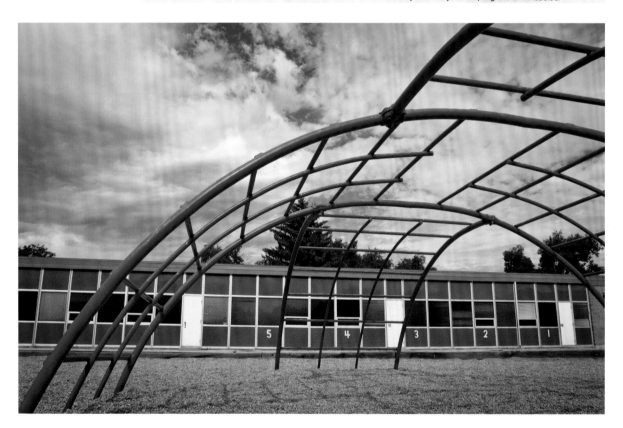

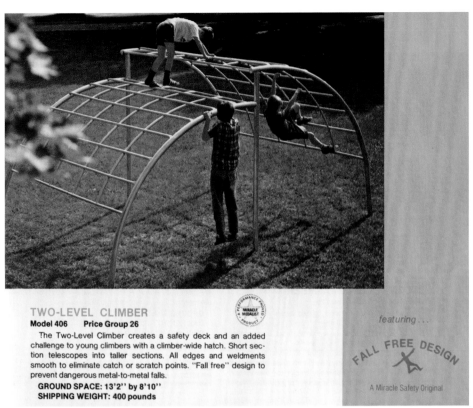

TWO-LEVEL CLIMBER
Model 406 Price Group 26

The Two-Level Climber creates a safety deck and an added challenge to young climbers with a climber-wide hatch. Short section telescopes into taller sections. All edges and weldments smooth to eliminate catch or scratch points. "Fall free" design to prevent dangerous metal-to-metal falls.

GROUND SPACE: 13'2'' by 8'10''
SHIPPING WEIGHT: 400 pounds

featuring . . .

FALL FREE DESIGN

A Miracle Safety Original

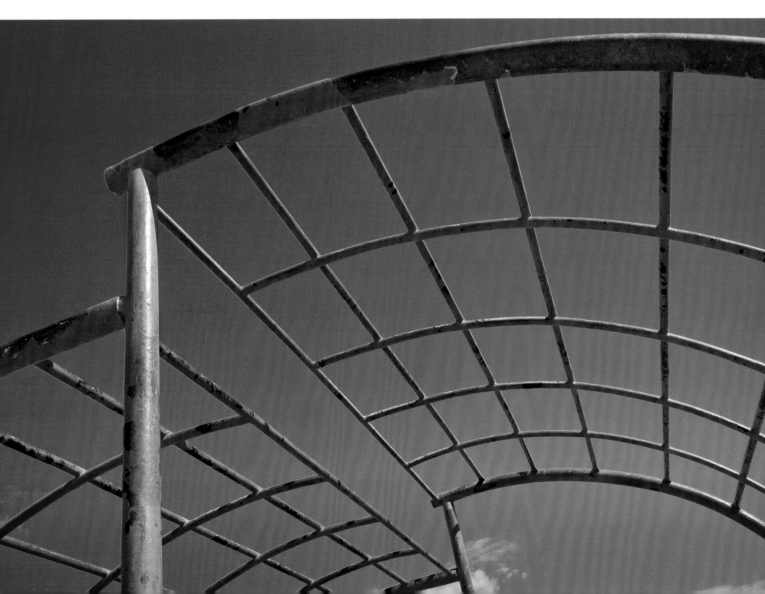

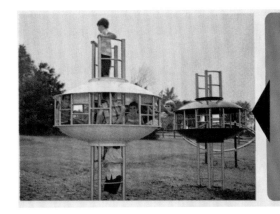

EAGLE'S NEST

Kids like to climb up inside the smooth 40" high by 66" wide galvanized, epoxy decorated nest. Mounted in pairs, the unit becomes twin eagles or space ships or whatever young minds can imagine.

Game Time's ''Eagle's Nest'' climber is designed as a safe place for smaller children to climb. Its dimensions are small enough to make larger children uncomfortable, keeping it free for the little ones who really enjoy it.

Manufactured from galvanized pipe and galvanized steel, the unit requires little maintenance.

No. 624 Eagle's Nest, wt. 420 lbs. (black epoxy finish) **$398.00**
No. 634 Eagle's Nest wt. 420 lbs. (white epoxy finish) **$398.00**

1971

Game Time, Inc.

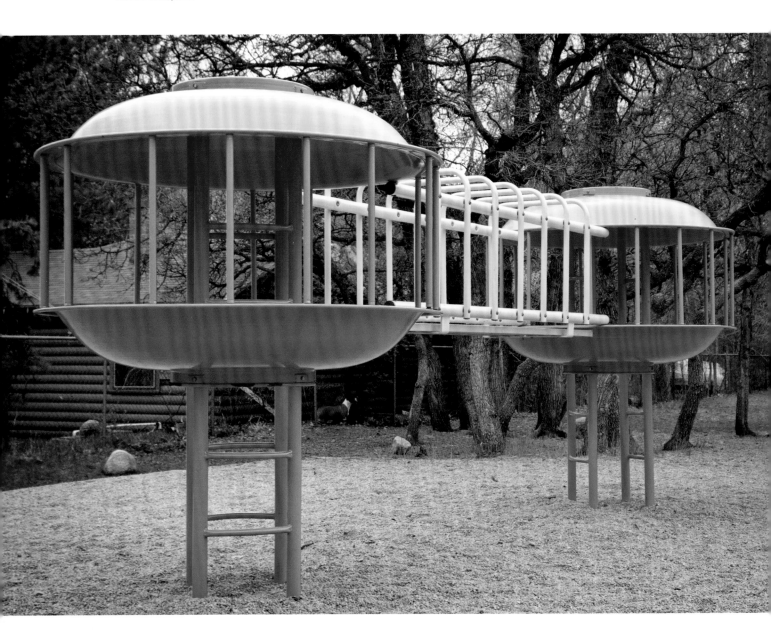

90

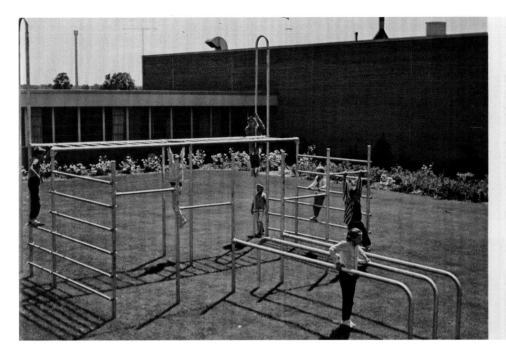

1971

Game Time, Inc.

91

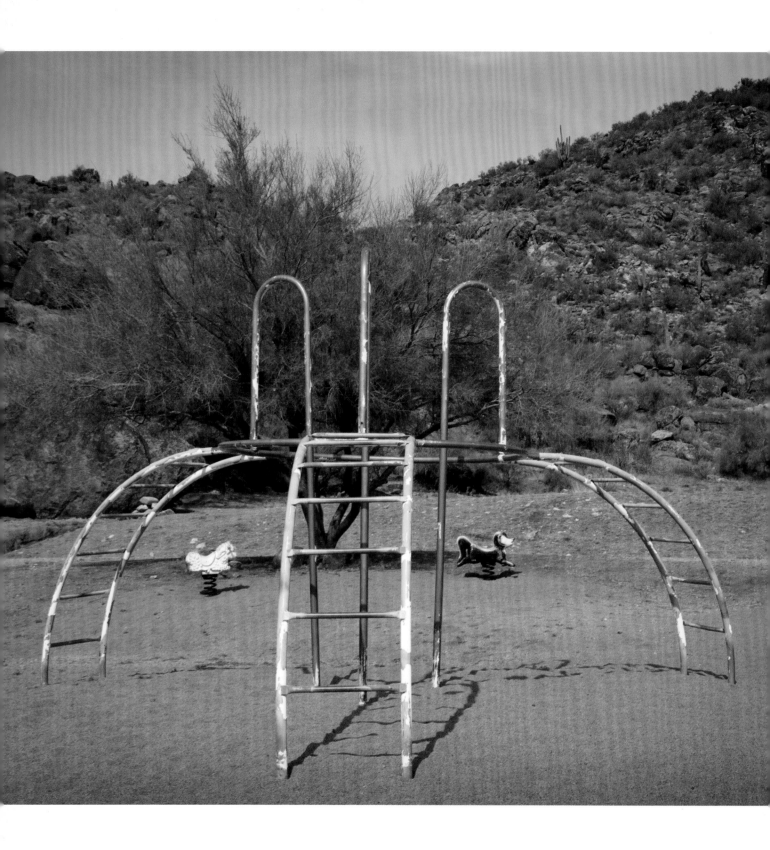

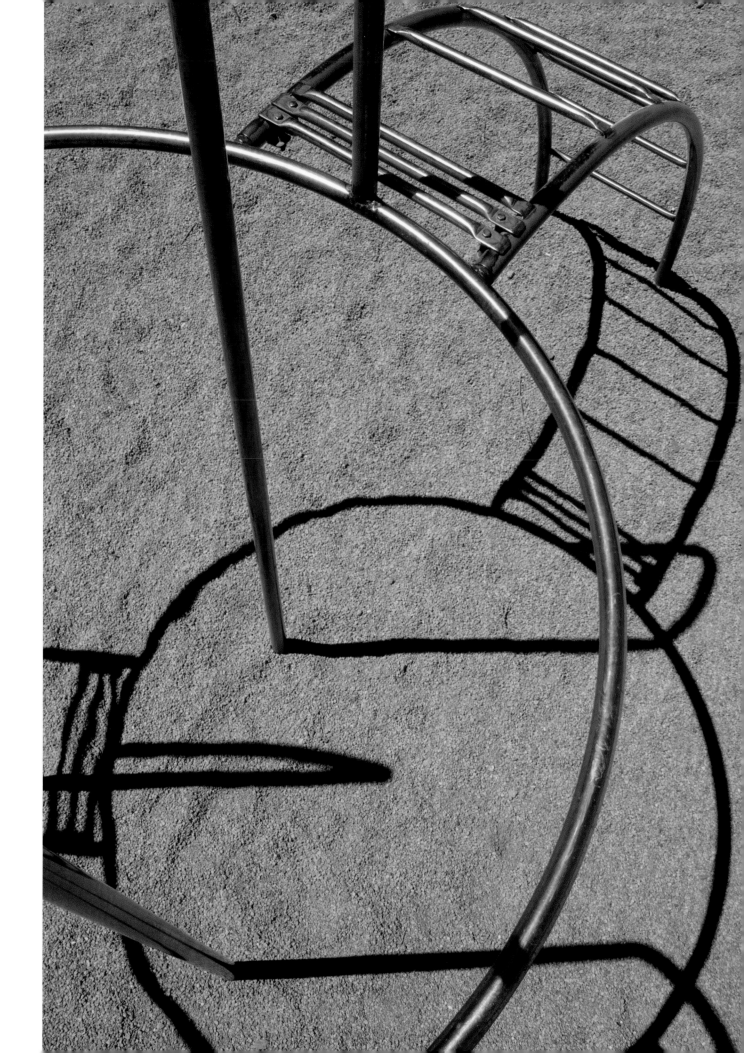

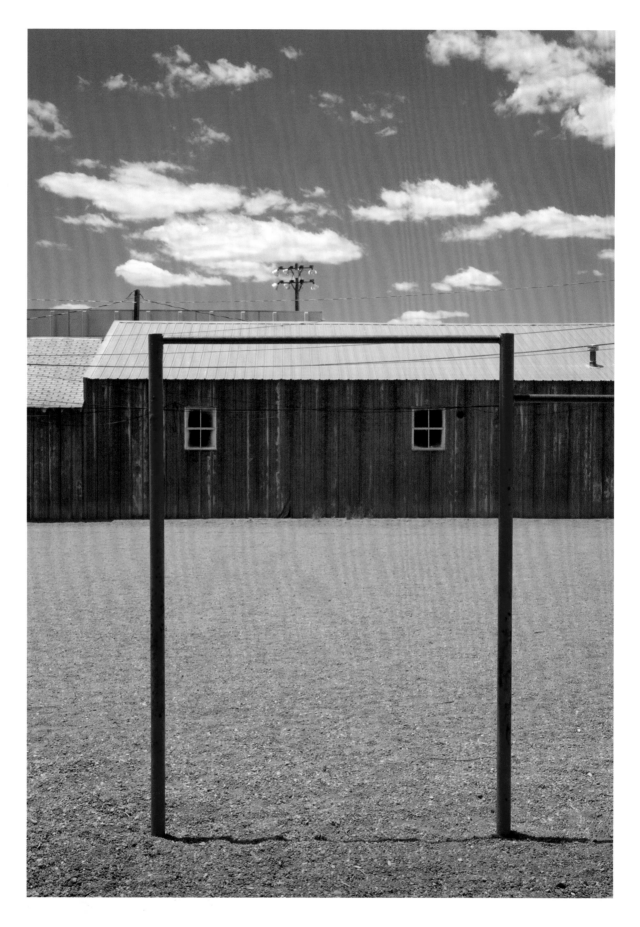

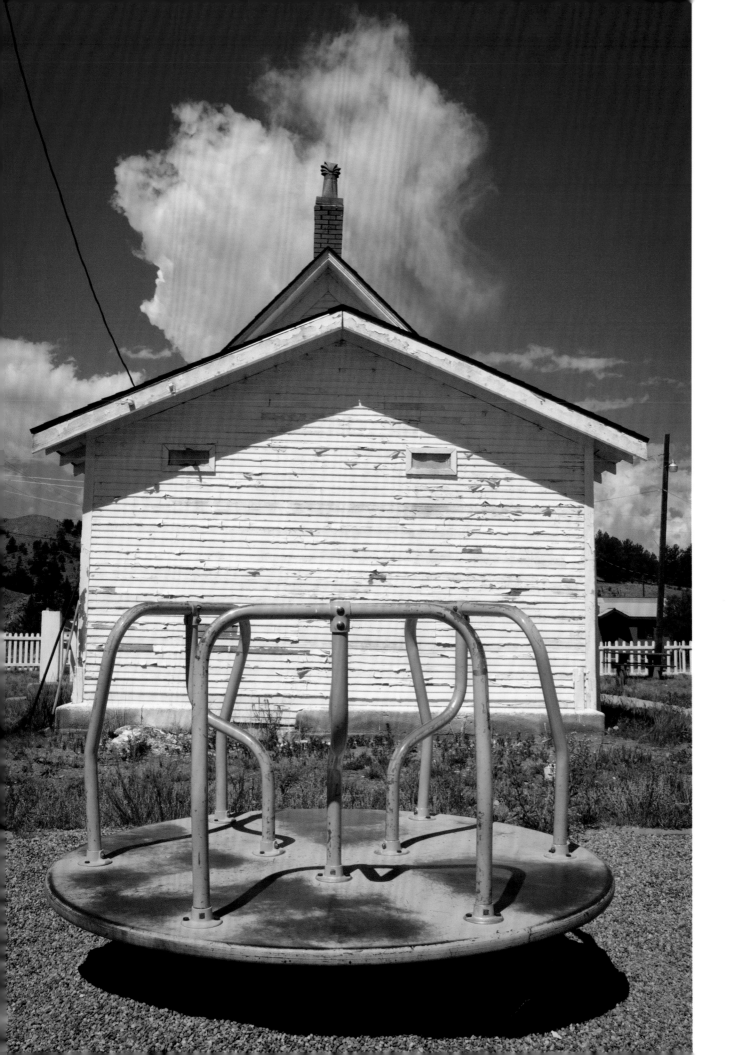

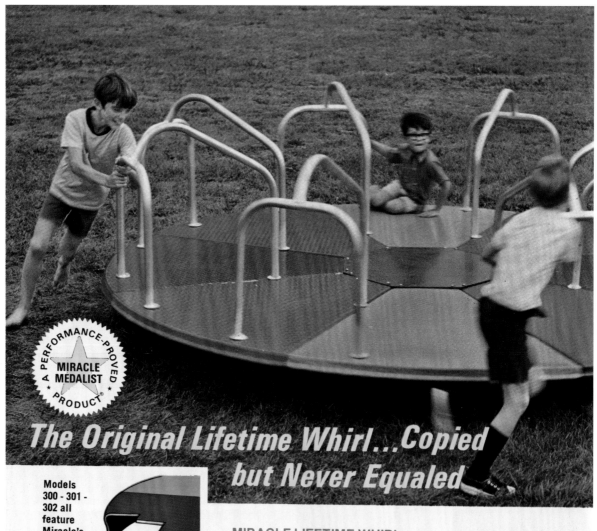

The Original Lifetime Whirl...Copied but Never Equaled

Models 300 - 301 - 302 all feature Miracle's guaranteed unbreakable die-formed edges.

Play Safely . . .

SAFETY NOTE:
We recommend that whirls be installed on a hard surface the size of the whirl to prevent children from burrowing under them.

MIRACLE LIFETIME WHIRL
Model 302 Price Group 23

Here it is — the whirl that built a company! It features the only all-MIRACOTE®, die-formed platform in the industry. This famous Lifetime Whirl has delighted three generations of children and still is a safe, playground favorite. Although it has gone through many improvements many of the original models are still spinning on playgrounds from coast to coast.

Specifications:
PLATFORM SECTIONS: One-piece 14-gauge non-skid galvanized steel floor plate, die-formed for safety and rigidity. Finished in multi-color MIRACOTE® - **HANDRAILS:** 1-1/2" O.D. galvanized MIRACOTE® steel tubing. **HUB ASSEMBLY:** 5" O.D. steel pipe, supported by four legs of 2-3/8" O.D. steel pipe and housing two ball bearings that revolve on a 3" steel shaft.

GROUND SPACE: 10' diameter
SHIPPING WEIGHT: 570 pounds

38

1975

Miracle Recreation Equipment Company

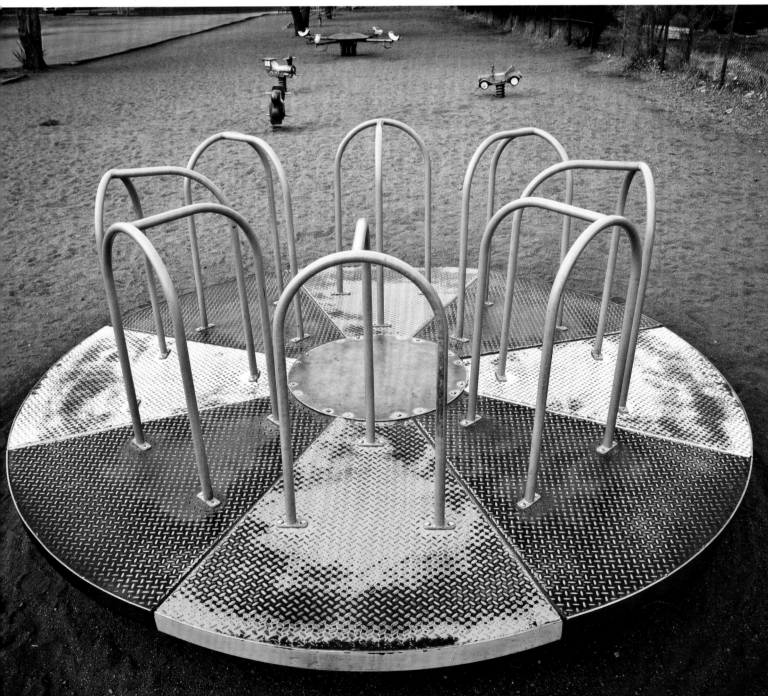

NO. 18 WHIRL-A-WAY

Now With New Rounded Edge Construction

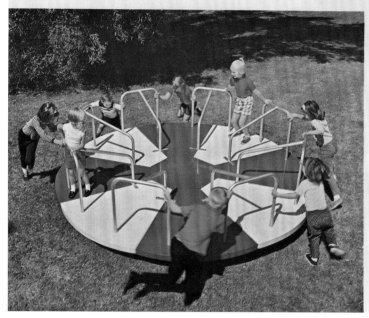

10 ft. in diameter, this 14 gauge floor plate marvel whirls on a permanently lubricated, permanently sealed combination radial load and thrust bearing. Built for fun and excitement, the Whirl-A-Way can be easily turned by the smallest child and has a capacity for as many as 30 children at a time. The Whirl-A-Way can be set up perfectly level . . . as conventional merry-go-rounds, or on a slight angle. The latter makes it possible for even one child to whirl the merry-go-round simply by shifting his weight.

Handrails are 1⅚₆" galvanized pipe permanently bolted to the platform surface.

Available for permanent installation only.

No. 18 Whirl-A-Way, permanent base, wt. 741 lbs. **$329.00**

U.S. Pat. No. 3,510,127

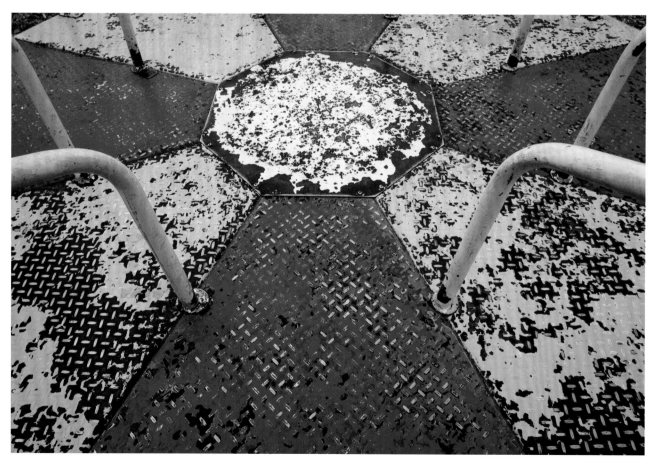

EAGLE WHIRL

The "Eagle Whirl's" child protecting, smooth, outer surface contours with safety rolled edges, combined with eight smooth zinc-grip steel hand rails make the 39' high 7' wide "Eagle Whirl" the safest on the market.

The 1" diameter hand rails are made of electrically welded zinc-grip steel and are designed to help a small child get a secure hand hold.

Rugged enough to take the roughest abuse, the "Eagle Whirl" accommodates up to twelve youngsters at one time.

Bright red and white or black and white epoxy decoration over galvanized steel gives years of maintenance free service.

No. 519 Eagle Whirl, black and white epoxy, wt. 588 lbs..............$419.00
No. 521 Eagle Whirl, red and white epoxy, wt. 588 lbs................$419.00

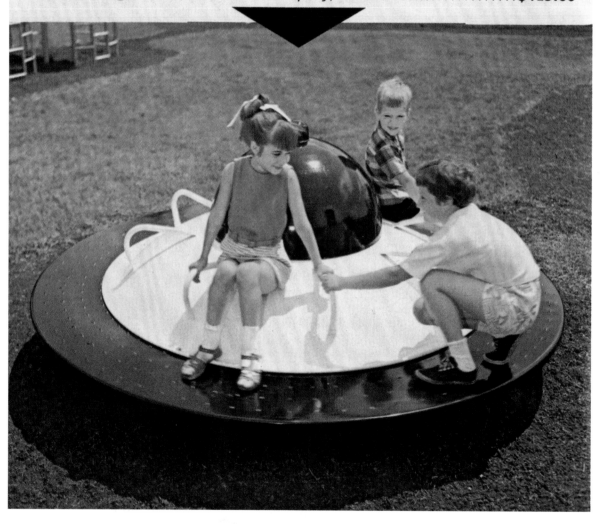

100

1971

Game Time, Inc.

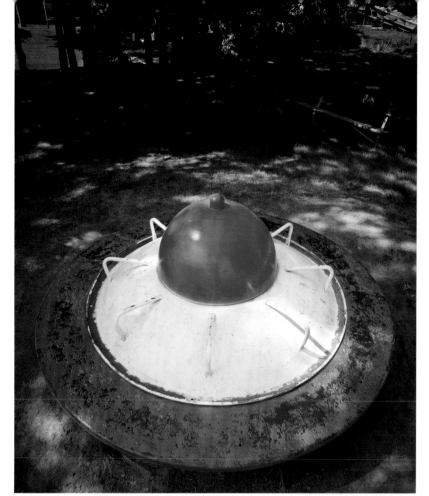

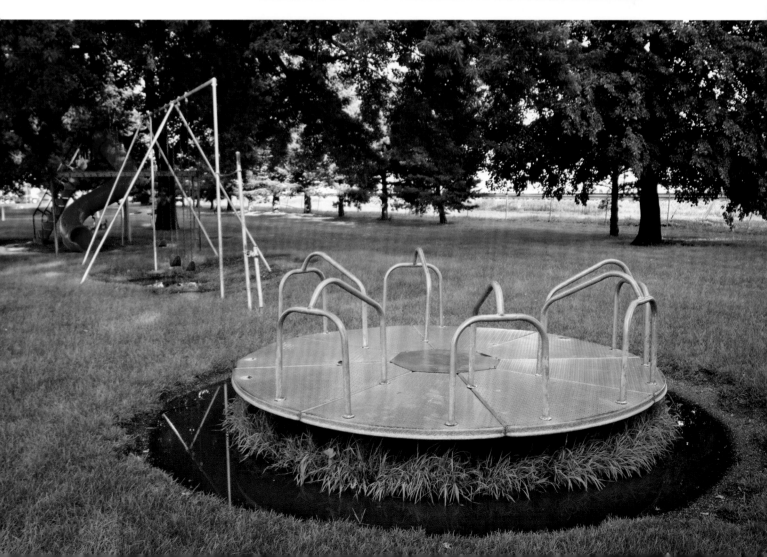

Circa 1968

Miracle Equipment Company

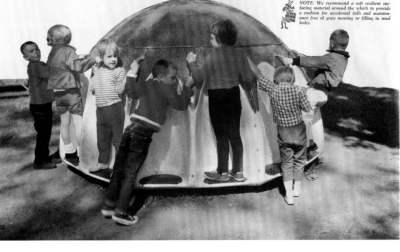

MIRACLE DOME WHIRL*

MODEL 304

Whenever it's installed, this Miracle creation is always the center of attraction. So exciting, yet so safe . . . and it's so easy to start the fun! Since the Miracle Dome Whirl is perfectly balanced and rotates effortlessly on double ball bearings, even the slightest push from the smallest child is rewarded with an amazing number of spins. Whirl rotates parallel to the ground so children can safely step on or off while it's in motion. Sixteen individual "booths" with stainless steel hand-holds provide thrills for an equal number of children. Thick, reinforced fiber glass shell always looks like new and is virtually indestructible. New and improved hub assembly for a longer lasting maintenance free service.

SPECIFICATIONS

SHELL: Eight sections and one cap of reinforced, molded in color fiber glass; foot plates of galvanized floorplate.

CENTER SUPPORT: One column of 3½" O.D. extra heavy steel pipe housing two ball bearings and supported by four legs of 2⅞" O.D. structural steel pipe, 10 gauge gussets with ¾" bolts for anchoring in concrete.

FRAME: Eight diagonal bars of ¼" thick flat steel with eight lower support steel angles, 2" x 1½" x ⅜".

HANDHOLDS: 1" O.D. stainless steel tube with steel back-up plates.

GROUND SPACE: 11' dia.; height, 5'6".

SHIPPING WEIGHT: 500 lbs.

*Patent No. D-194,689

NOTE: We recommend a soft resilient surfacing material around the whirls to provide a cushion for accidental falls and maintenance free of grass mowing or filling in mud holes.

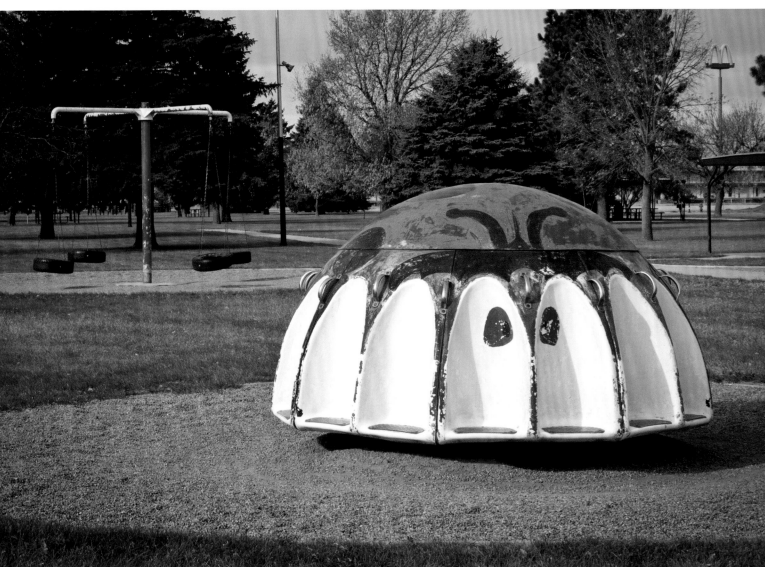

MIRACLE ALL-STEEL SEE-SAWS
Price Group 28

No more splinters, no more painting, no more seesaw problems on your playground when you install Miracle's patented* All-Steel See-Saws. These modern, attractive all-steel units outlast old-fashioned board styles by far. Much safer, too, because Miracle's All-Steel See-Saws are designed to discourage dangerous antics that are common when youngsters use ordinary seesaws. Support leg is 2-3/8" O.D. steel pipe, finished in baked enamel candy-stripe design.

Model	Units	Ground Space	Shipping Weight
602	2	6'6" by 14'8"	150 pounds
604	4	9'6" by 14'8"	275 pounds
606	6	16' by 14'8"	400 pounds
607	Seesaw only with clamps		50 pounds

*Patent No. D184,552

1975

Miracle Recreation Equipment Company

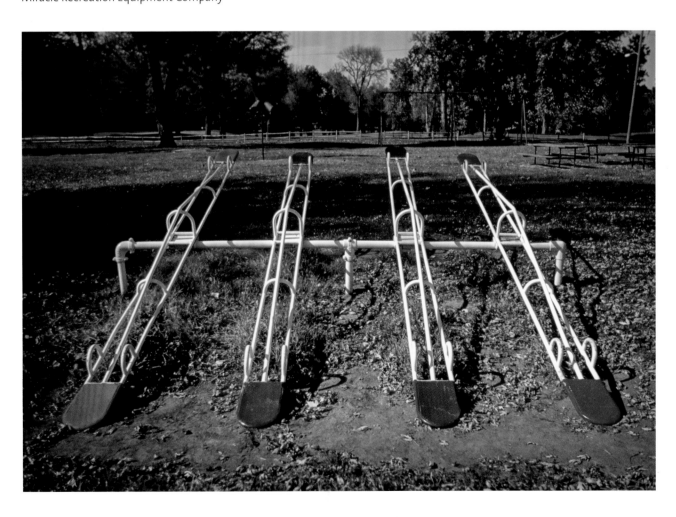

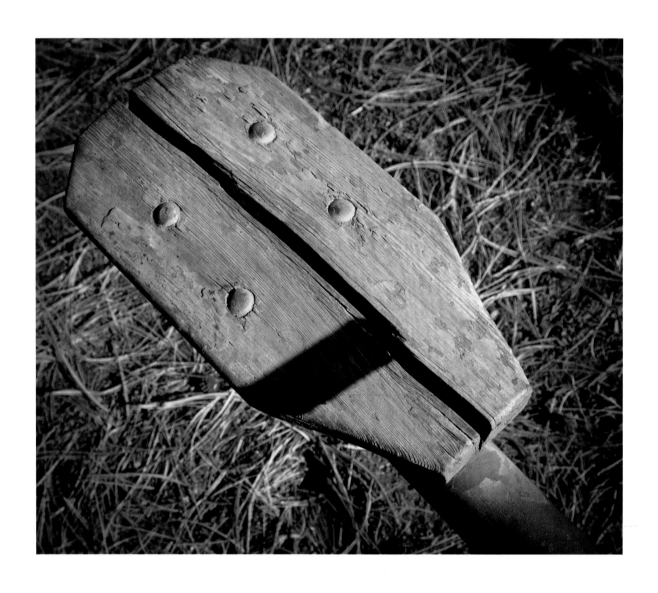

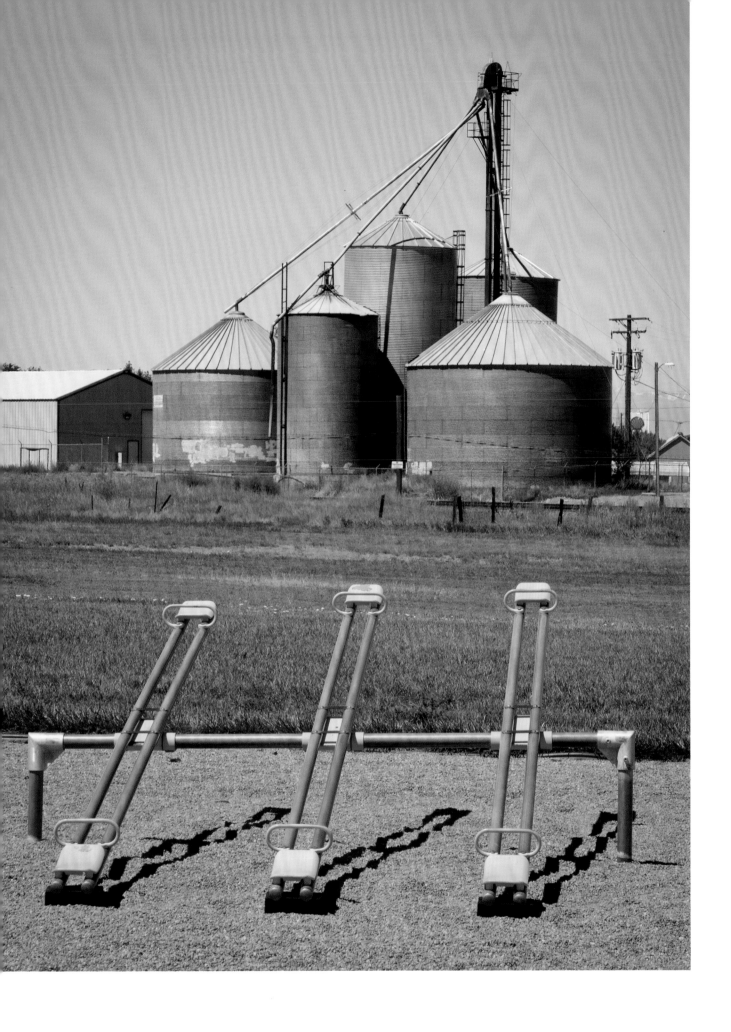

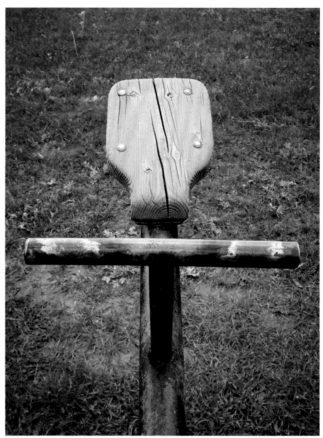

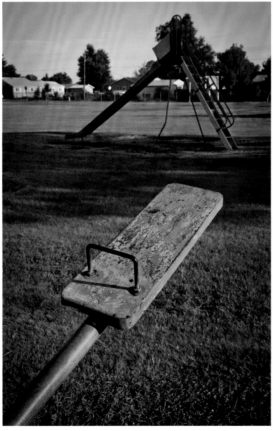

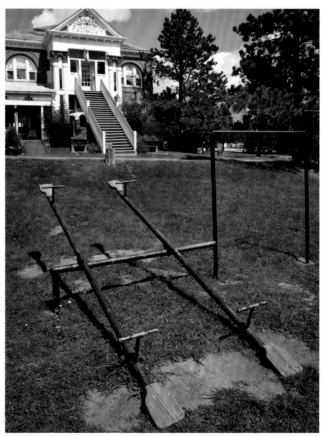

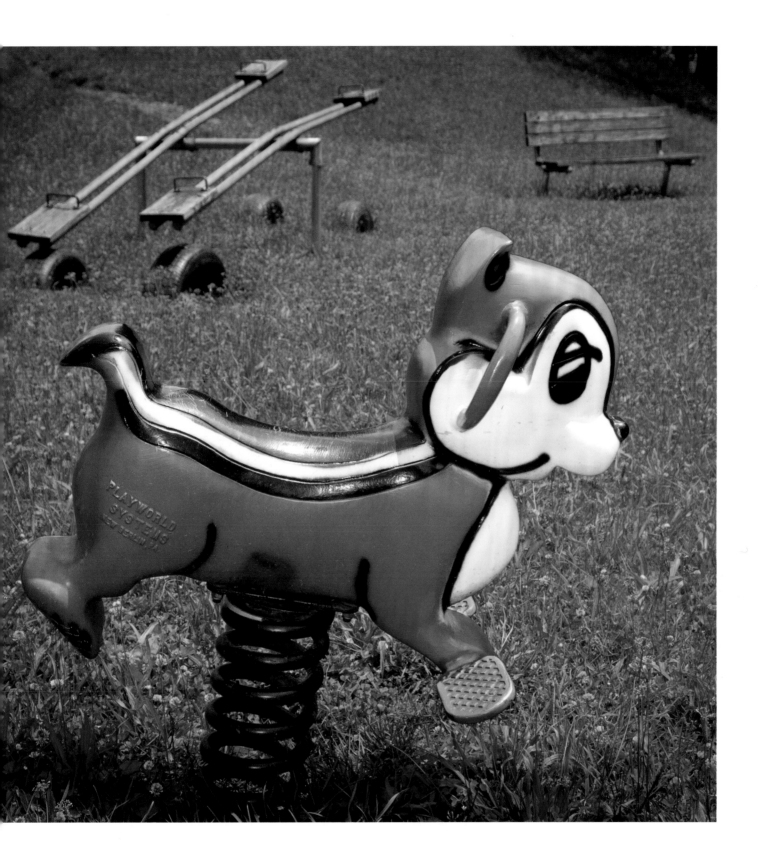

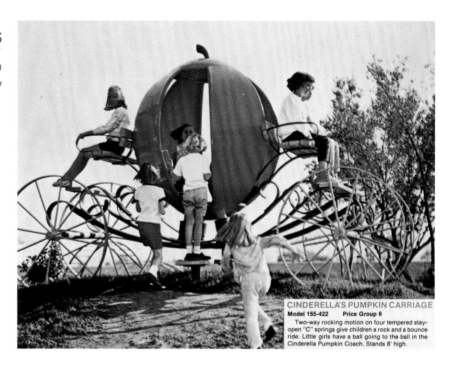

CINDERELLA'S PUMPKIN CARRIAGE
Model 155-422 Price Group 6
Two-way rocking motion on four tempered stay-open "C" springs give children a rock and a bounce ride. Little girls have a ball going to the ball in the Cinderella Pumpkin Coach. Stands 8' high.

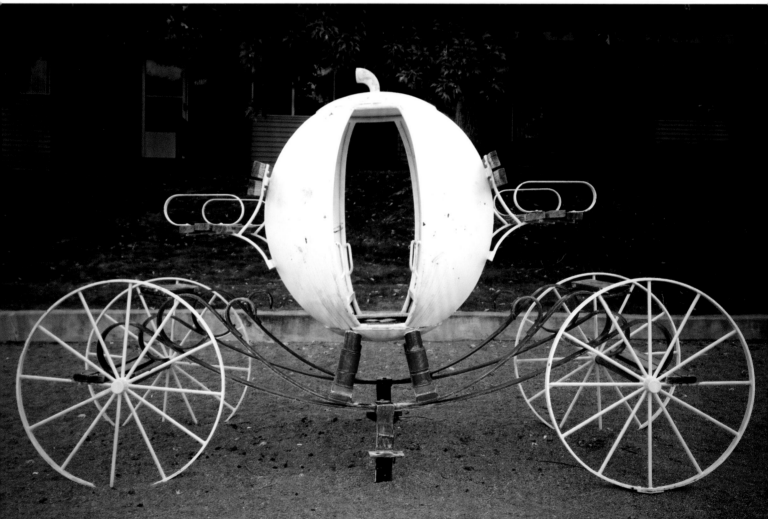

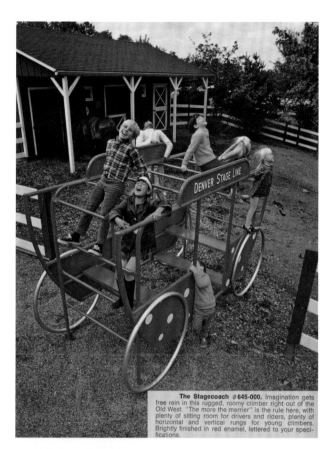

The Stagecoach #645-000. Imagination gets free rein in this rugged, roomy climber right out of the Old West. "The more the merrier" is the rule here, with plenty of sitting room for drivers and riders, plenty of horizontal and vertical rungs for young climbers. Brightly finished in red enamel, lettered to your specifications.

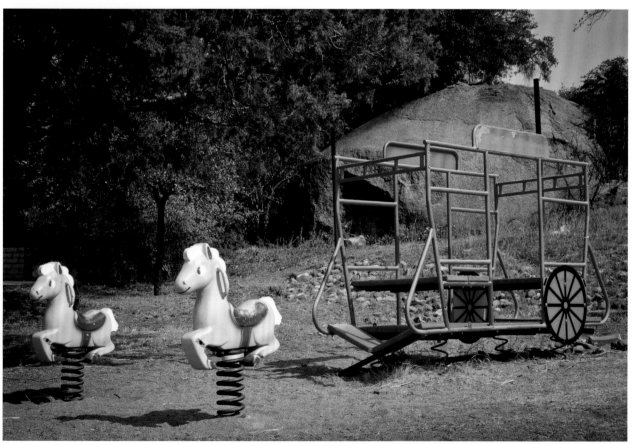

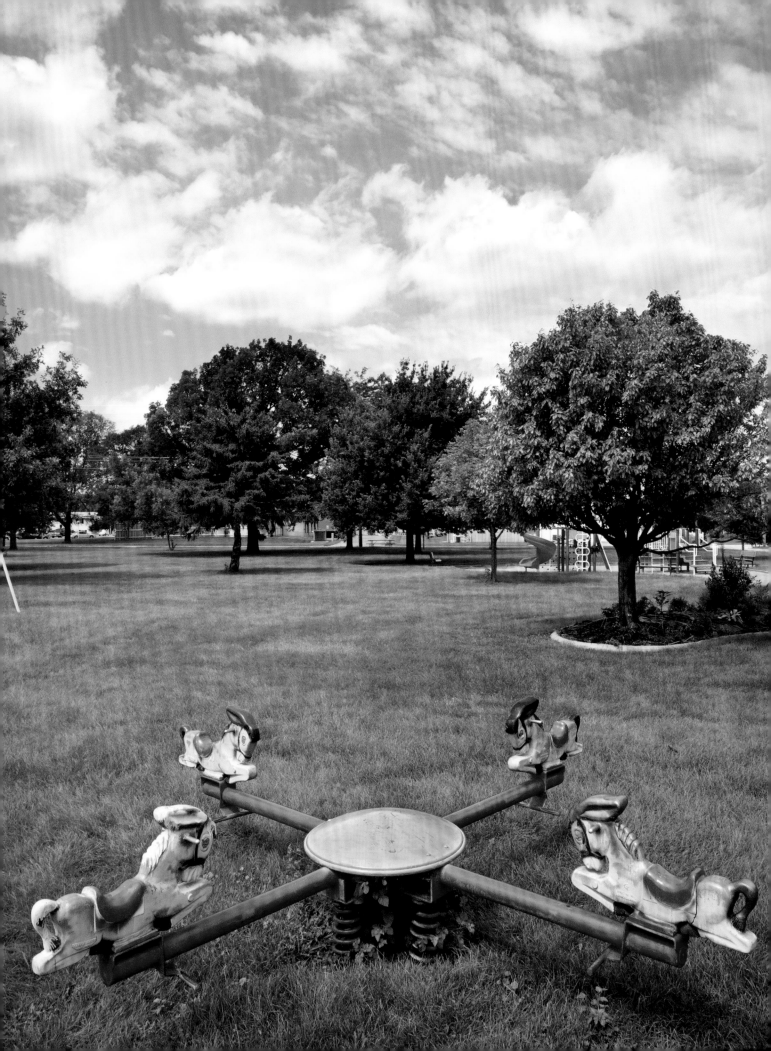

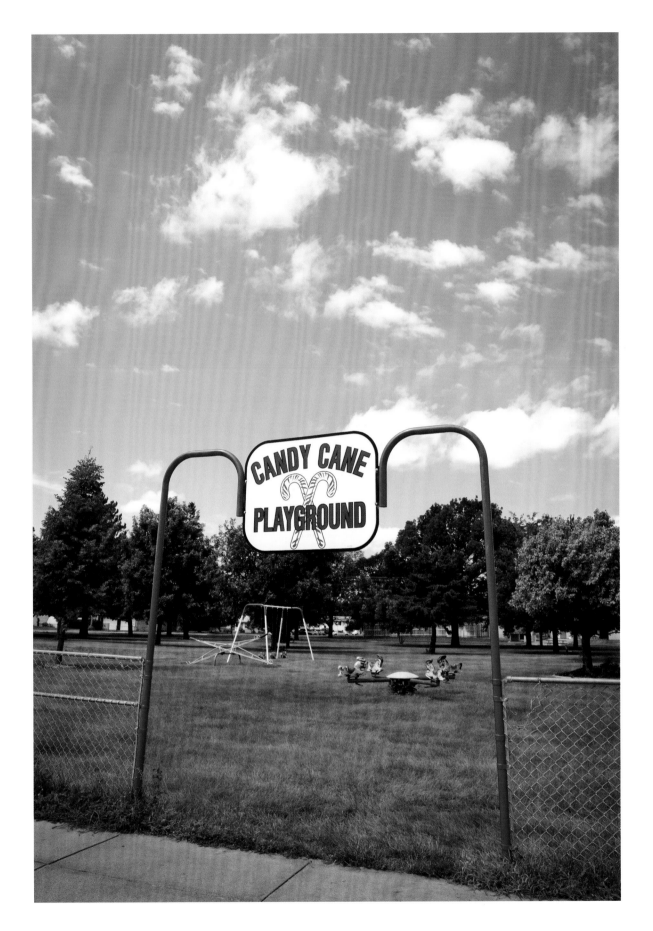

SADDLE MATES®

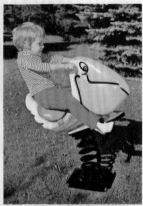

NEW Saddle Mate Cow
No. 177 wt. 74 lbs. $76.00
"Who says I'm bossy?"
U.S. Pat. No. 213,277

Saddle Mate Ram
No. 186 wt. 70 lbs. $76.00
"Out of my way!"
U.S. Pat. No. 209,604

Saddle Mate Pelican
No. 174 wt. 69 lbs. $76.00
"Fishin's my business."

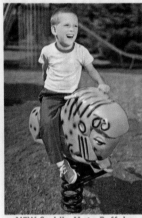

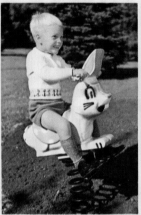

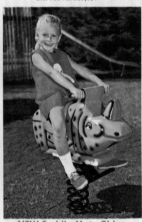

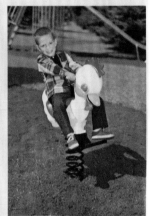

NEW Saddle Mate Buffalo
No. 183 wt. 81 lbs. $79.00
"Straight from Indian country."
U.S. Pat. No. 213,276

NEW Saddle Mate Rabbit
No. 181 wt. 78 lbs. $76.00
"Faster than lightning."
U.S. Pat. No. 213,274

NEW Saddle Mate Rhino
No. 184 wt. 81 lbs. $79.00
"For a rugged ride."
U.S. Pat. No. 213,278

Saddle Mate Chicken
No. 187 wt. 64 lbs. $76.00
"Fun on the farm."
U.S. Pat. No. 209,602

1971

Game Time, Inc.

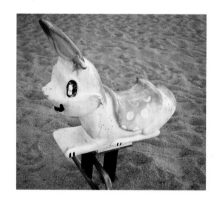

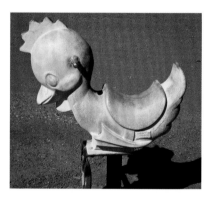

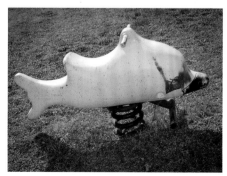

112

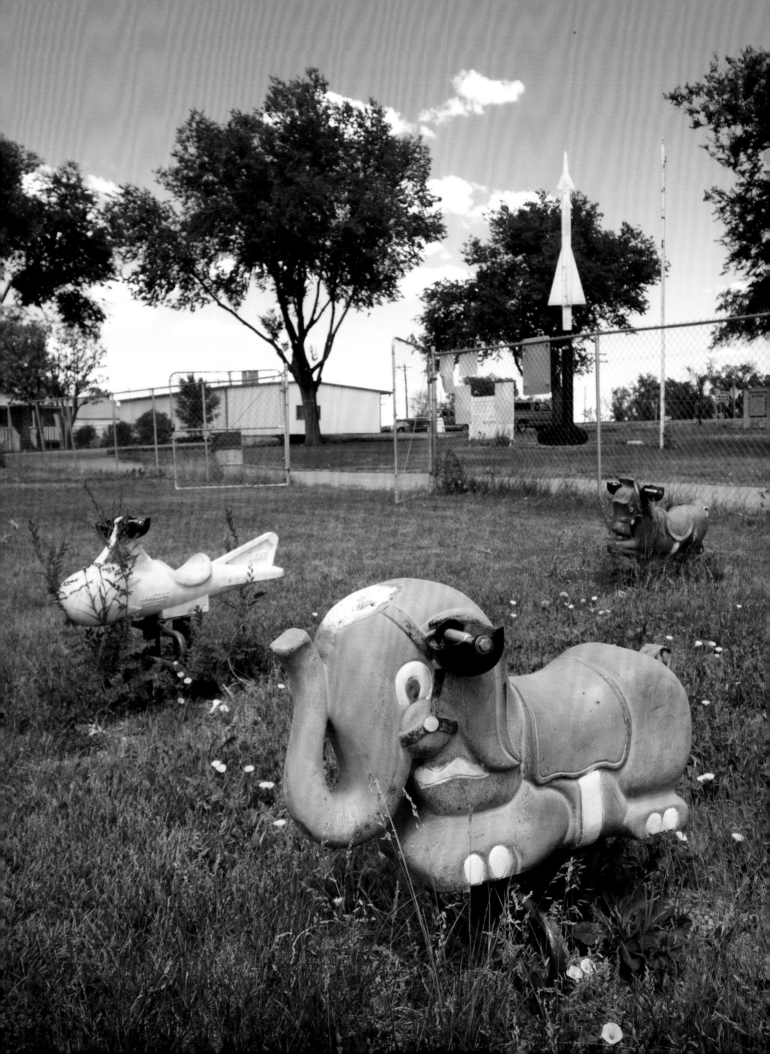

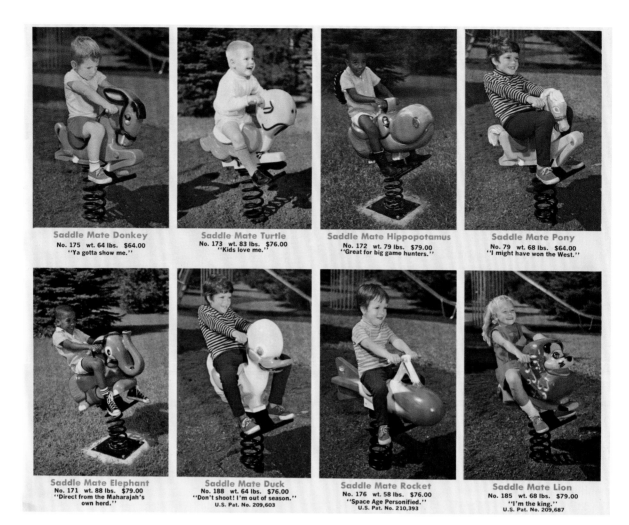

Saddle Mate Donkey
No. 175 wt. 64 lbs. $64.00
"Ya gotta show me."

Saddle Mate Turtle
No. 173 wt. 83 lbs. $76.00
"Kids love me."

Saddle Mate Hippopotamus
No. 172 wt. 79 lbs. $79.00
"Great for big game hunters."

Saddle Mate Pony
No. 79 wt. 68 lbs. $64.00
"I might have won the West."

Saddle Mate Elephant
No. 171 wt. 88 lbs. $79.00
"Direct from the Maharajah's own herd."

Saddle Mate Duck
No. 188 wt. 64 lbs. $76.00
"Don't shoot! I'm out of season."
U.S. Pat. No. 209,603

Saddle Mate Rocket
No. 176 wt. 58 lbs. $76.00
"Space Age Personified."
U.S. Pat. No. 210,393

Saddle Mate Lion
No. 185 wt. 68 lbs. $79.00
"I'm the king."
U.S. Pat. No. 209,687

1971

Game Time, Inc.

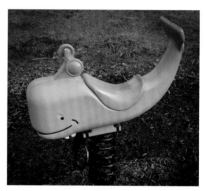

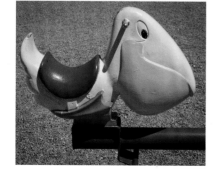

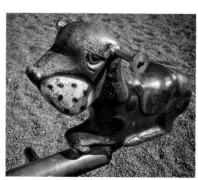

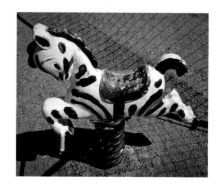

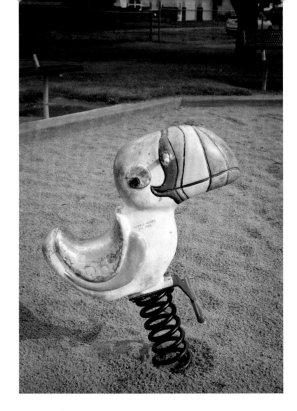

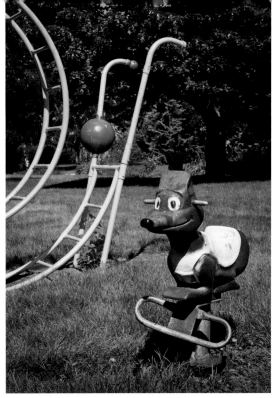

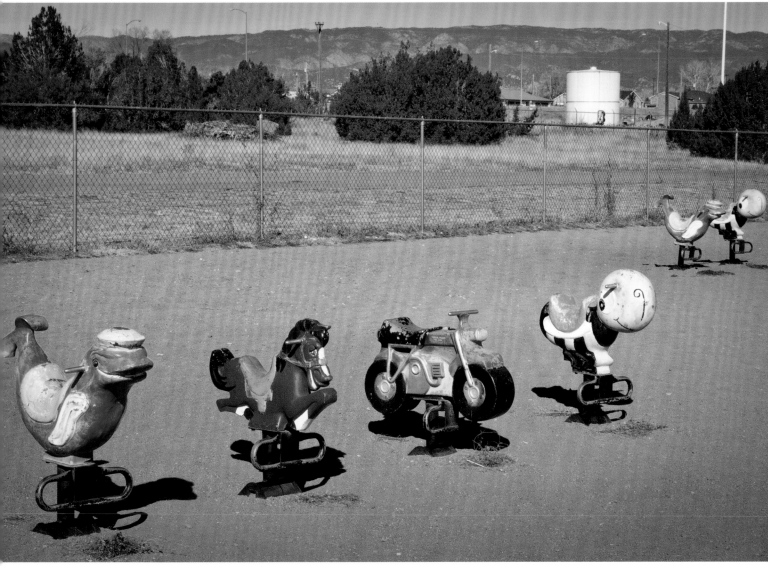

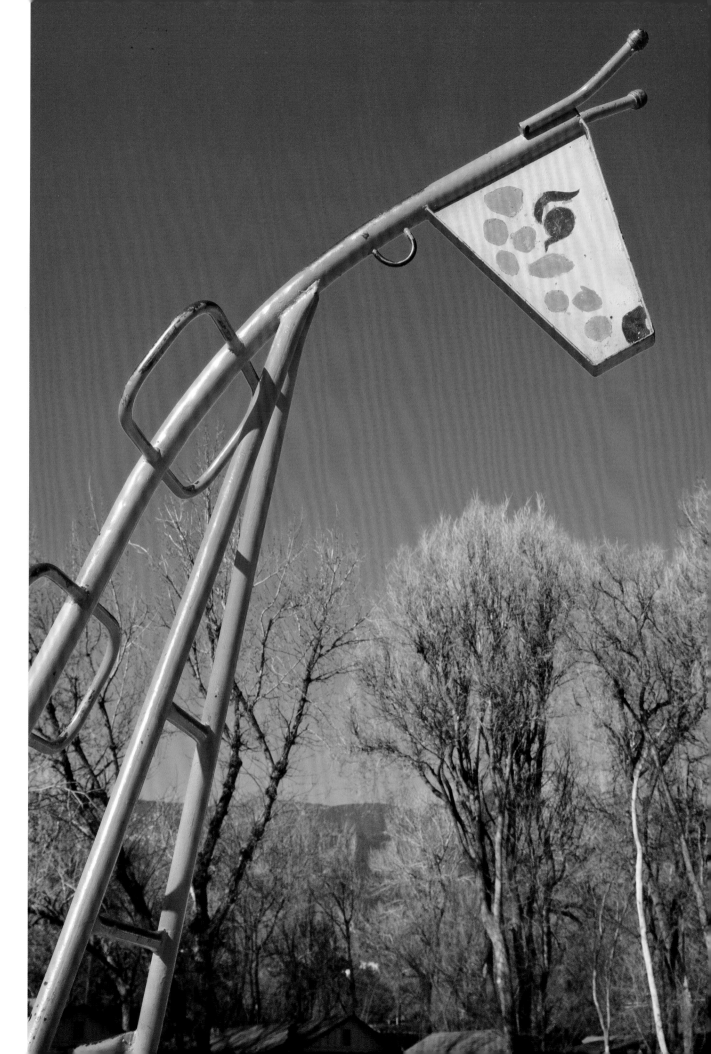

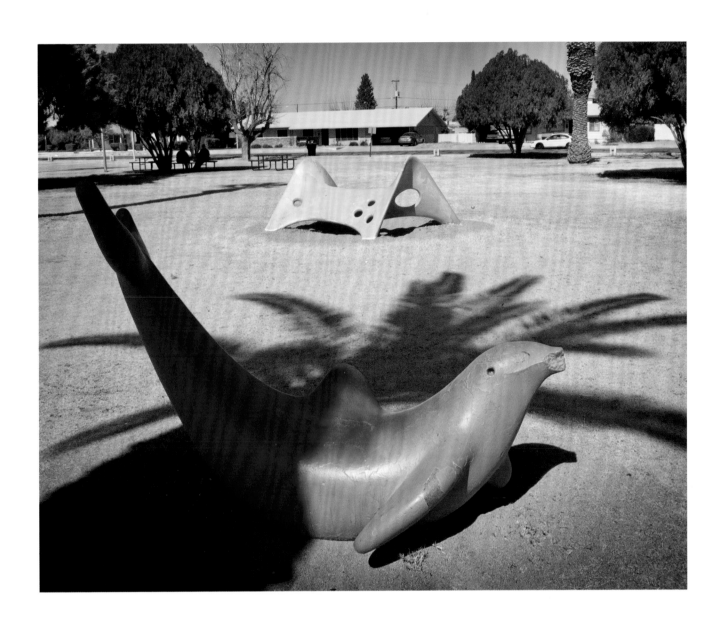

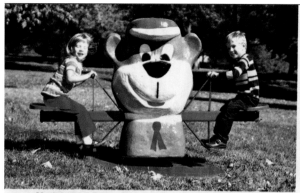

Model 608-2 Bear

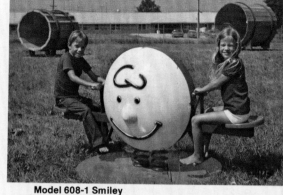

Model 608-1 Smiley

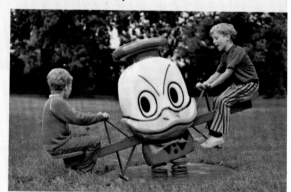

Model 608-3 Duck Design Patent No. 227,384

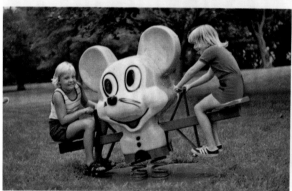

Model 608-4 Mouse Design Patent No. 228,647

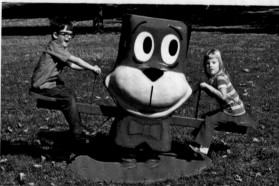

Model 608-5 Pooch

MIRACLE'S TWIN RIDERS
Model No. 608 Price Group 28

Small tots will get a charge out of these two-faced (identical on both sides) springy animals. Twin coil springs on a rugged steel platform give them a four-way rock and teeter. Sturdy steel pipe frame, aluminum seats, steel hand grips and foot rests give these patented Twin Riders more bounce per pound than any other. A youngster can solo or ride with a partner. Engineered for safety and long life. Built so durable

they carry a full-year guarantee. Priced very low; you get two in one. Animal heads or caricature permanent color molded fiber glass. Portable models optional for indoor use. Ideal, safe for pre-schoolers.

Order a set of Twin Riders today, but be sure to indicate if indoor model is desired and specify type of head by last digit of model number.

SHIPPING WEIGHT: 150 lbs.
GROUND SPACE: 8' by 12'

Patent number 3,390,879

62

1975

Miracle Recreation Equipment Company

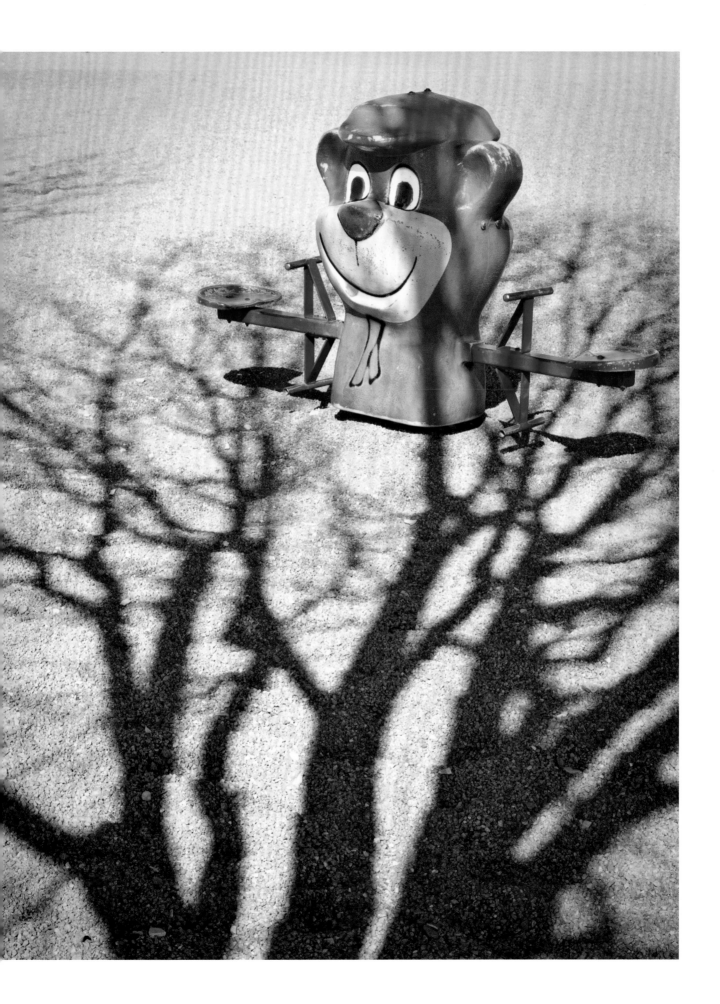

1971

Game Time, Inc.

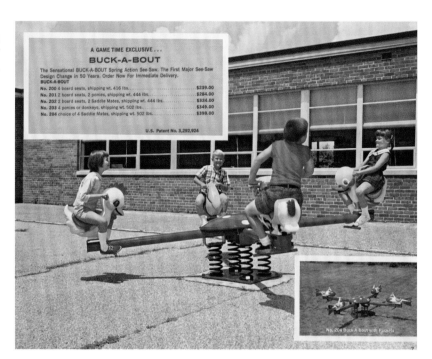

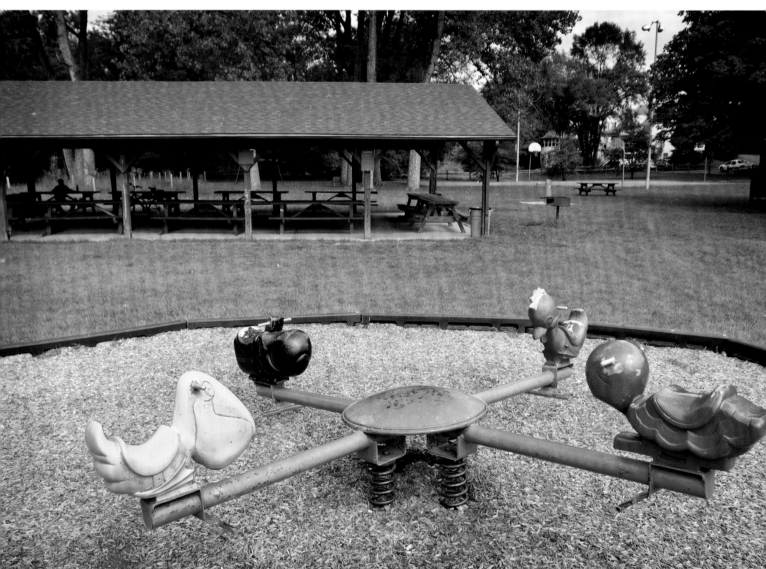

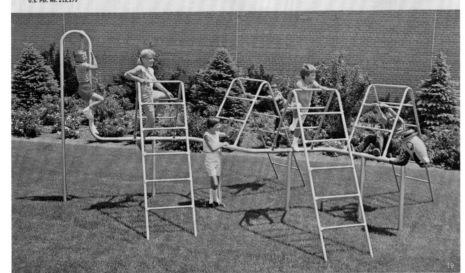

THE RELUCTANT DRAGON

. . . featuring a cast aluminum head that will last a lifetime.

"Climb on my back, and see if you can balance yourself along my 16 ft. length. Shinney up my 8 ft. high tail and slide back down again or climb any one of my 6 ft. high legs. I'm built for a lifetime of fun and "Imagineered" excitement, since Game Time has used only the finest galvanized and steel materials in my construction. I'm fun . . . I'm loveable . . . I'm exciting, and more than anything, I'd like to be on your playground."

No. 400 The Reluctant Dragon, wt. 384 lbs. .. $268.00
U.S. Pat. No. 213,275

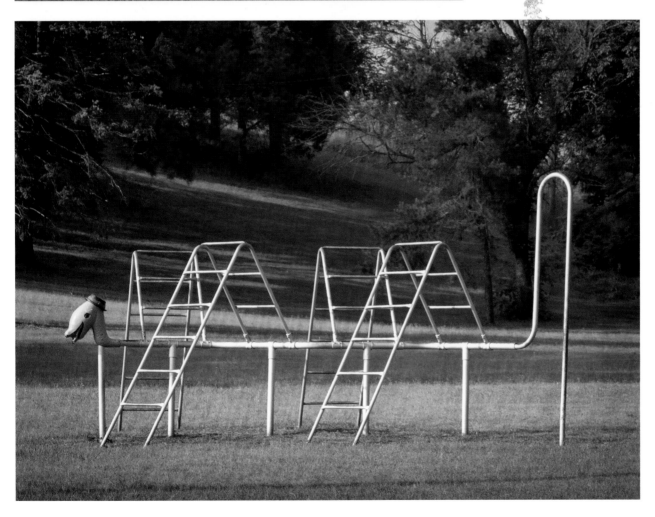

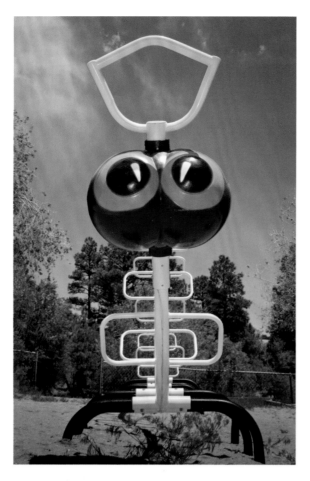

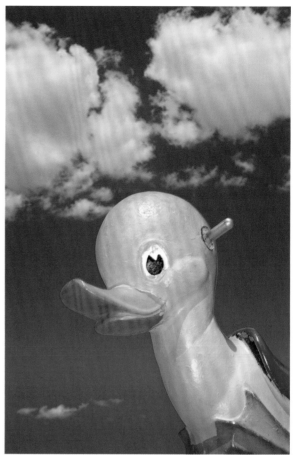

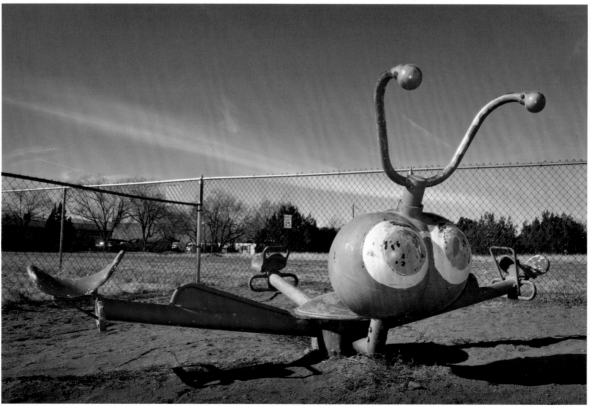

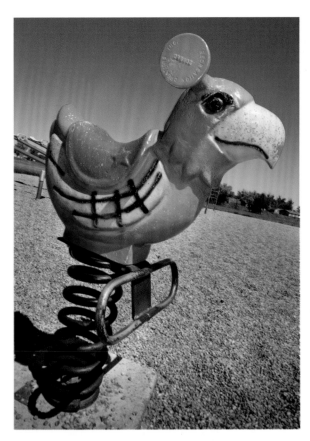

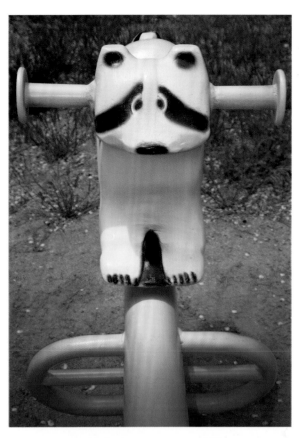

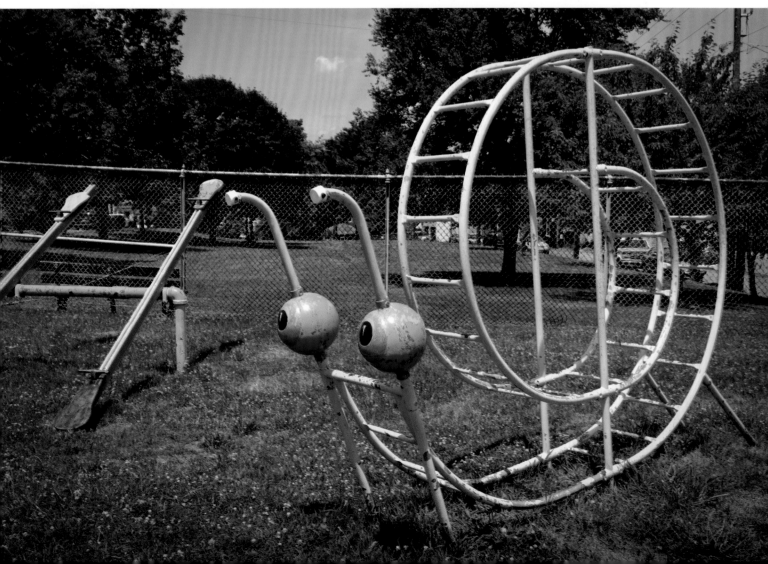

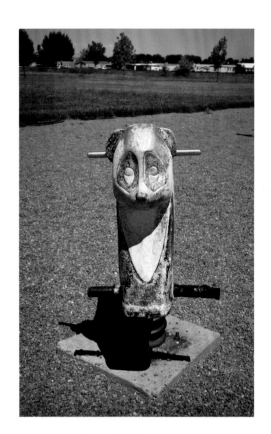

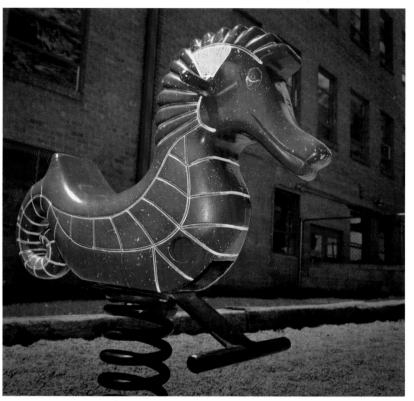

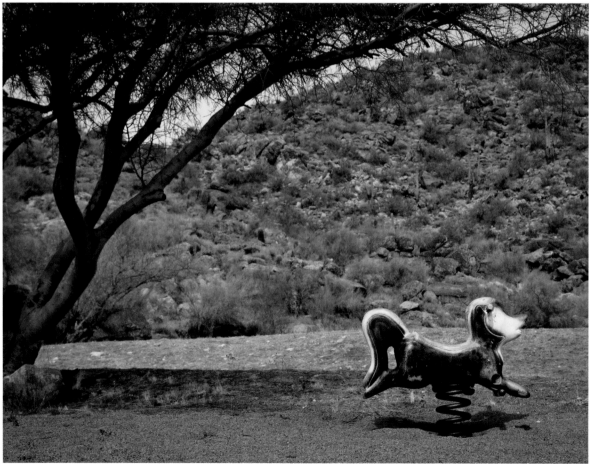

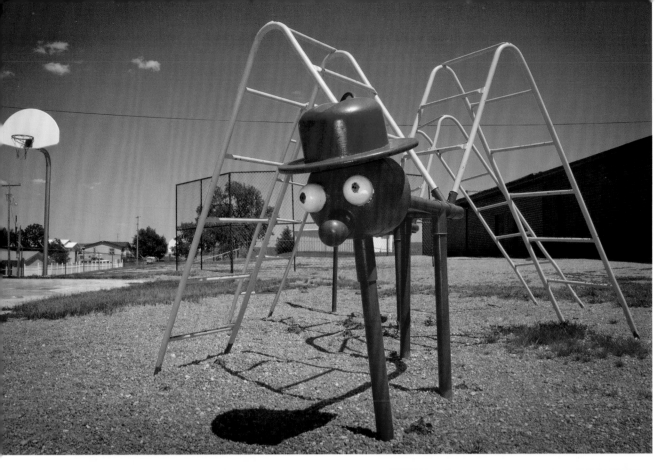

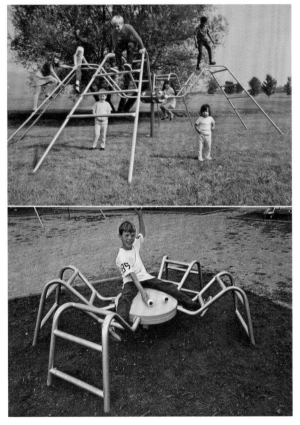

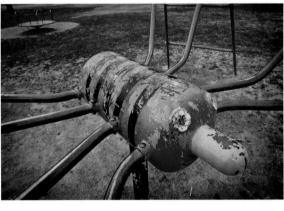

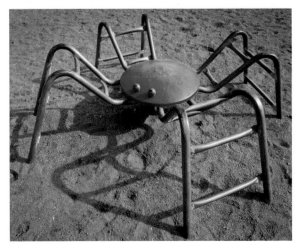

1970

Mexico Forge, Inc.

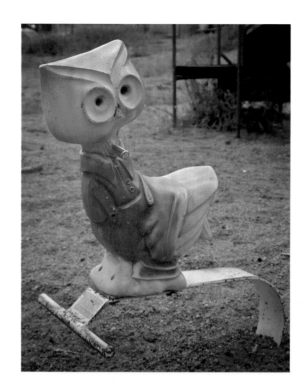

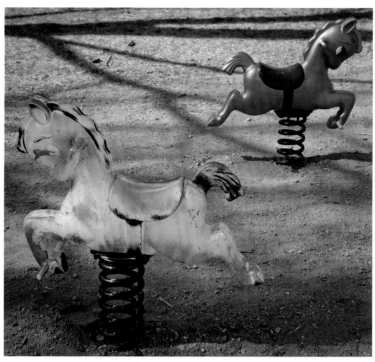

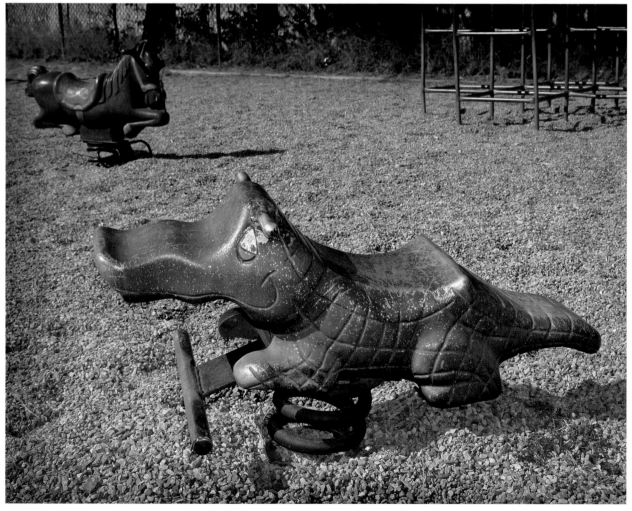

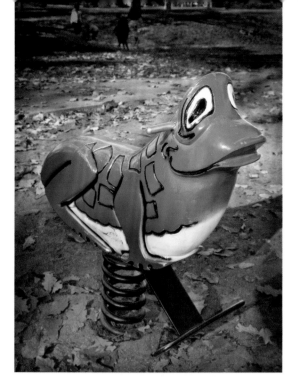

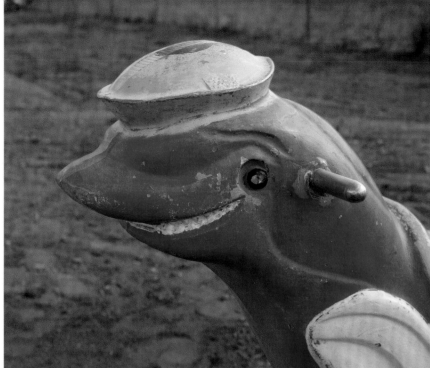

NEW

ONE PIECE ALL ALUMINUM SADDLE MATES FROM GAME TIME

No. 194 Giraffe

Game Time's "Giraffe" creates a completely new stimulus for imaginative play. This handsome creature is extremely durable and safe.

No. 194 Giraffe with spring, wt. 74 lbs.... $79.00

No. 191 Stallion

"Ladies and gentlemen. Introducing the great circus 'Stallion!' He rocks. He bounces. He rides like a dream. Step right up, kids for the most thrilling ride of your life."

No. 191 Stallion with spring, wt. 64 lbs.... $76.00

No. 193 Porpy

What a whopper! Young sailors will set sail and weigh anchor from all points on earth to get a ride on this beauty. It's a magnificently colorful Porpoise—the pride of the high seas. "Porpy" can be mounted on springs, swings, Buck-A-Bouts, or Pull-A-Rounds.

No. 193 Porpy with spring, wt. 56 lbs.... $79.00
U.S. Pat. No. 215,064

No. 180 Pig and No. 190 Wolf

"Three Pigs" and a "Big Bad Wolf" make an exciting addition to your Saddle Mate collection. All aluminum, of course, these colorful characters capture the interest and stimulate the imagination of children everywhere.

No. 190 Wolf with spring, wt. 69 lbs...... $76.00
U.S. Pat. No. 215,065
No. 180 Pig with spring, wt. 64 lbs........ $76.00
U.S. Pat. No. 215,066

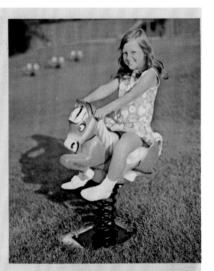

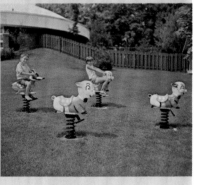

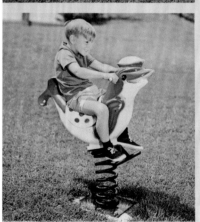

1971

Game Time, Inc.

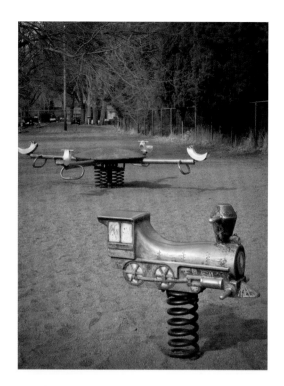
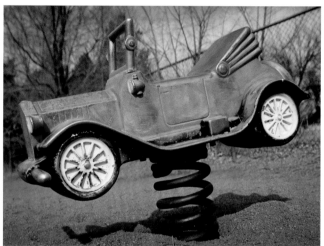
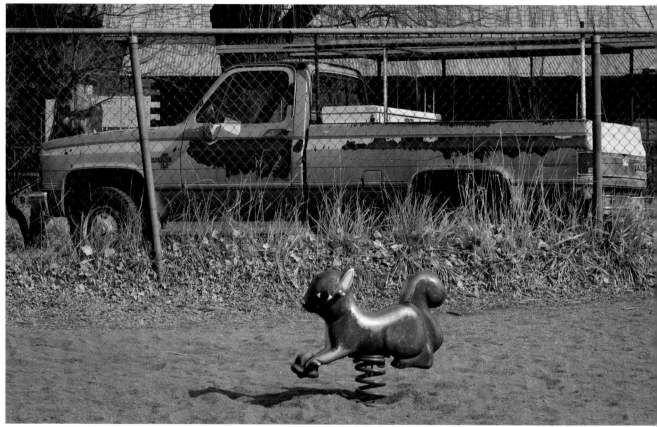

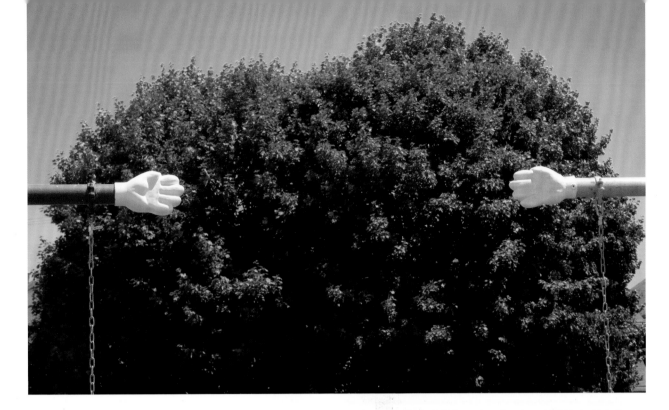

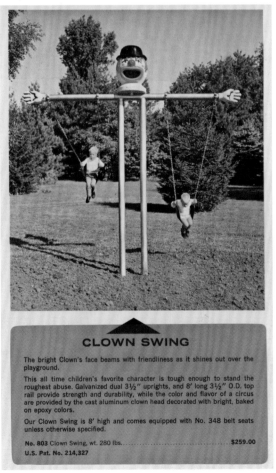

CLOWN SWING

The bright Clown's face beams with friendliness as it shines out over the playground.

This all time children's favorite character is tough enough to stand the roughest abuse. Galvanized dual 3½" uprights, and 8' long 3½" O.D. top rail provide strength and durability, while the color and flavor of a circus are provided by the cast aluminum clown head decorated with bright, baked on epoxy colors.

Our Clown Swing is 8' high and comes equipped with No. 348 belt seats unless otherwise specified.

No. 803 Clown Swing, wt. 280 lbs..$259.00
U.S. Pat. No. 214,327

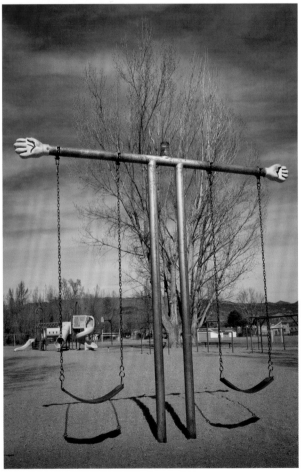

1971

Game Time, Inc.

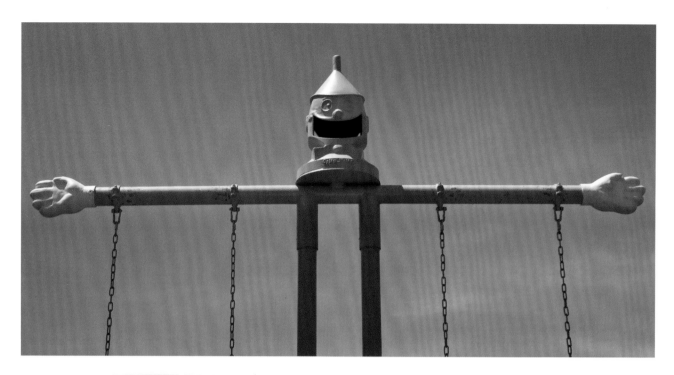

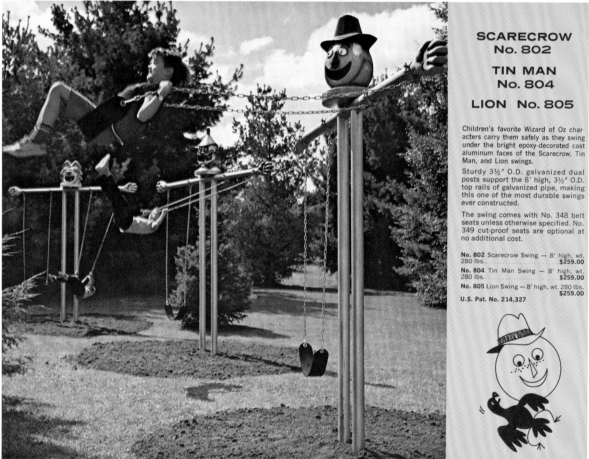

SCARECROW
No. 802

TIN MAN
No. 804

LION No. 805

Children's favorite Wizard of Oz characters carry them safely as they swing under the bright epoxy-decorated cast aluminum faces of the Scarecrow, Tin Man, and Lion swings.

Sturdy 3½" O.D. galvanized dual posts support the 8' high, 3½" O.D. top rails of galvanized pipe, making this one of the most durable swings ever constructed.

The swing comes with No. 348 belt seats unless otherwise specified. No. 349 cut-proof seats are optional at no additional cost.

No. 802 Scarecrow Swing — 8' high, wt. 280 lbs. **$259.00**
No. 804 Tin Man Swing — 8' high, wt. 280 lbs. **$259.00**
No. 805 Lion Swing — 8' high, wt. 280 lbs. **$259.00**

U.S. Pat. No. 214,327

1971

Game Time, Inc.

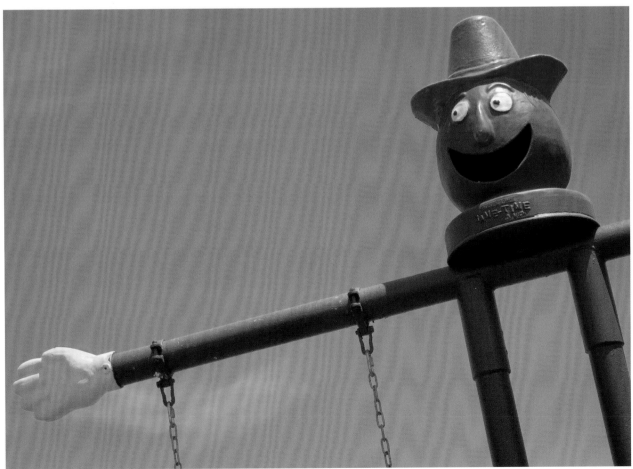

Giant Swings. Friendly giants all, these colorful new characters make clever use of rugged, heavy-duty materials to create new play equipment that's unsurpassed in attractiveness and stability. Used singly, in groups or in combination with other items to create a theme area, these Giant Swings make practical—and colorful—additions to any playground.

Materials. Head: 11 gauge steel cylinder. Arms: 2⅜" O.D. steel pipe. Body: 12 gauge hot-rolled steel plate and 3½" O.D. steel pipe long enough for 2' to enter concrete.

Size: 9' wide, 10' 4" high.

(top, left to right) Indian Giant Swing #854-500. Weight: 365 lbs. Shipping Space Required: 49 cu. ft. .Price: **$220.00**
Fireman Giant Swing #851-500. Weight: 360 lbs. Shipping Space Required: 60 cu. ft. Price: **$220.00**
Coolie Giant Swing #850-500. Weight: 362 lbs. Shipping Space Required: 60 cu. ft. Price: **$220.00**

(bottom, left to right) Cowboy Giant Swing #855-500. Weight: 354 lbs. Shipping Space Required: 60 cu. ft. .Price: **$220.00**
Astronaut Giant Swing #852-500. Weight: 342 lbs. Shipping Space Required: 42 cu. ft. Price: **$220.00**
Toy Soldier Giant Swing #853-500. Weight: 347 lbs. Shipping Space Required: 49 cu. ft.
. .Price: **$220.00**
(Not shown) Clown Giant Swing #856-500. Weight: 365 lbs. Shipping Space Required: 49 cu. ft.
Price: **$220.00**

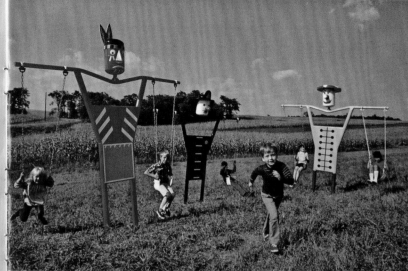

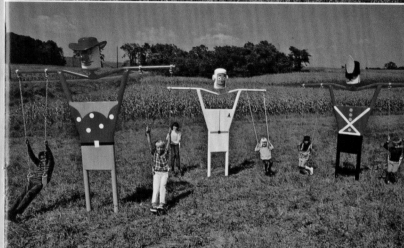

1970

Mexico Forge, Inc.

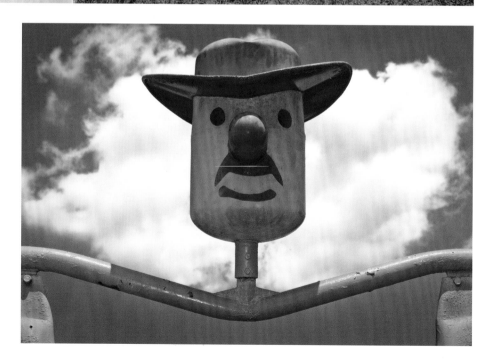

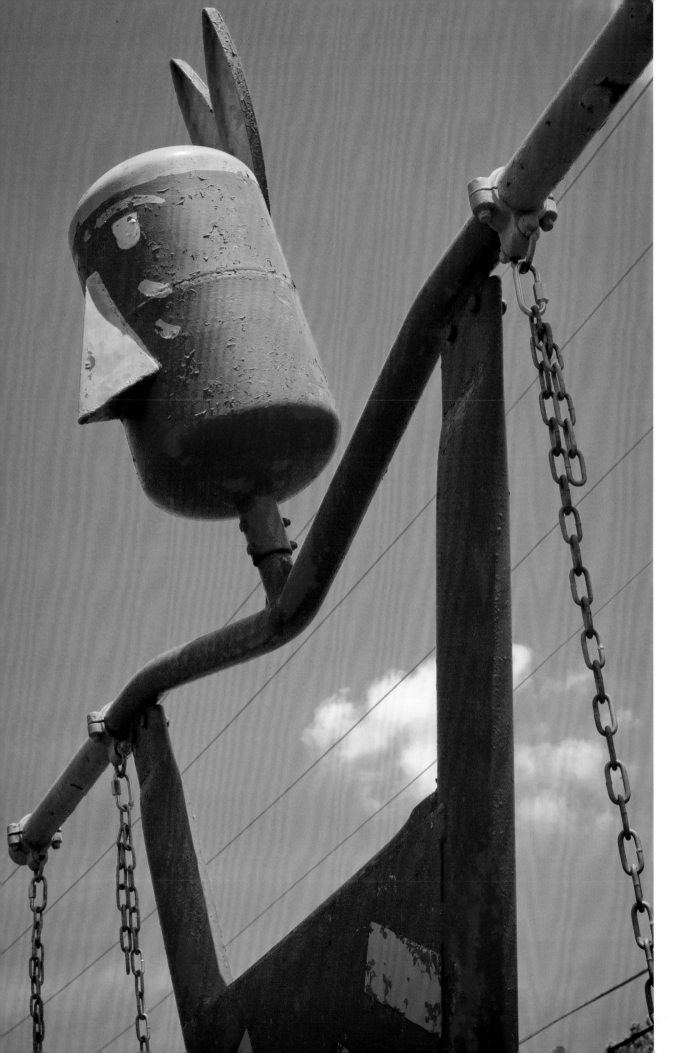

1971

Game Time, Inc.

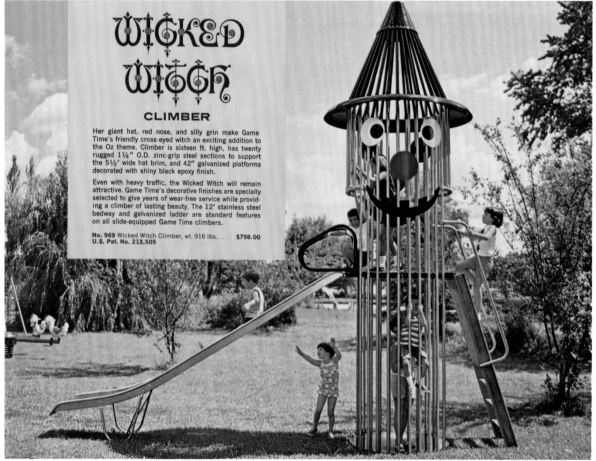

1971

Game Time, Inc.

134

Postcard captioned *Part of Santa's Playground, Santa's Village, US. Route 2, Jefferson, N.H. Children frolic on "Gargantua." A very popular part of Santa's playground.*

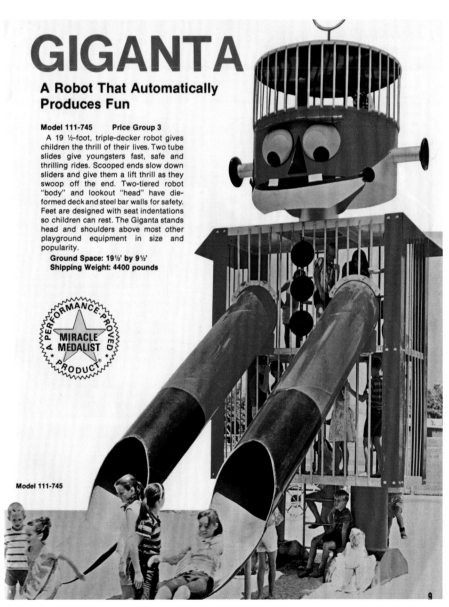

GIGANTA

A Robot That Automatically Produces Fun

Model 111-745 Price Group 3

A 19 ½-foot, triple-decker robot gives children the thrill of their lives. Two tube slides give youngsters fast, safe and thrilling rides. Scooped ends slow down sliders and give them a lift thrill as they swoop off the end. Two-tiered robot "body" and lookout "head" have die-formed deck and steel bar walls for safety. Feet are designed with seat indentations so children can rest. The Giganta stands head and shoulders above most other playground equipment in size and popularity.

Ground Space: 19½' by 9½'
Shipping Weight: 4400 pounds

A PERFORMANCE-PROVED PRODUCT
MIRACLE MEDALIST

Model 111-745

1975

Miracle Recreation
Equipment Company

9

135

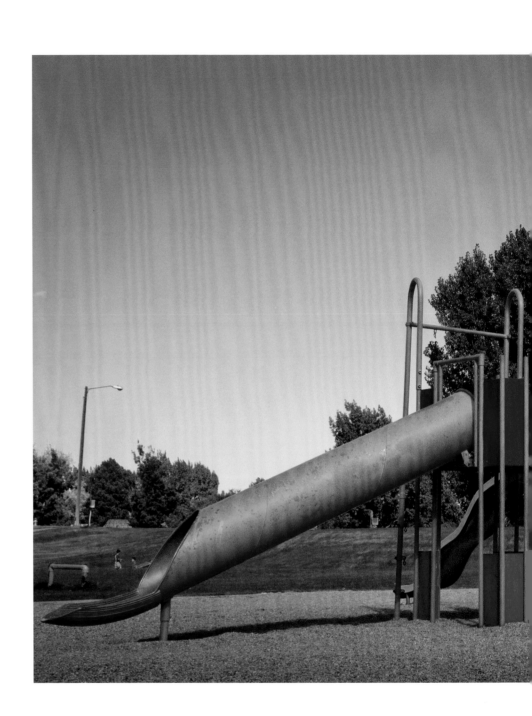

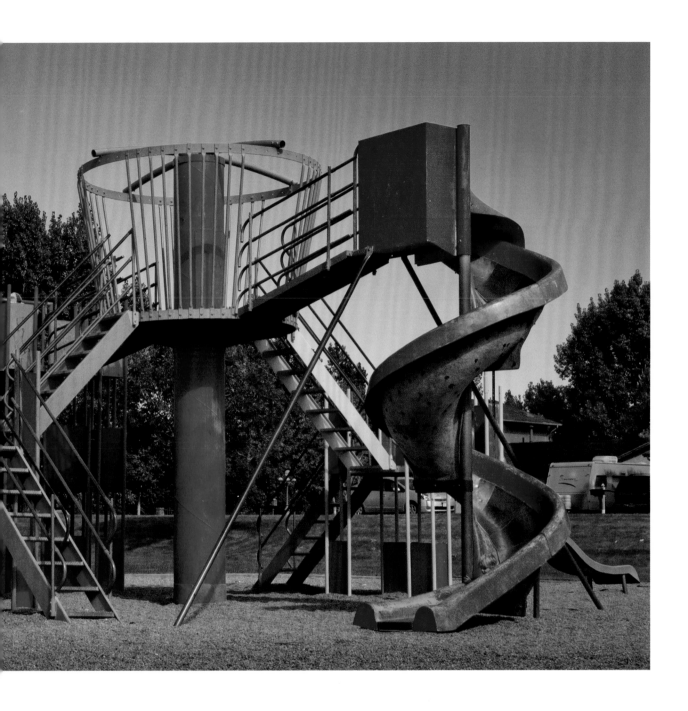

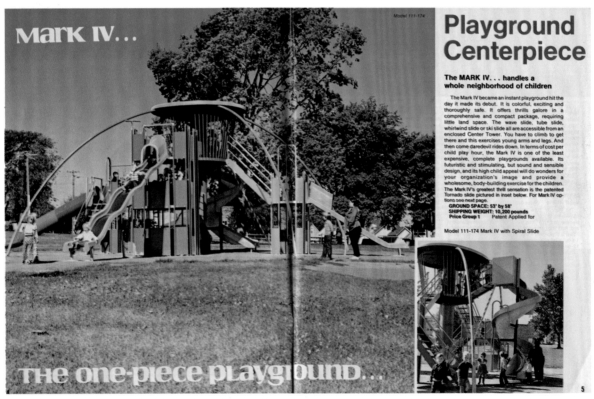

The text within image 2 (advertisement) includes:

Mark IV...

Model 111-174

Playground Centerpiece

The MARK IV . . . handles a whole neighborhood of children

The Mark IV became an instant playground hit the day it made its debut. It is colorful, exciting and thoroughly safe. It offers thrills galore in a comprehensive and compact package, requiring little land space. The wave slide, tube slide, whirlwind slide or ski slide all are accessible from an enclosed Center Tower. You have to climb to get there and this exercises young arms and legs. And then come daredevil rides down. In terms of cost per child play hour, the Mark IV is one of the least expensive, complete playgrounds available. Its futuristic and stimulating, but sound and sensible design, and its high child appeal will do wonders for your organization's image and provide a wholesome, body-building exercise for the children. The Mark IV's greatest thrill sensation is the patented Tornado slide pictured in inset below. For Mark IV options see next page.

GROUND SPACE: 53' by 58'
SHIPPING WEIGHT: 10,200 pounds
Price Group 1 Patent Applied for

Model 111-174 Mark IV with Spiral Slide

THE one-piece playground...

1975

Miracle Recreation Equipment Company

138

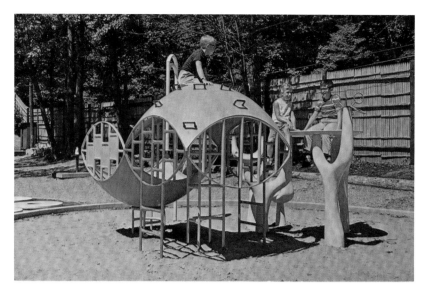

1961

Postcard captioned
*Space age playground awaits
children visiting Sterling Forest
Gardens — the family outdoor
entertainment attraction on N.Y.S.
Route 210 near Tuxedo, N.Y.*

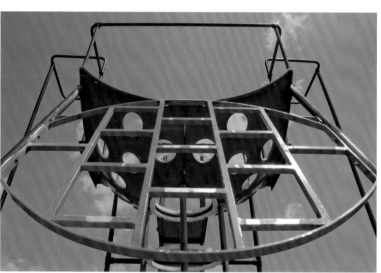

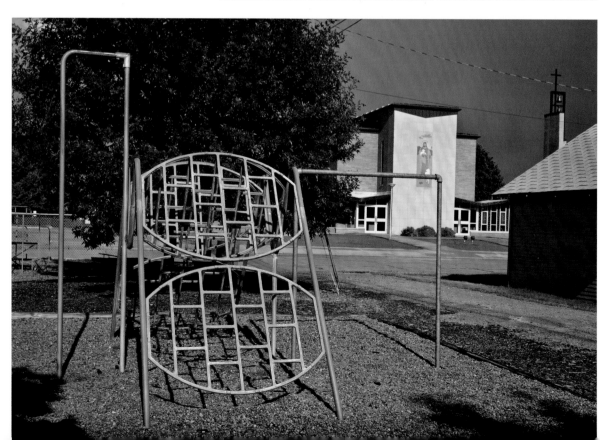

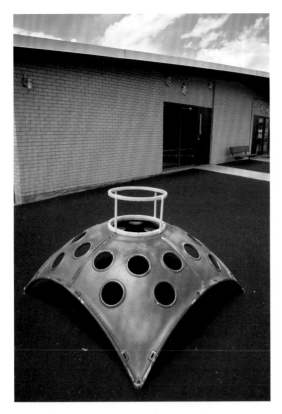

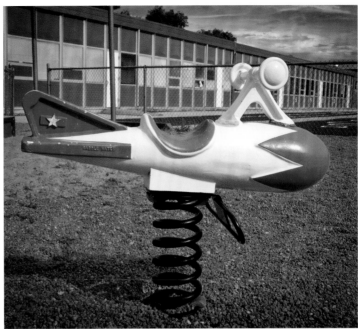

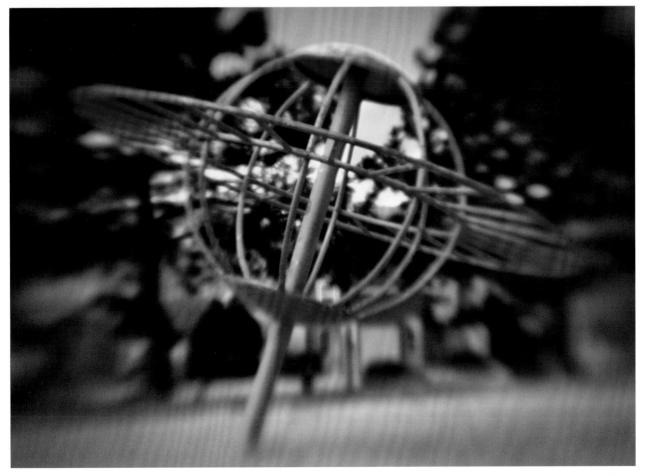

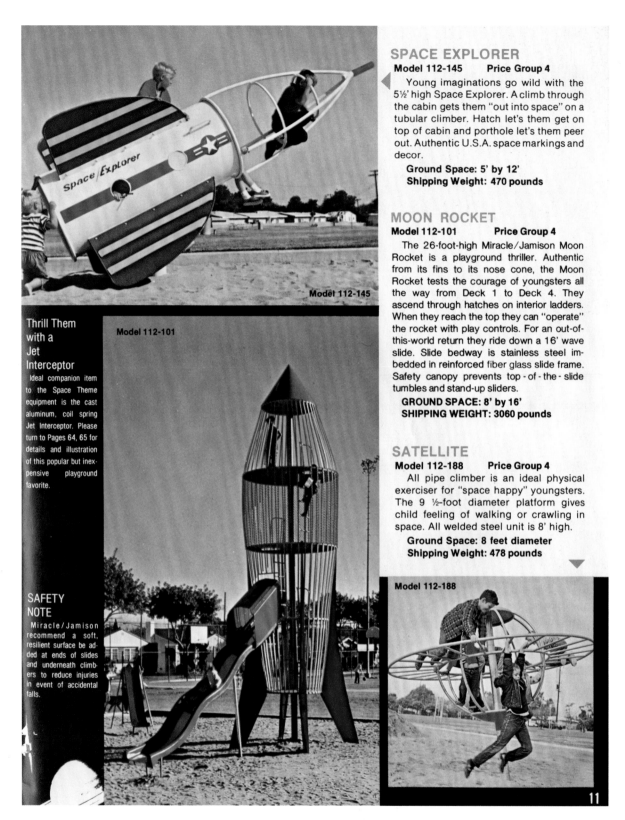

SPACE EXPLORER

Model 112-145 Price Group 4

Young imaginations go wild with the 5½' high Space Explorer. A climb through the cabin gets them "out into space" on a tubular climber. Hatch let's them get on top of cabin and porthole let's them peer out. Authentic U.S.A. space markings and decor.

Ground Space: 5' by 12'
Shipping Weight: 470 pounds

MOON ROCKET

Model 112-101 Price Group 4

The 26-foot-high Miracle/Jamison Moon Rocket is a playground thriller. Authentic from its fins to its nose cone, the Moon Rocket tests the courage of youngsters all the way from Deck 1 to Deck 4. They ascend through hatches on interior ladders. When they reach the top they can "operate" the rocket with play controls. For an out-of-this-world return they ride down a 16' wave slide. Slide bedway is stainless steel imbedded in reinforced fiber glass slide frame. Safety canopy prevents top-of-the-slide tumbles and stand-up sliders.

GROUND SPACE: 8' by 16'
SHIPPING WEIGHT: 3060 pounds

SATELLITE

Model 112-188 Price Group 4

All pipe climber is an ideal physical exerciser for "space happy" youngsters. The 9 ½-foot diameter platform gives child feeling of walking or crawling in space. All welded steel unit is 8' high.

Ground Space: 8 feet diameter
Shipping Weight: 478 pounds

Model 112-145

Thrill Them with a Jet Interceptor

Ideal companion item to the Space Theme equipment is the cast aluminum, coil spring Jet Interceptor. Please turn to Pages 64, 65 for details and illustration of this popular but inexpensive playground favorite.

Model 112-101

SAFETY NOTE

Miracle/Jamison recommend a soft, resilient surface be added at ends of slides and underneath climbers to reduce injuries in event of accidental falls.

Model 112-188

11

1975

Miracle Recreation Equipment Company

142

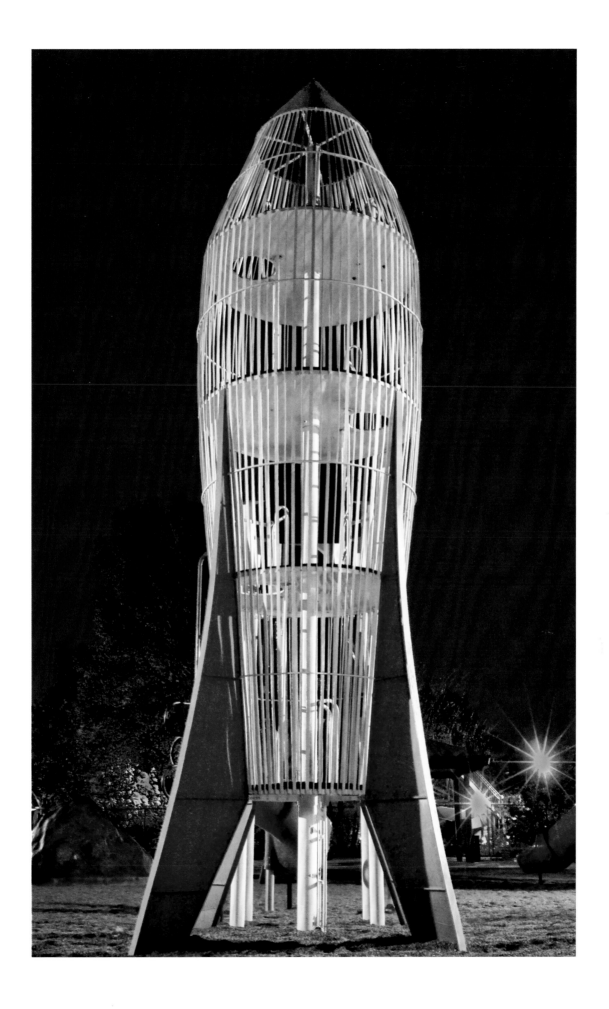

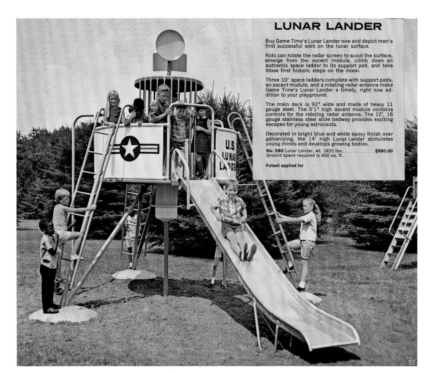

LUNAR LANDER

Buy Game Time's Lunar Lander now and depict man's first successful walk on the lunar surface.

Kids can rotate the radar screen to scout the surface, emerge from the ascent module, climb down an authentic space ladder to its support pod, and take those first historic steps on the moon.

Three 10' space ladders complete with support pods, an ascent module, and a rotating radar antenna make Game Time's Lunar Lander a timely, right now addition to your playground.

The main deck is 92" wide and made of heavy 11 gauge steel. The 5'1" high ascent module contains controls for the rotating radar antenna. The 12', 16 gauge stainless steel slide bedway provides exciting escapes for young astronauts.

Decorated in bright blue and white epoxy finish over galvanizing, the 14' high Lunar Lander stimulates young minds and develops growing bodies.

No. 580 Lunar Lander, wt. 1450 lbs.................**$980.00**
Ground space required is 400 sq. ft.

Patent applied for

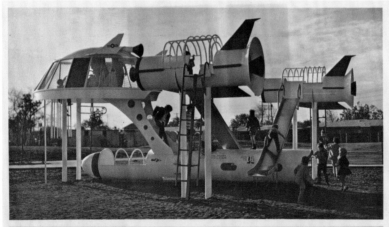

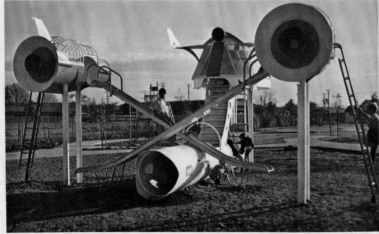

SPECTACULAR NEW SPACE CRUISER

(PICTURED ON COVER)

Young astronauts everywhere are enthusiastic about Game Time's newest spectacular—the Space Cruiser! Standing a full 12' high, the Space Cruiser measures 30' x 24' and is a major attraction wherever it lands.

All parts of the Space Cruiser are patterned after actual or planned vehicles of the U.S. space program. The main cockpit, reached by climbing a specially designed ladder, contains two "gravity chairs" and an armrest console. Other features of the Space Cruiser include sliding poles, caged hatches, play telescopes, slides, and ground level climbing and crawling spots for children of all ages.

The Space Cruiser is "imagineered" to stimulate active young imaginations at the same time as it encourages healthy body-building fun.

No. 1111 Space Cruiser, wt. 11,400 lbs.........**$11,800.00**

IF IT'S GAME TIME . . . IT'S GREAT

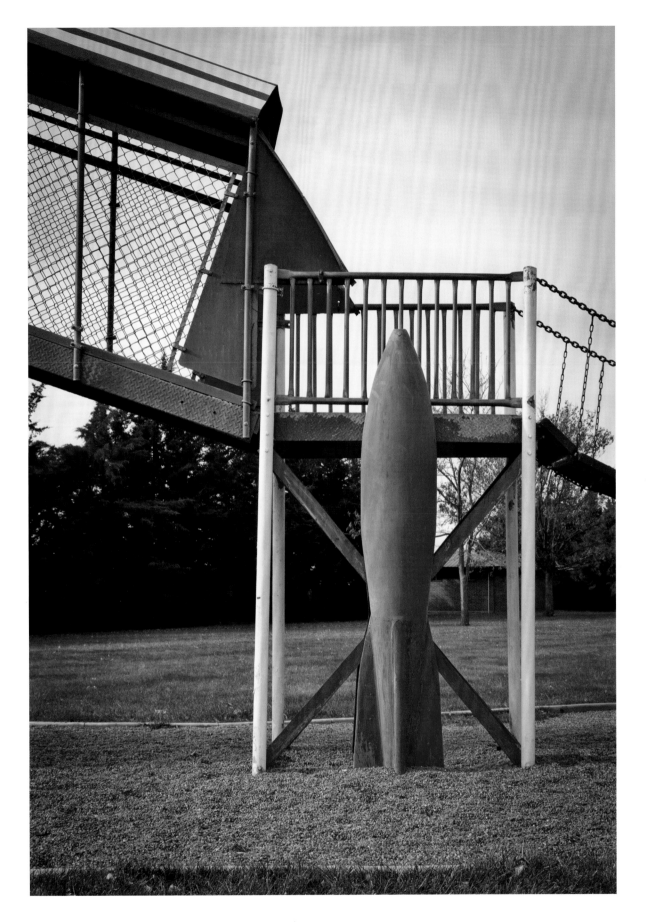

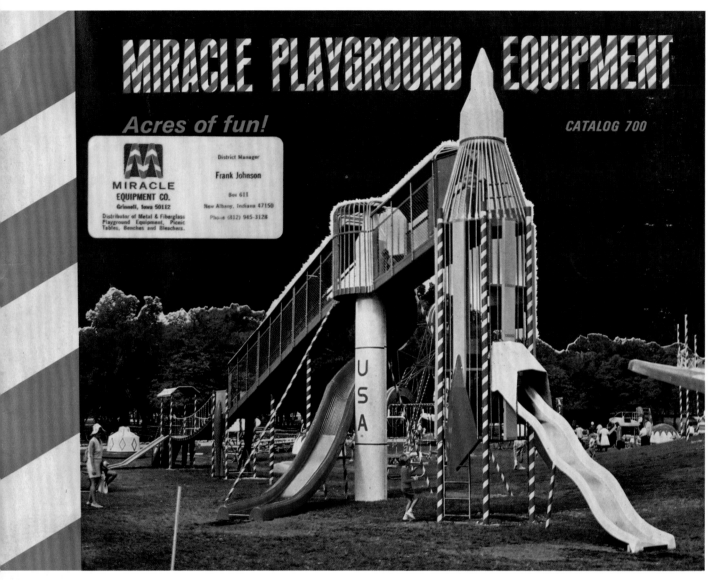

MIRACLE PLAYGROUND EQUIPMENT
Acres of fun!
CATALOG 700

MIRACLE
EQUIPMENT CO.
Grinnell, Iowa 50112
Distributor of Metal & Fiberglass
Playground Equipment, Picnic
Tables, Benches and Bleachers.

District Manager
Frank Johnson
Box 611
New Albany, Indiana 47150
Phone (812) 945-3128

USA

Circa 1968

Miracle Equipment Company

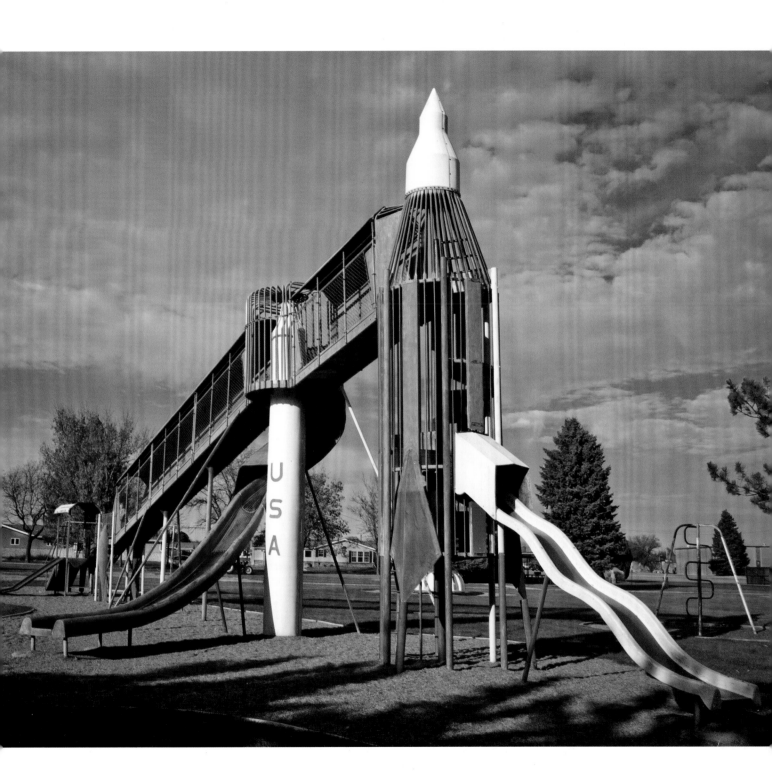

Afterword

Although playgrounds have been around for more than a century, play is needed now more than ever. As neighborhoods have become increasingly isolated and dependent on cars, as schools have become increasingly focused on teaching to the test, and as families have become increasingly reliant on large and small screens for entertainment, our children need a safe, communal space within walking distance where they can move their bodies, exercise their imaginations, and make friends—in short, a space where they can play.

That's why the national nonprofit I founded, KaBOOM!, has a vision of a playground within walking distance of every child. As a nation, we need to restore a culture of active play in our homes, our schools, and our neighborhoods. If we do not act now, we will fail an entire generation of children, depriving them of the childhood they deserve.

Erasing the play deficit starts at home. I've witnessed—and fought against—the steady rise in the number of hours the average American child spends in front of a screen and the parallel decline in active play. Parents and children are becoming more sedentary, contributing to rising obesity rates and a slew of associated health problems, such as cardiovascular disease and diabetes. One in three children is now overweight or obese, and the current generation of kids is on track to becoming the first with a lifespan shorter than that of their parents.

But active play isn't just about active bodies—it's also about active minds. I often say that play is the best natural resource in a creative economy. I'm not the only one who thinks so. Harvard education expert Tony Wagner cites a wide variety of play as being key to fostering creativity in children in his book *Creating Innovators*. And, in a recent IBM study of fifteen hundred CEOs, creativity was deemed the most important leadership quality in today's complex social and economic environment. Numerous studies demonstrate the correlation between play and academic achievement. Increased physical activity during the school day can help children pay attention, improve classroom behavior, and boost achievement test scores. Meanwhile, the decline of play is closely linked to ADHD, behavioral problems, and stunted social, cognitive, and creative development. It's our job to give kids access to environments that will

March 2013

Volunteers building a
KaBOOM! playground at
a domestic violence shelter
in Atlanta, Georgia (Photos
courtesy KaBOOM!)

inspire and fuel their imaginations and set them up for educational suc-cess—and playgrounds provide that outlet.

The problem is that playgrounds are too scarce a resource, particularly for the 16 million American kids living in poverty. In fact, only one in five children in the United States lives within walking distance of a park or playground. According to the Trust for Public Land, U.S. cities have on average just 8.1 acres of dedicated park space. Yet our parks and play-grounds all too often slip off the radar of those designing our neighbor-hoods and designating government funds. Planners and policy-makers routinely push play down the priority list, but a recent study by the Se-attle Children's Research Institute found that children living in walkable neighborhoods with access to both healthful food and parks with play equipment are 59 percent more likely to be a healthy weight.

Play is how kids develop socially and emotionally, and it is particularly vital for vulnerable children living in less stable environments. Follow-ing hurricanes Katrina and Rita, which devastated America's Gulf Coast, KaBOOM! built nearly 150 playgrounds in some of the hardest-hit com-munities. Play is essential for maintaining a sense of stability amid tur-moil, and for helping to work through emotional trauma. This is because play is simple, familiar, and joyful—all the things that adversity is not. Not only does play make kids more resilient, but kids who don't play are at greater risk of failing to integrate socially, even to the point of engag-ing in criminal activity. When kids play actively together, they learn how to make and keep friends—in a word, they learn empathy.

It's time to push play up the priority list at home, in schools, and in our communities. The health, happiness, and success of our children depend on it. No matter where they live and under what circumstances, children need time and space to play. And that starts with a playground.

Acknowledgments

My thanks go first and foremost to my husband, Sean, who over the course of nine years supported, in myriad ways, my efforts to document disappearing playgrounds and to bring those photographs out into the world. I'm also grateful to my children, Sophia and Connor, for inspiring me to revisit my own childhood and to appreciate how important playgrounds are to children of all generations.

Special thanks also go to a host of people who offered encouragement and guidance over the years. Many of them are part of the incredibly supportive photographic community of Colorado's Front Range, including Rupert Jenkins, the director of the Colorado Photographic Arts Center, whose feedback helped me keep my book idea on track; Mark Sink, tireless promoter of the photographic community in Colorado and beyond; Holly Parker Dearborn, the curator who gave me my first solo exhibit of photographs; and many other friends and acquaintances who cheered me on from the very beginning.

Much gratitude also goes to Mary Virginia Swanson, whose expert advice and insight into the photography and publishing worlds helped me craft my playground project into a viable and appealing book proposal.

Aline Smithson deserves my sincere thanks for encouraging me to continue working on my book project when I was discouraged, and for getting me excited about it again.

I am also indebted to Robert Morton, whose interest and support bolstered my determination to get this work published.

And, finally, I am grateful to Mike Burton and his talented team at the University Press of New England, who enthusiastically embraced this project and brought it to beautiful fruition.

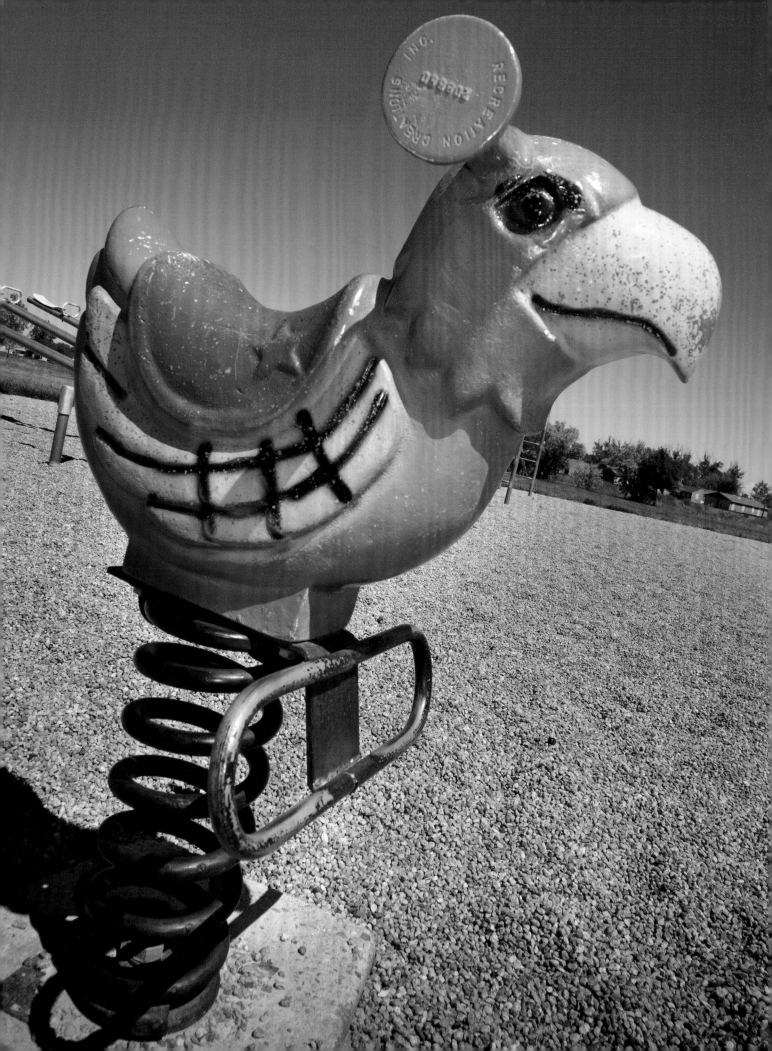

Photo Locations

Unless otherwise specified, locations are given top to bottom.

Historical Image Credits

American Playground Device Company of Anderson, Indiana — 42, 58

Ashland Manufacturing Company, Ashland, Ohio — xvii, xviii

EverWear Manufacturing Company of Springfield, Ohio — vii, xvi, 23

Game Time, Inc., of Litchfield, Michigan (Courtesy GameTime) — 74, 76, 78, 82, 90,
 91, 98, 100, 112, 114, 120, 121, 127, 129, 130, 134, 144

Giant Manufacturing Company of Council Bluffs, Iowa — 8, 12, 20, 30, 32

J. E. Porter Corporation of Ottawa, Illinois — 49, 56

General Equipment Company of Kokomo, Indiana — 18, 28, 52

Karymor Playground Apparatus catalog, by R. F. Lamar and Co. of Pueblo,
 Colorado — 10, 14

Library of Congress
 Bain News Service — xiv, xv, 13
 Detroit Publishing Co. — xiv
 Lewis Wickes Hine — xvii

Mexico Forge, Inc., of Lewistown, Pennsylvania (Courtesy Landscape
 Structures) — 109, 125, 132

Miracle Recreation Equipment Company of Grinnell, Iowa (Courtesy Miracle
 Recreation) — 72, 84, 88, 89, 96, 102, 103, 108, 118, 135, 138, 142, 146

Mitchell Manufacturing Company of Milwaukee, Wisconsin — xix, xx, 26

Recreation Equipment Corp. of Anderson, Indiana — 64

Several of the manufacturers whose playground equipment is featured in this book are still in business today. Burke (founded in 1920), GameTime (1929), Miracle (1927), and Landscape Structures (which was founded in 1971 and purchased Mexico Forge in 1984) are among those that continue to create play structures for children around the country.

To learn about current innovations in playground design, to see more historical playground images that didn't make it into the book, and to find links to numerous playground-related sites, please visit www. OnceUponAPlayground.com.

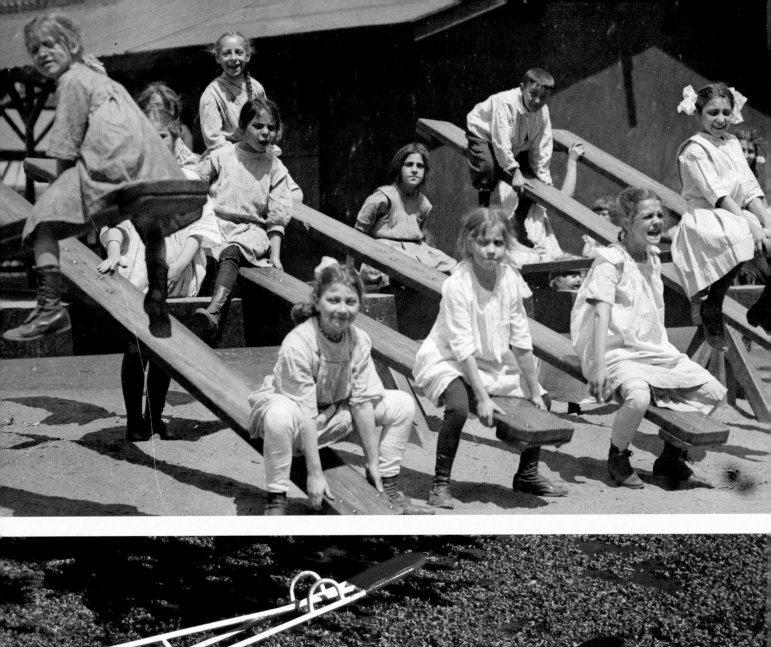
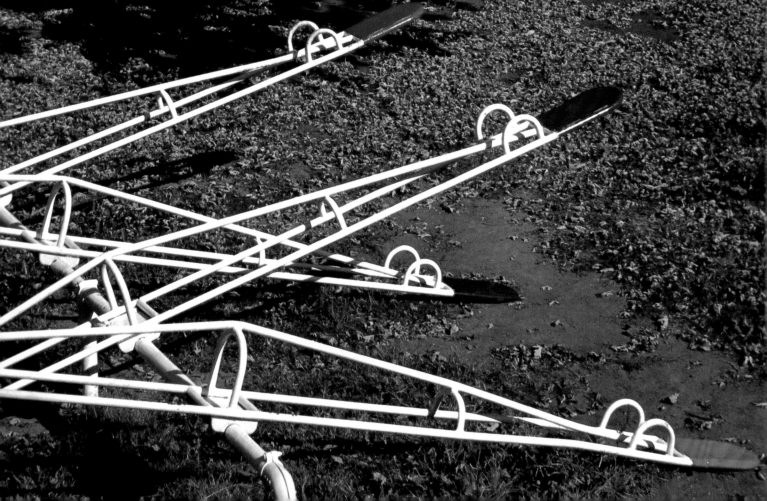